D1288373

ALL

about techniques in

AIRBRUSH

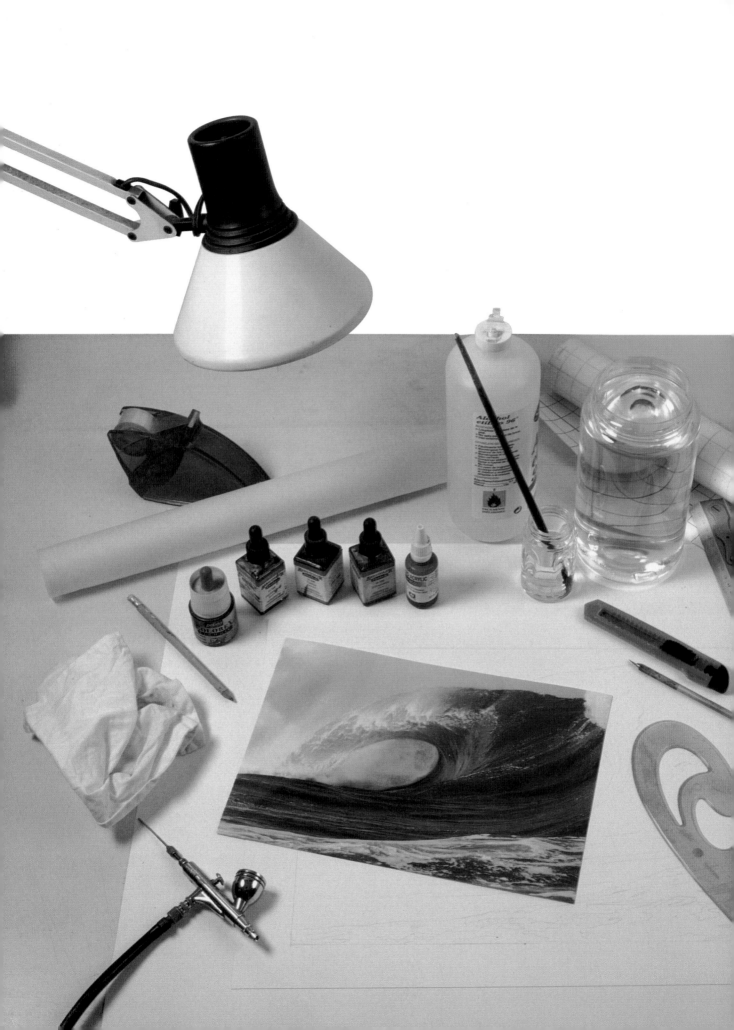

ALL
about techniques in
AIRBRUSH

BARRON'S

Contents

When people take up the airbrush for the first time, they have a sensation of confronting an alien tool that they can't control the way they are accustomed to with a pencil or a brush. The reason for that feeling is very simple: In airbrush painting, the tool doesn't touch the paper, and the paint is sprayed. Those features can make us feel confused; however, as with other techniques, practice and persistence are our best allies. After a while we discover the many advantages of airbrush painting, which makes it possible for us to cover large areas and paint fine details. In addition, the painter's job is made easier because the paint dries quickly. The effects that can be created using this technique are spectacular. By spraying a mist of paint, it's possible to produce shading and blending that would be very difficult to achieve in any other medium. There are no marks or brushstrokes, and colors take shape in a wispy and progressive way.

We will see how this technique was first applied in the world of art, what needs led to the invention of a new tool for illustrating, and how it was developed and perfected over time. We will also see how airbrush painting has influenced computer software and graphic art on the computer. This is a delicate area, since both processes aim for the same result: design, illustration, advertising. Both methods have advantages and disadvantages, and many times they can be regarded as complementary rather than opposed to one another.

Airbrush painting is an artistic medium that has very little tradition. It has existed for only about a hundred years. Its modern development and technique at first placed airbrush painting in an uncomfortable spot where it was looked down on and kept apart from traditional artistic methods. Its status improved as time went on until it finally achieved equality with other techniques and became part of some movements and decisive vanguards in the history of art.

The development of airbrush painting throughout the twentieth century didn't follow an easy path, and it was always conditioned on an acceptance of modern mechanics and technology on the part of artistic movements. Since the paint is sprayed from a distance and the painter doesn't touch the surface, it is considered to be an impersonal, cold, and mechanical technique. At first these factors limited its use to very inartistic purposes such as touching up photographs, creating series of greeting cards, filling in backgrounds, and so on. After World War I, movements such as Bauhaus, in Germany, began to strengthen the nature of this technique by legitimizing the mechanism and appreciating the synthesis of art and technology. From then on, airbrush painting entered the field of design, illustration, and poster art, areas in which it is still a fundamental tool. In the 1960s, with the growth of pop art, posters and record covers took on a great deal of prestige. Advertising turned into the queen of mass culture, and it has not relinquished that role up to the present day.

The functions of airbrush painting have been changing. It is still used in free artistic creations and in the field of illustration. The ability of this technique to imitate any type of texture makes it an indispensable tool for all kinds of themes, especially ones in which photography can't explain what the text requires. At the same time, in advertising, the computer has succeeded in imposing graphic creations, since it offers more possibilities for combining, retouching, and modifying photographs and images.

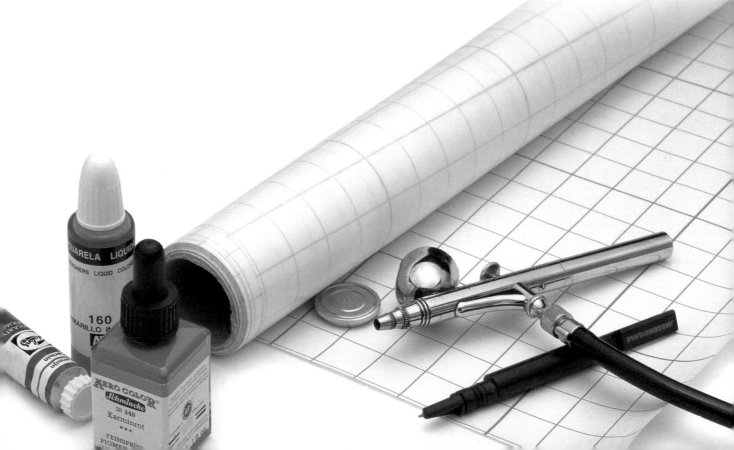

A Brief History of the Airbrush

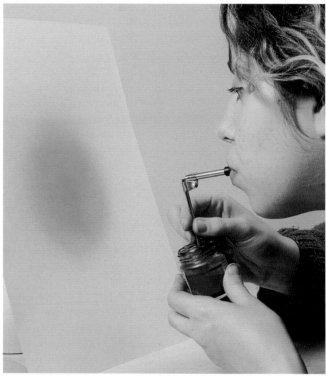

I n reality, modern illustration began with the invention of printing, and the possibility from that time forward of printing series of images for disseminating all kinds of information (literary, artistic, scientific, technical), or for graphically decorating and complementing texts. Ever since that time, the different styles of illustration have developed hand in hand with technological advances in the reproduction of images. As far as the style of illustration goes, the tendencies of each era have existed in harmony with changing pictorial models, adapting them to the graphic needs in an increasingly popular form.

The atomizer, like most airbrushes, air guns, and aerosols, works on the Bernoulli principle: The air that enters is under greater pressure than the medium, causing the paint to flow upward in the vertical tube until it mixes with the air and forms a generous and uniform mist.

CAVE PAINTINGS

Even though we are dealing with a contemporary tool for illustrating, images created with mists of color are as ancient as paint itself. The foundations of airbrush painting are rooted in prehistory; in cave paintings such as those in Lascaux, France, or the caves of the Pinturas River in Argentina, we find pigments sprayed around a hand so that it is blocked off and the area outside its silhouette is colored. The figures of large animals indicate that the technique of spraying colors was more common than we might think, and made it possible to fill large areas quickly and efficiently. In many drawings the silhouette was colored with a brush and the interior was sprayed several times. The presence of several layers of paint indicates that paint was added successively as time went on in order to reinforce the color.

PULVERIZED PAINT

We find the first evidence of sprayed paint in prehistory; later the methods of application became a little more refined. Some examples of that include works with wispy backgrounds and textures where no brush marks are visible. These probably involved using a mouth atomizer or a blow-pipe. This tool was used both for filling in backgrounds and for fixing and varnishing paintings. This involves two metallic tubes that form a ninety-degree angle with one another. The artist blows into one pipe while the other is submerged in the paint. The paint and the air mix in the middle so that the paint comes out in a spray. Obviously, the main problem was the effort required to fill in a large area. More efficient ways to propel the air were not developed until modern times.

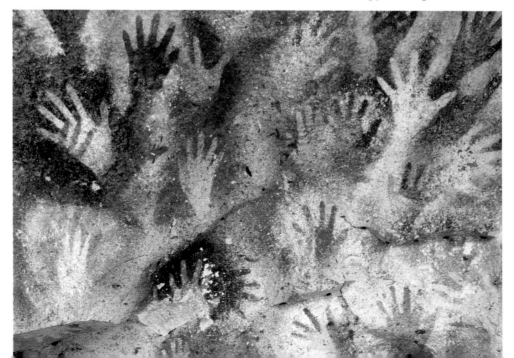

First approximation of a very simple and rudimentary form of spray painting. The blocked-off area is the hand itself, and the tool for pulverizing the paint was a hollow bone or a piece of reed. Cave in Pinturas River region, Patagonia, Argentina.

Charles L. Burdick, inventor of the airbrush in 1893.

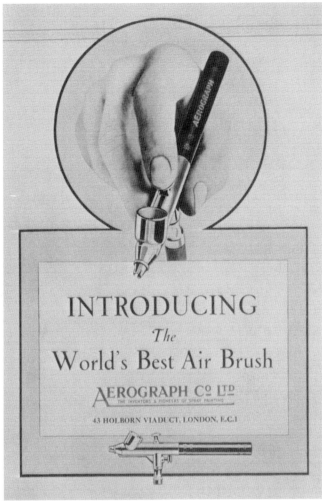

Poster publicizing the new tool known as an airbrush; it appeared in magazines and fine arts catalogs. Many artists embraced this new creative tool. The airbrush gives art a very different focus, more mechanized and in step with the social and industrial revolution that took place during the early years of the twentieth century.

THE FIRST AIRBRUSHES

The airbrush was invented around 1893. The discovery was made by the American watercolorist Charles L. Burdick, who wanted to discover a way to apply several layers of water color without affecting the underlying color. The airbrush turned out to be perfect for this purpose. Burdick named the device and patented the technique. He did numerous works with the airbrush, but they were rejected by the Royal Academy of Art. In spite of that, he set up shop in the United Kingdom, where he started an airbrush company named Fountain Brush.

The nose and throat specialist Allan De Vilviss, who was an associate of Burdick, invented an atomizing system to pulverize not only paints but also other substances such as anesthetics and perfumes.

THE PAASCHE AB TURBO

The Paasche AB Turbo is still the most precise airbrush in existence. Its design and con-

struction, which use external atomization, make it different from the rest of the models that are commonly used. In this tool the mixing of air and paint is accomplished outside the airbrush, and therefore it is not activated by suction.

The needle is activated by a high-velocity turbine that gives it a rapid back-and-forth movement, and its travel is controlled by the control lever. The paint is gravity-fed in front of the nozzle and it is propelled by the air that comes out of that orifice.

Both the speed of the turbine and the air pressure can be controlled independently, which makes the Paasche a very precise instrument.

Most of the airbrushes that we encounter today were already in existence during the 1920s; they were made of platinum, had a centralized nozzle .007 inches (0.18 mm) in diameter, a needle and a control lever, an air supply hose, and so on. In the last eighty years only tiny modifications have been added: threaded hoses, interchangeable paint reservoirs, and especially air compression systems that have varied in accordance with evolving technology.

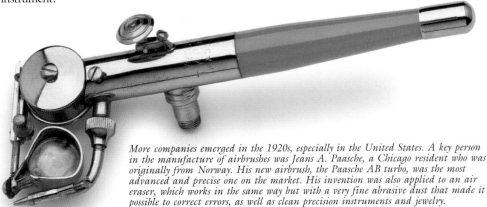

More companies emerged in the 1920s, especially in the United States. A key person in the manufacture of airbrushes was Jeans A. Paasche, a Chicago resident who was originally from Norway. His new airbrush, the Paasche AB turbo, was the most advanced and precise one on the market. His invention was also applied to an air eraser, which works in the same way but with a very fine abrasive dust that made it possible to correct errors, as well as clean precision instruments and jewelry.

AIRBRUSHING—IN THE VANGUARD

It is very important to understand the role that the airbrush as a new mechanical tool has had in art. Its acceptance depended entirely on the position that artistic movements would adopt in regard to technology and modernity. Some vanguard movements fled from mechanization, cities, and technology, but others relied heavily on this new social reality that was tied to industry and progress.

The first person to revolutionize the use of the airbrush was Man Ray. In his effort to unchain himself from artistic tradition, he began to spray figures and shapes in black and white on canvasses, with no attempt at realism, but he produced some very fine shapes. Unfortunately, his work was scorned during his time because he used mechanical means in painting.

Starting with World War I, there was a desire to break with tradition, and progressive movements such as Germany's Bauhaus Movement appeared; it defended the synthesis of art and technology.

People such as Paul Klee and Vasily Kandinsky analyzed art from the viewpoint of several disciplines, and established their own principles and rules. These creators, connected to Bauhaus, combined advertising, art, and design, and they produced posters, collages, and photomontages. The airbrush combined with other techniques in all these works in order to recreate space and texture. It was used to support montages and photographs, not as a medium unto itself, but as a supplement.

Art Deco appeared in France; it was a movement strongly reinforced by technology and often guided by the creation and design of furniture and tools that were painted and varnished using the airbrush. Given the importance of the teachings of Bauhaus and Art Deco, the airbrush quickly spread throughout the world.

Man Ray, La Volière, 1919. Gouache on paper, 28 × 10 inches (71 × 56 cm). The layers of paint can be distinguished in the painting as glazes, along with the blending that is done easily and efficiently with the airbrush.

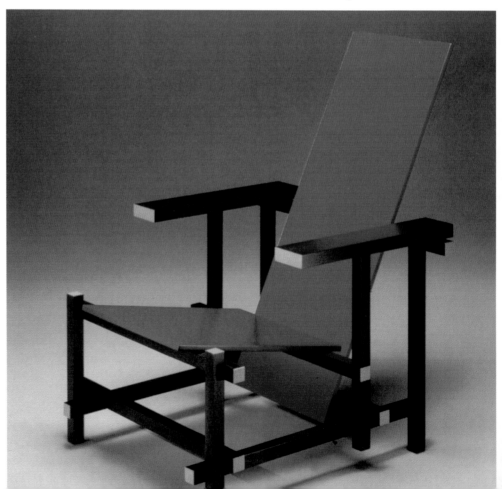

Red and Blue Chair by Rietveld, 1918. Lacquered wood. Innovative artists in the vanguard movements used the airbrush in their creations, but without elevating the instrument to the category of an artistic technique. It was used as a support tool, a means of intervening in the production of works of art, especially in furniture design. In this case, an air gun was used to paint each of the pieces that make up the chair. The air gun, which is a type of airbrush, produces a flat mist, and the paint remains smooth and uniform and without the problems in using a brush. This was an industrial rather than an artistic application of the airbrush.

POSTER ART BETWEEN THE WARS

So far we have discussed the role of the airbrush in the world of art, and we have seen how difficult it was to gain acceptance by the serious disciplines. For creating propaganda posters, however, the airbrush took on great relevance. The people were participating in the war and politics, and graphic arts were being used in the service of information and spreading ideas for society. Art ceased to be a privilege of certain strata of society and began to interest the population in general. More and more people wanted to get to know the works and their meaning, and the language became clear and simple so it would be accessible to all. Geometric and simplified forms predominated, and ornamentation and superfluous details were eliminated in order to communicate only the basics. Colors were flat, with scarcely any gradations, and were based on the primary colors, with the addition of black and white. This made it easier to print posters by the thousands.

What role did airbrushing play in this social and artistic reality? Posters, magazines, and other publications were the foremost means of communication. Illustration made with airbrushes is attractive and direct, and it has a stronger impact than other techniques, especially in blends and fusions of color.

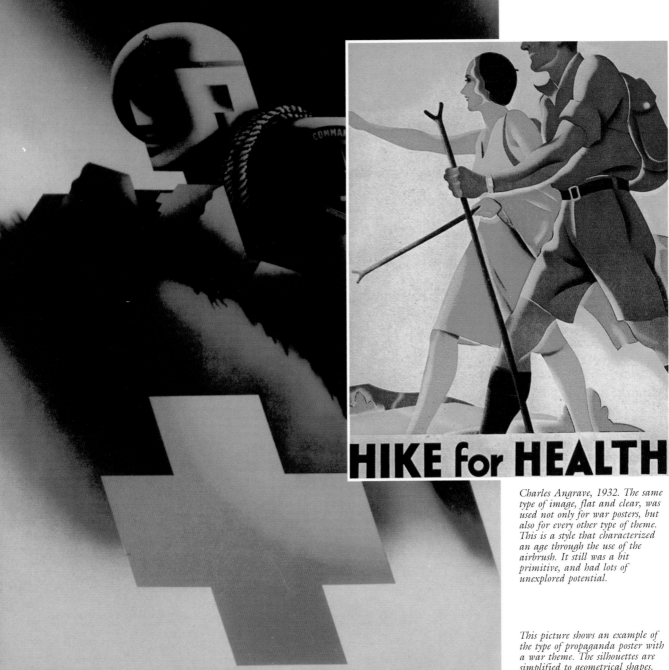

Charles Angrave, 1932. The same type of image, flat and clear, was used not only for war posters, but also for every other type of theme. This is a style that characterized an age through the use of the airbrush. It still was a bit primitive, and had lots of unexplored potential.

This picture shows an example of the type of propaganda poster with a war theme. The silhouettes are simplified to geometrical shapes. The human body is blunt and comprised of basic shapes. As already mentioned, the colors are primary ones plus black and white.

FESTIVE POSTERS FROM THE 1930s AND 1940s

In addition to cold and geometrical poster art, many other images have been produced with the airbrush, which in the long run have proven much more significant for posterity. This involves posters that deal with festive and leisure time themes.

As a result of the 1929 stock market crash and the wars that devastated Europe, the Depression really captured everyone's attention, and magazines, movies, and musicals seemed to offer a means of escape. Theater and movies offered uninhibited and spectacular dancers and *femmes fatales*, and these images and female prototypes were transformed into models to emulate. Two important illustrators from the period, George Petty and Antonio Vargas, provided a new focus for the airbrush. As collaborators on the magazine *Esquire,* they began to depict images that were caricatures of people on the one hand, and beautiful, sexy women on the other. These pictures of girls were so successful that they were reproduced on posters and calendars. One of the producers of *Esquire* founded *Playboy* in 1953; the center page was always reserved for one of the Vargas girls, models that were part of the American Dream. These were idealized women, with perfect bodies and fantasy faces. The styles of Vargas and Petty were adapted to many other outlets, such as posters for movies, the theater, and musicals. The airbrush was used in most of these illustrations to form the standards of beauty that had been transformed into the prevailing fashion. The airbrush was also used for touching up photographs: faces were refined to eliminate imperfections. Overall, it was a tool that brought the image close to perfection. The ability of the airbrush to perfect and idealize was established definitively in the 1930s and 1940s; it is still the technique's main attraction. The airbrush goes where no other technique can and transforms fantastic and imaginary images into reality.

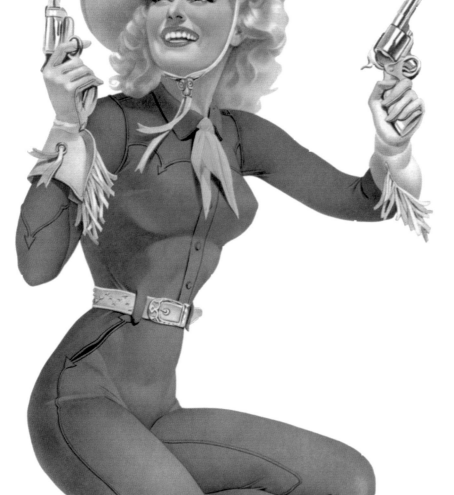

The perfection attainable with the airbrush makes idealized female images like this one possible, with smooth, flowing hair, curvaceous bodies, and perfect shapes.

THE EXALTATION OF FEMININITY

The result of the festive posters with their exuberant women goes far beyond mere propaganda and the distribution of items for leisure activities. It was a revolution in images of women, an absolute exaltation of femininity and beauty, comparable to what the fashion world and television offer today. The glamor of the movie-star faces is translated to paper using female images that are absolutely idealized through the use of the airbrush. This involves not only ideal bodies and fine, flowing hair created with this technique, but also consumer articles such as cosmetics, lingerie, and jewelry, which likewise became part of this revolution.

THE POP REVOLUTION

We have arrived at a time that broke with many traditions and introduced innovative styles and ideas. Music reached the masses, and musical shows became very important, as did posters, the covers of records and books, and so on. Two movements in particular stand out—pop art and surrealism—and the airbrush was central to both of them.

Pop art is based on the communications media and the power of advertising. The airbrush increased its prestige through integrated advertising images. In photo retouching, the presence of the airbrush is discreet, practically invisible; alterations are hard to detect, so publicists see in it the possibility of perfecting the image of their products, of manipulating them, and making them more attractive. Other artists use the airbrush entirely to create images, without recourse to photographs. The style of pop art is ingenious and festive, and it goes along with the times. The creators like the impersonal aspect of the airbrush. Artists' works don't seek individuality or their own personality; there is no trace of the artist in them, but the image depicts a product that must be entered through the eyes, a polished image that is perfected and flamboyant. The airbrush is the best tool to idealize everyday objects in the service of advertising. Just the same, it's not a magic wand that delivers images at the snap of the fingers; it still requires creativity. If art is a reflection of society, pop art is based on a society that is impersonal and productive, with an aesthetic derived from it and a tool that is right for the requirements.

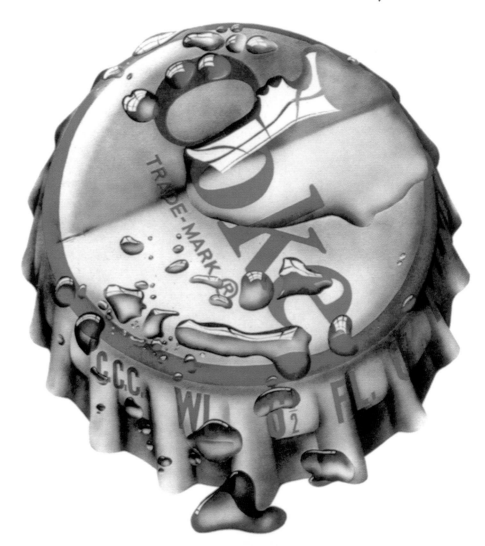

Michael English, Coke, 1970. Gouache on canvas, 48 × 36 inches (122 × 91 cm). In this example of pop art, the airbrush was used to convey textures such as water and metal, and to perfect the product and make it more attractive.

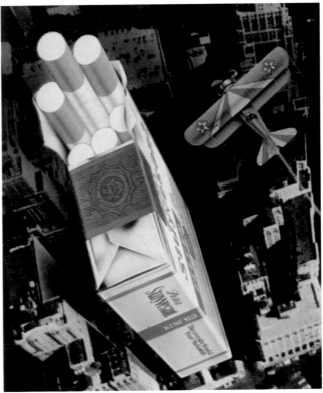

Skyscraper cigarette pack by Dick Ward. This image follows all the guidelines of pop art with respect to the promotion of the brand and its representation as an artistic theme. In this case, photo and image have been combined; the buildings and streets are part of an aerial photo, and the image of an enormous pack of cigarettes seen from the same vantage point has been imposed onto it. The realism of the cigarette pack and the cigarettes has been created using the airbrush to produce a totally faithful effect, and the concept of enlarging an object to make it resemble a large skyscraper is a basic element of pop philosophy.

SUPERREALISM

Following along with the tendencies of the sixties, we arrive at the superrealist style. Whereas pop art was found in all kinds of techniques and aspects of culture, superrealism was produced only in the world of drawing and painting. It is based in the imitation of photographic images, and it has lasted to our time, resisting both more abstract and minimalist tendencies. The pictures in which several types of realistic images appear are astonishing in their detail and preciseness. Like pop art, superrealism takes pleasure in photography, although the techniques and the context in which the works are exhibited require a new perspective on the part of the observer. The works are commonly in large format and of very diverse themes such as landscapes, interiors, and portraits. Once again, the airbrush is the best ally for creating all the textures that are found in nature. The airbrush is a mechanical device that offers as many possibilities for expression as a paintbrush and whose artistic result depends, of course, on the accomplishment and the personality of the painter. Finally, people have come to accept an instrument that they never should have doubted.

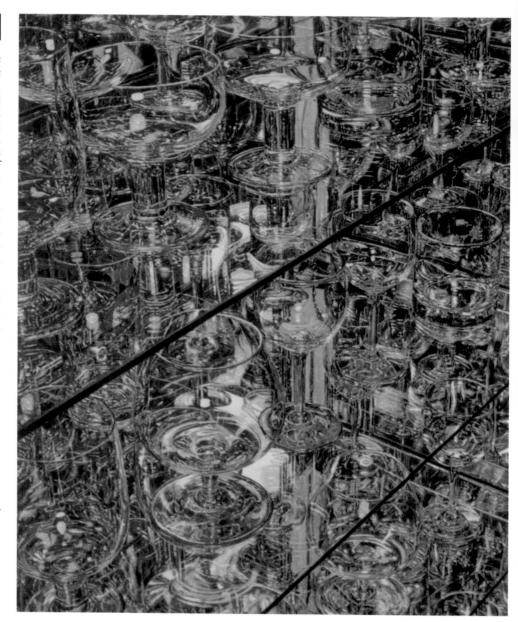

Don Eddy, Glassware, *1978. Acrylic on canvas. 53 × 40 inches (133 × 102 cm). It is plain to see that the superrealist artist confronts the challenge of conveying textures regardless of how complex they may be. The goal is absolute fidelity to reality, perfection, and maximum detail.*

John Salt, Green Chevrolet in a Green Field. *Oil on canvas. There is as much variety in the themes of superrealism as there is in reality itself; any theme can be applied to art, and the only condition that the artist must observe is an absolute faithfulness to the model, a photographic realism as in this picture. There is no need to have recourse to complex images or spectacular landscapes; a simpler and more basic situation can yield an absolutely realistic work based on faithful imitation of the textures and qualities of every element.*

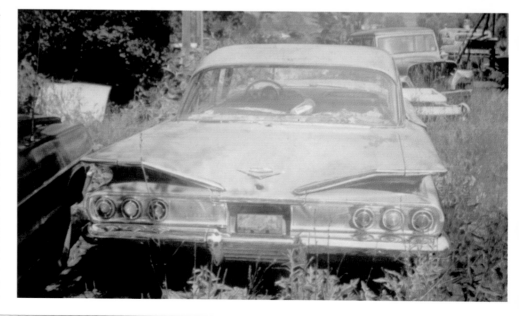

FUTURISTIC IMAGES

The ability to idealize images and create fantasy with the airbrush is a legacy from the surrealist movement; it is characterized by freedom to link reality and dreams. This results in a postsurrealist movement in which fantastic art predominates and science fiction is transformed into the preeminent theme for the airbrush. This interest in the fantastic worlds of the future comes from many areas of the culture. The new millennium is upon us, and movies, advertising, and television are filled with spaceships, robots, creatures from other worlds, and so on. We are looking for a different reality linked to the future to bring people together with new discoveries and new technologies. The result is an idealization of the future, space voyages, construction of artificial satellites, and a vision of other planets and other galaxies. An obsession with the future requires the graphic artists to make these as yet undiscovered worlds tangible. The airbrush, in its capacity as a precision instrument that leaves no fingerprints or brushstrokes, offers the possibility of creating images as detailed and pure as reality itself. It can create an illusion of reality in those fantastic worlds.

THE AIRBRUSH AND SCIENCE FICTION

The boom in airbrush use has culminated in depictions of these fantastic themes of space and futurism. During the 1970s and 1980s, the aerospace industry experienced tremendous growth, and that has repercussions in all facets of daily life: in movies, television, and especially in the visual arts. The airbrush is a modern and effective tool that makes it possible to depict with ease all the fantasies related to the growing world of science fiction. We encounter not only personal creations by independent artists, but the airbrush is also used to illustrate covers for movies, records, and books connected to this theme. It can be used to create images that are still inaccessible in space and the phenomena that occur there, as well as depicting imaginary or real spaceships that are becoming increasingly advanced for space exploration.

Fantastic illustration by Chris Moore, one of the specialists in space and futuristic themes. The airbrush makes it possible to create all types of textures convincingly, including the surface of the planet and the metallic qualities of the spaceship. In addition, sprays and blending make for very realistic conditions of light and shadow.

Images of robots and bionic creatures are also part of the fantastic world of the future. Here is a mixture of human anatomy and technological elements. This involves concepts that presently are possible only in the imagination of graphic artists.

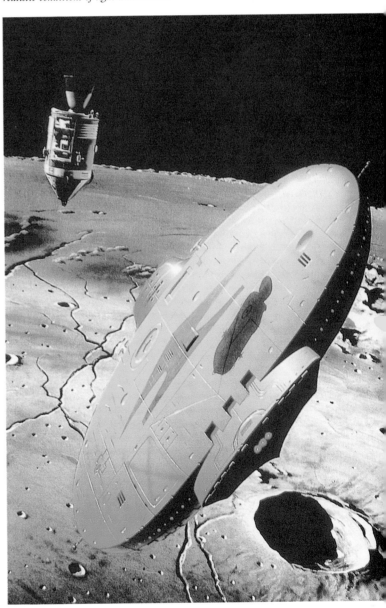

Airbrush Applications

The applications for the airbrush are not limited to the simple creation of visual images; that is something that can be accomplished using any artistic technique. Because of its representational abilities, the airbrush has been used in many areas of design and illustration for books and publications, and especially in advertising. Since the spray can be made extremely fine, it has also been used in other areas such as photography, painting models, and others.

Medical illustration by Miquel Ferrón for an anatomy atlas. Medicine is one area that has an enormous need for illustrations. The internal organs of the body can be represented cleanly and minutely using the airbrush. Their texture and color are perfectly evident, and that is something that can't be observed in a natural state.

THE AIRBRUSH IN ILLUSTRATING

We now arrive at the most important use of the airbrush. While it was difficult to integrate this technique into the field of conventional painting, it immediately proved to be an advantage and a major find in illustrating. Unfortunately, the illustrations do not have the prestige of great and pretentious works, but they are so widespread in daily life that they require absolute professionalism on the part of the artist who gets the assignment.

There is no limit to the themes that can be illustrated, and the degree of detail depends entirely on the nature of the material depicted. For example, short narratives, children's stories, and comics can be conveyed perfectly through simple means, without details and precision. Sometimes a drawing is clearer if it is simplified and free of complications.

In other fields, especially in scientific and technical areas, meticulous visual documentation is indispensable. Scientific illustrations have always been done in a very precise way. The airbrush is very practical and effective in creating all kinds of realistic effects and thoroughly illustrating the textual in-formation. The branches of science are very diverse: geology, astronomy, ecology, zoology, botany, medicine, and so on. In all cases it is common to include a maximum number of details, and the images are idealized to make the text as understandable as possible. In many instances, photography is incapable of reproducing all the details because it depends on focus; but an illustrator can manipulate the images and render them more comprehensible. Another advantage involves illustrating elements that are invisible to the eye, such as atoms, molecules, and cells, or galaxies, planets, and solar systems. In all these cases, the information is usually very theoretical—the images depend on microscopes and telescopes that, no matter how precise they may be, cannot achieve the perfection of the airbrush.

Fragment of the human epithelium in which are visible the various layers of the skin, the capillaries, the hair, and the sweat glands. This is an example of how illustrating with the airbrush makes it possible to beautifully represent a microscopic vision of our body. The illustrations are clear and understandable, and the colors used are slightly artificial to make every part a little more comprehensible; a photographic image of this would be practically impossible to understand. The airbrush makes this image accessible to any observer and creates an attractive and precise image, with all elements clearly represented, something that is very difficult to do in a real image.

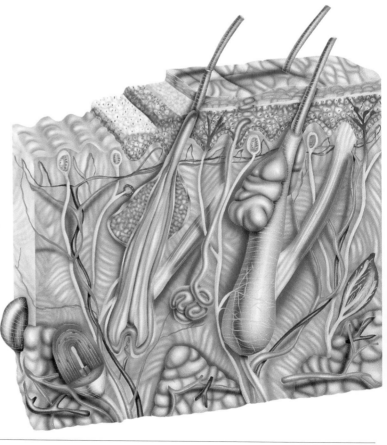

Scientific illustration by Miquel Ferrón depicting outer space. The effects of light and shadow, which are so important in space pictures, are perfectly resolved using the spray from the airbrush. With the high-quality airbrush paints that are available, the result is fascinating and very realistic.

Technical illustration by Miquel Ferrón. The cross-sectional view makes it possible to see the set of internal mirrors, the area where the film is inserted, and so on. All the internal elements are placed correctly, and the perfect functioning of the camera is assured. Obviously, not all details can be resolved using the airbrush. The tiniest parts and details require combinations involving other techniques such as colored pencils and gouache.

A SLOW PROCESS

Of all the applications for the airbrush, technical illustrations are the most complex and laborious. In these images, the information has to be exhaustive and perfectly faithful to the machine, with the added complication that it has to explain its internal functioning. The endless quantity of tiny details, circuits, and parts means that each one of them has to be treated with precision and accuracy. Airbrush work is very distinct from purely artistic work; it involves using the tool in a technical and meticulous way without the freedom that other themes offer. The work has to be developed slowly, clarifying the parts one at a time, first with the large planes and then the very precise details. It is a good idea to start with the dark colors and progress to the lightest ones; that is one way to advance the work in an organized manner. The complexity of the work requires cutting many masks and proceeding step by step until you arrive at the final touches. In this type of illustrating, it is not enough to manipulate the airbrush; other techniques such as colored pencils, markers, and gouache will also have to be used, since there are many linear shapes that help to define the elements.

TECHNICAL ILLUSTRATIONS

Technical illustrations are another broad area in which the airbrush is tremendously helpful in clarifying images. In every drawing project, aside from the specific views that establish the proportions, there is a final picture in perspective that shows the object in a realistic and detailed form. People were quick to discover the quality of the airbrush in representing plastic and metallic textures and all their shines and reflections. Cross-sectional pictures of technical devices are also frequently used to explain their internal workings. Technical illustrations require a great mastery of realistic drawing and of the different systems of scale representation and perspective. In addition to these skills, the artist needs a rigorous attitude in creating the work and a graphic talent for discovering the most effective graphic representation of the object. This last consideration is the one that requires a strong artistic component. Being able to depict a beautiful or flamboyant shape implies a

highly developed creative sensitivity.

Technical illustrations require an exhaustive adaptation to technical documentation. Although the picture should be attractive, the precision and fidelity to the mechanism must be absolute. It is necessary to have access to a multitude of reference books and pamphlets, and in certain cases to the advice of an expert.

CONCEPTUAL ILLUSTRATIONS

This is a type of illustration that is essentially creative and imaginative; normally it doesn't accompany a text, but rather it is a graphic representation of an idea. Conceptual illustrations have to be bold and show a personal conception of the idea; in other words, they have to comply with certain requirements of originality and clear transmission of ideas. The personal focus of the artist is important; nearly all the qualities of the picture are based on this focus on the idea, and the style and the finished picture comes after that. The shapes depicted may be multiple, from the most minute works up to the simplest and most minimalist. It should be noted that the latter are the most popular and widely accepted ones today. In any case, the airbrush offers the possibility of reinforcing the visual impact that this type of illustration requires.

Transverse and longitudinal cross sections through the terrain are one basic graphic resource used in many geology and geography illustrations. The airbrush of Marcel Socias made these views perfectly convincing.

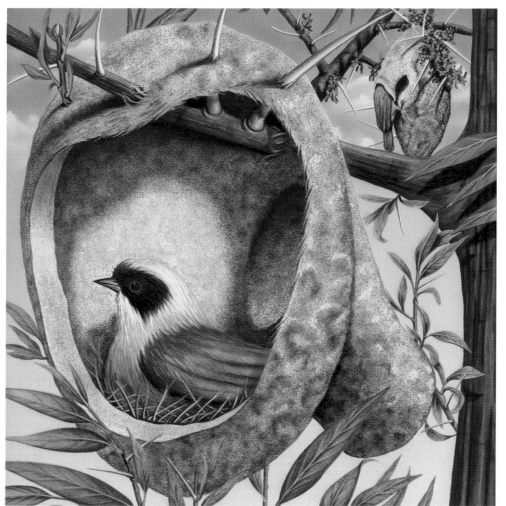

The technical adaptability of the airbrush becomes clear in this scientific illustration by Francisco Arredondo.

NARRATIVE ILLUSTRATIONS

In contrast to conceptual illustration, narrative illustration accompanies a concrete text, so it needs to be explicit and clear. Once again, the style can be quite varied; the simplest drawings are used in the same way as the complex ones, and simple shapes are commonly used in texts that are not very complicated, such as children's stories and short stories. In these cases the pictures are a complement to the text and don't need to explain it, so any procedure can be appropriate. Complex illustrations always accompany texts with scientific, historical, technical, and other similar connotations. In these cases the illustration needs to clarify the text and offer a clearer image of what is being explained. For such purposes the airbrush is practically indispensable because of its ability to convey qualities and textures.

ILLUSTRATIONS FOR ADVERTISING

Illustrating for advertising comes from a basic need of consumer society; around the middle of the twentieth century, artistic tendencies became focused on movements of popular urban culture and its products. Pop art was the first to elevate this tendency to a valued artistic style, although parallel to this, people were creating works with other purposes that were less pretentious, yet totally valid. Illustration began to experiment with traditional popular formulas such as street ads, comic strips, magazine and book covers, and so on. Magazines and other publications offered the greatest possibilities for experimental and avant-garde works, with a constant demand for new and imaginative creators. Imagination and originality are the main hook in creating illustrations for advertising. The illustrators have to be up to date on the aesthetics of the moment and popular tastes so they can adapt their work to them. Since the airbrush is so versatile, it's the ideal means for representing any idea.

Illustration for advertising goes along with a specific commercial brand, a product,

a social phenomenon, and so on. It entails a thorough knowledge of the product to exploit its possibilities to the maximum and create an image with strong visual impact. These commercial brands involve the graphic design of the product, the typography and aesthetics, some strong preferences for the colors used, the distribution of space, and other considerations.

Illustrations for packaging of commercial products present an image of the global brand with variations applied to the various containers, wrappings, and accessories that the brand displays to the public, from simple labels to projects for decorating public places. In this entire field, the typography and graphic design are fundamental. The illustrator has to be very familiar with both worlds and have access to all kinds of information on posters, letters, and colors. The airbrush has been used a lot in creating this sort of typographical design. That's why we see letters that imitate neon lights, metallic or plain letters, shadows, blurred letters, and other effects. Thus we have a new application for airbrush applied to advertising and focused on the design of the letters.

Professional illustrators have to produce a book or a portfolio where they file all the works they have done, duly protected in plastic and presented in a polished and organized fashion, with descriptions to accompany the illustrations if necessary, including titles, materials, and techniques. It is a good idea to incorporate the broadest possible range of themes and technical challenges. Sometimes it is hard to include original works, since they have been delivered or published; in such cases color copies or printed pages can be made to provide the most detailed image possible.

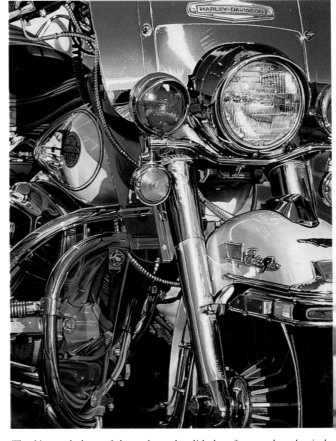

The shine and gleam of chromed metal, polished surfaces, and mechanical splendor are some of the best things that airbrushing brings to commercial illustration. This Harley Davidson motorcycle was done by Hideaki Mundama.

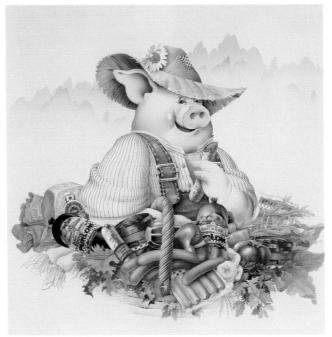

The airbrush is adaptable to any kind of illustrative style. This picture by Miquel Ferrón combines a caricaturelike style and the detailed realism that commercial illustration almost always requires.

RETOUCHING PHOTOGRAPHS

The airbrush has often been used to retouch photographs. At first the reason was very simple: Photographs were available only in black and white, and they often contained imperfections when the image was reproduced on paper. Starting in 1860 photos were colored using paintbrushes, but after the appearance of the airbrush, it became clear that this tool was far better suited to the task. It left no visible brushstrokes, and it was very precise when masks were used.

As time passed, photographic images improved in quality, and today photographs are so good that they don't need any retouching or heightening of contrast or color. At the same time, if the photo is old or imperfect, the airbrush is still very useful in polishing and perfecting the surface. In any case, we now have very finely pulverized pigmented colors, both flat and gloss, that are specially made for retouching photographs. There are also very broad spectrums of gray for retouching black-and-white photographs, especially old ones that have suffered more deterioration. Photos are also commonly retouched to modify the background, to eliminate objects that appear there, or to nuance the colors in general.

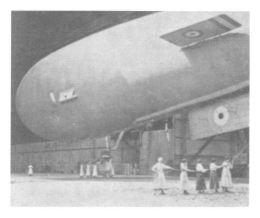
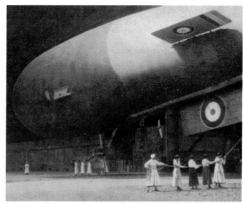

Example of coloring a photographic image from the start of the twentieth century.

COMBINING PAINTING AND PHOTOGRAPHY

The line that separates a sprayed image from photography keeps getting narrower, especially when an airbrush is used. In the first collages that appeared, the photographic image was part of a composition of shapes and colors with a certain artistic goal. There was, for example, a high point in this technique in dadaism, surrealism, and other avant-garde tendencies. In those instances the drawing or the manual intervention was obvious and clearly distinguishable from the photographic image. The airbrush entered that arena to combine much more discreetly with the image; its use was limited to perfecting the photo, to complementing it without drawing attention to itself, to touching up backgrounds and textures. As a result, when it is used in this way, there are few examples where the airbrush is clear and distinct from the photograph—only in some ads where it sought to create impact and contrast, as elsewhere it was merely a source of support.

Example of retouching a photograph to perfect the metallic texture and eliminate the rust and distress. The imperfections and deterioration disappear and give way to a new luster.

AIRBRUSHING ON GLASS

Images for advertising are still of primary importance for the airbrush; the product image is emphasized to make it attractive and desirable. In this broad field of images made for commercial use, painted works really stand out when they are applied in the very places for which they are made. This involves decorating show windows. The themes are very diverse, depending on the nature of the business. A clear example that is seen in many bars and restaurants is the decoration of picture windows with themes related to food.

Decorating display windows involves the same techniques that are used for working on paper, but in much larger format. Shading and details are also done with brushes, but the materials change. The airbrush needs to have a fairly large reservoir.

Synthetic enamels are required for this type of work; these are paints that adhere to most nonporous surfaces, have great covering power, and a spectacular shine.

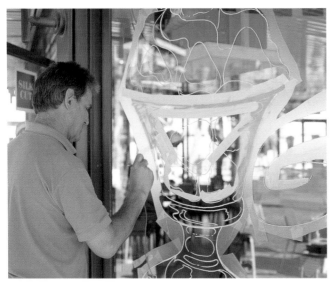

The preliminary sketch is usually done using an acrylic paint that is erased with a damp cloth when the images are applied onto glass. In dealing with a transparent surface, a white or very light base is required.

The stencils for spraying these large images have to be prepared and cut out beforehand in the studio so that everything is ready when it is time to get to work. The stencils have to be able to withstand the working conditions.

When working vertically and in large format, many details can be done freehand.

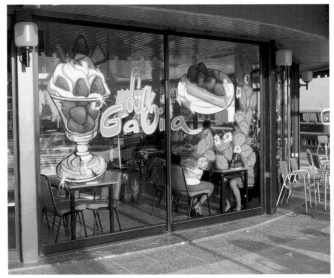

Final result of a dish of strawberries and whipped cream on a restaurant window; artwork by Josep Pena.

PAINTING MODELS AND THREE-DIMENSIONAL FIGURES

Industrial painting in manufacturing dolls, models, and toys in general is one of the many applications of the airbrush in artistic fields. Porcelain and plastic dolls can be painted with acrylics; those made out of latex and papier mâché can also be painted with enamels.

It is easy to recognize an airbrushed object: Note the fused colors and smooth textures that rarely can be accomplished with a brush.

The tool for this type of activity is not exactly an airbrush, since the detail and the precision are not so demanding. The painting is done with an industrial paint sprayer or an airbrush gun.

ENAMELS FOR MODELS

Enamels used by model makers usually contain very fine pigmentation and come in very small containers in an extremely broad range of colors, so it is not necessary to mix them. Enamels are very volatile and they dry quickly. The fact that they are sold in small containers implies that they are used just once. The variety of colors means that we can apply them directly without mixing. If we were to mix them, we would lose a lot of the contents and their special qualities; the paint could dry considerably during the mixing process and clog the airbrush. Keep in mind that after using this type of paint, the airbrush must be cleaned very thoroughly and quickly using nitro-type solvents that should not be inhaled.

In order to paint models or other objects that need certain areas left unpainted, use masking tape or any other flexible material that adheres; it must conform to the contours of the three-dimensional object.

If the outlines of the area to be left unpainted are solid, a craft knife can be used to cut off the excess tape. That way you preserve the shape of the glass perfectly.

The paint spray has to be ample and uniform so that it is equally intense on all parts. To be sure that everything gets painted, the car is held with tweezers that are inserted into some opening in the model.

The airbrush can also be used to color clothing effectively. There are some professionals who produce true works of art on T-shirts, but the usual practice involves creating simple, decorative shapes without great attention to detail; otherwise the article of clothing would be very costly because of the hours and the work invested in it. Sprays are usually applied to cloth in series, in order to color many shirts in a short time. Movable stencils are needed for that; they are usually made of cardboard and are applied to shirt after shirt. Special inks for fabric are used, and they can be applied to any type of material (cotton, linen, nylon, etc.). They are expensive, so it's advisable to buy just the primary colors plus black and white.

In order to paint a T-shirt with an airbrush, the shirt has to be put onto a wooden board to keep it flat and free of wrinkles. Take care that it is not stretched too tight, or the picture might be distorted when the tension is released.

T-shirt designed and painted by Miquel Ferrón. The drawing is simple and the colors are very basic. The motif has been transferred to a piece of cardboard and cut out with a knife to serve as a mask. The inks were carefully chosen for their compatibility with the type of fabric.

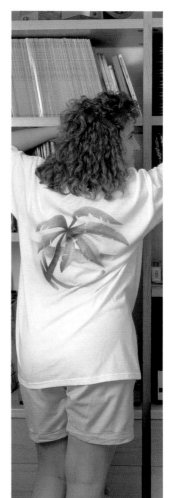

USING TEMPLATES

The most important thing to keep in mind in using an airbrush on fabric—a T-shirt in this case—is that we must never cut masks on it; otherwise we could damage it, and our work would be wasted. The palm tree, designed in a simple shape, is done entirely with a movable stencil made of cardboard in which the outline has been cut. The last way to work on T-shirts involves creating a complex illustration; in such cases we have to use an airbrush mask, but the problem is that we can't cut it directly. We have to do the design on a separate rigid surface such as cardboard or a file folder. We put the mask onto that and cut it out, and then every stencil is applied to the T-shirt until the spraying is finished.

THE ADVENT OF COMPUTER GRAPHICS

One might say that the advent of graphic design by computer has been a serious setback for traditional airbrushing; however, we have to keep in mind the pros and cons of both techniques. At first people thought that the airbrush was cold and impersonal, but the role of the artist is even farther removed when computers are used. In this latter case there is also no real original work; the work of art disappears and is used to produce a multitude of copies, as many as anyone would want to print. On the other hand, the computer offers so many ways to facilitate the artist's work that ability and skill are often called into question. Scanners digitalize images, and then all the features that need retouching can be changed to produce truly astonishing results. Many programs are used for illustrating including Adobe Illustrator, Adobe Photoshop, and Freehand (made by Macromedia). The equipment for doing illustrations with computers is expensive, and you need prior training in order to use all the program tools.

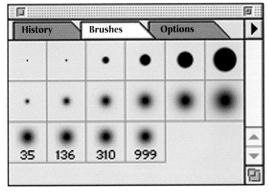

Airbrush function is included in some programs, such as Adobe Photoshop, and it is possible to calculate the area sprayed, air pressure, etc.

The painter's palette is established by the samples window, but it is possible to create new colors using mixtures of other tones.

TOOLS FOR DRAWING

The computer involves a manual part, as opposed to a mechanical one, which is undoubtedly where artists develop their qualities as illustrators and enjoy doing more traditional work. Drawing the illustration and filling it in have to be done by hand, on a surface that is not the computer screen, but rather a graphic palette. The artist needs to get used to drawing on a flat surface while watching the monitor. The graphic palette is a sensor on which you draw your lines as if it were paper; you use a special pencil whose point transmits the hand movements to the computer. So the pressure that you exert on the palette will be reflected on the screen as if it were being done on paper; the same pencil is used to fill in color, using the program options to select the areas you want to color in our application.

Another option for illustrating involves using the mouse. In this case the graphic palette is not used, and normally the tool requires less pressure than the electronic pencil. It is a good idea to use an optical mouse that does not have mechanical elements, but does offer great precision. With a standard mouse you have to be very careful with its internal cleanliness, because any vestige of dirt can make it more difficult to draw a line and complicate the work; you have to take out the central ball and clean out any trace of dirt using an artist's brush with stiff bristles.

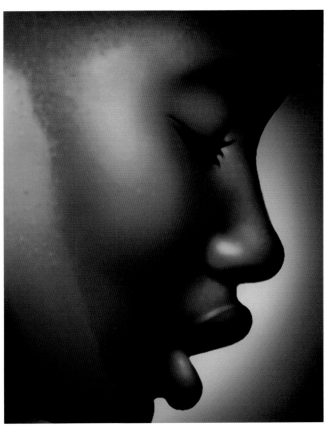

As you can see, the result of computer illustrations is spectacular, detailed, and perfect. The resolution of illustrations is commonly 120 pixels per centimeter, the same as films and photolithographs, so the quality of the image is perfect.

Despite the great quantity of graphic imagery done by computer, the creative process is often interrupted to open and close windows that allow choosing options. This does not happen in airbrushing by hand: The painter is in much closer contact with the image, and the options of pressure and color arise more spontaneously and directly; it all depends on the artist's mastery of drawing and the tool. Many artists use the computer to create the basic image or drawing, and prefer to color by hand in order to become more involved in creating the final product.

Tools

Although there are certain differences among airbrushes with respect to their internal structure, you can see that they have a similar mechanism that uses analogous parts inside. Whether the airbrushes are single or double action, the basic components are always the same.

COMPONENT PARTS OF AIRBRUSHES

The airbrush consists of a metal body into which a valve is inserted to let in air, and a reservoir that contains the ink. The paint propelled by the compressed air produces a spray; if this occurs inside the airbrush, it is called internal atomization; if it happens outside, the atomization is external. The control for the quantity of paint and air pressure is a lever that is pressed downward to determine the quantity of air; pulling it backward determines the flow of paint. When the lever is simply pressed down, you control only the air, and in that case it is called single action. If the air pressure is fixed and you can only pull back on the lever, it is called fixed double action. If you can control both the backward movement and the pressure, it is called independent double action. Most airbrushes today, like the one depicted on these two pages, belong in this last group; they are more versatile, and the lever allows absolute control of line and spray.

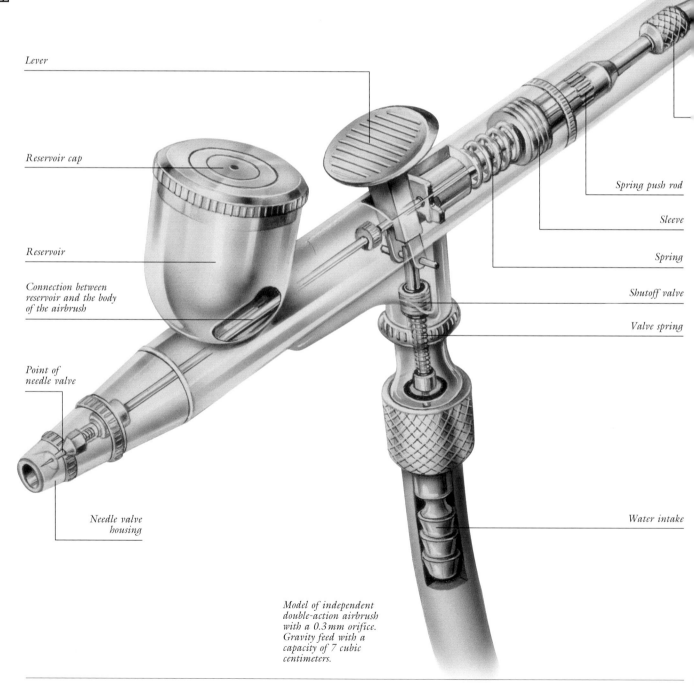

Lever

Reservoir cap

Reservoir

Connection between reservoir and the body of the airbrush

Point of needle valve

Needle valve housing

Spring push rod

Sleeve

Spring

Shutoff valve

Valve spring

Water intake

Model of independent double-action airbrush with a 0.3 mm orifice. Gravity feed with a capacity of 7 cubic centimeters.

HANDLE OR BARREL FOR THE NEEDLE

External part that protects the needle and keeps it from breaking or bending. It is screwed to the body of the airbrush.

AIRBRUSH BODY

External part that goes from the orifice to the handle and houses the internal mechanism.

FLUID NEEDLE

The main part in the functioning of the airbrush. The position of the needle relative to the aperture in the nozzle determines the flow of paint. If the needle blocks it totally, no paint comes out. As the needle retracts, the spray increases.

NEEDLE ADJUSTMENT

Part that screws in to set the position of the needle. It moves backward as the activating lever is moved.

NEEDLE SPRING

Part that controls the forward and backward movement of the

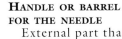

Handle or barrel

Fluid Needle

Needle valve adjustment

operating lever when paint is released to provide a gradual spray.

SPRING STOP

Screw or screws that limit the movement of the spring and set the conditions for the backward movement of the needle.

SPRING PUSH ROD

Metallic piece through which the needle passes. In the rear, where the diameter is larger, the lock nuts are adjusted. In the front, the part narrows down and passes through the interior of the barrel and the spring.

SLEEVE

The part that separates the front and rear parts of the airbrush. It is attached to the body of the airbrush, and it secures and centers all the interior parts.

OPERATING LEVER

The part that is used to control the working of the airbrush. Its backward movement retracts the needle that

controls the flow of paint. Moving the lever downward regulates the airflow, since it is in direct engagement with the valve in the sleeve.

NEEDLE SUPPORT

Thick cylinder through which the needle passes. It is centered from its passage through the activating lever until it reaches the spring push rod.

WASHER NEEDLE

Part that keeps the needle centered properly with respect to the nozzle.

SHUTOFF VALVE

Part that moves downward by means of the operating lever and provides access to the air supply.

VALVE SPRING

Part that creates the optimum conditions so that pressing the operating lever downward and airflow are gradual and controlled.

TURBO-AIR MOUNTING

Threaded area that secures the body of the airbrush to the hose.

POINT OF NOZZLE

Small, delicate part with a tiny orifice through which the needle passes. When the needle is all the way forward, the nozzle is blocked and paint cannot flow.

NEEDLE HOUSING

Part that mainly serves to protect the point of the needle, but it also determines the direction of the spray.

RESERVOIR

Part that contains the liquid paint. There are many shapes and sizes, but they are part of the airbrush body, as in this case, or they are separate pieces that are attached with a bolt. The reservoirs that are part of the airbrush body are made of the same material and soldered in place. The separate reservoirs may be of metal, plastic, or glass. Whatever the case, the reservoir needs to have a cover to keep paint from spilling onto the painting.

CONNECTION BETWEEN THE RESERVOIR AND THE AIRBRUSH

Hole in the reservoir through which the paint gets into the interior and is mixed with the air. With airbrushes that have siphon feed, the reservoir is located below the body; the paint does not filter through the hole, and instead has to be absorbed through a small tube.

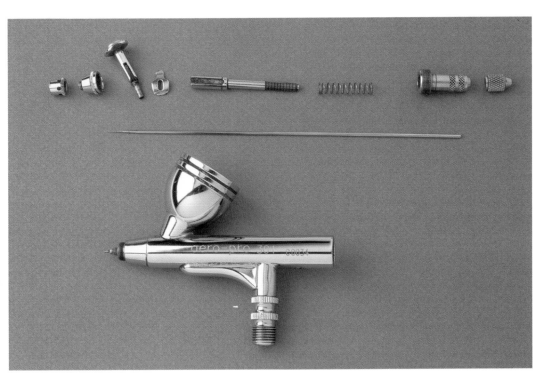

Disassembled airbrush of the type illustrated on the facing page; the actual pieces described can be identified.

AIRBRUSH CHARACTERISTICS

On the functional level, all airbrushes are based on the same principle as breath spray. This involves the Bernoulli principle, which combines air and ink in a spurt that is expelled under pressure through a nozzle. Based on this fundamental idea, numerous systems have been invented to control the pressure and the breadth of the spray of paint. Since their invention, airbrushes have not undergone many developments, but their finish has been perfected. The best material for making airbrushes is stainless steel, which is lighter and easier to clean than the heavier metals that were used to make the first prototypes. With respect to classifying airbrushes, you have to consider various issues. Here is a general way of classifying airbrushes:

1. Suction-feed Airbrushes
 Gravity-feed Airbrushes

2. External Atomizing Airbrushes
 Internal Atomizing Airbrushes

3. Single-Action Airbrushes
 Double-Action Airbrushes

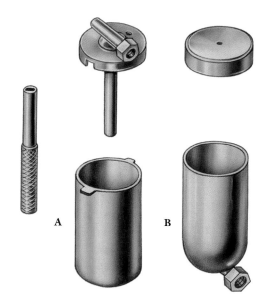

Airbrushes can have different types of paint reservoirs depending on whether they use gravity or suction. In the first case, many airbrushes incorporate a reservoir as part of the metal body, and therefore they cannot be removed; that means that they have to be cleaned thoroughly every time the color is changed. Detachable reservoirs make it easier to keep the tool clean, and they come with refills for quick color changes.

In the picture we see two types of removable reservoir: suction (A), and gravity (B). With the first type, the cover contains the tube through which the paint moves upward, for which purpose these parts are essential. In the second case, the cover serves only to keep the paint from spilling; the paint gets into the airbrush through the bottom of the reservoir.

Gravity-fed airbrush. The paint descends through its own weight and enters the interior of the airbrush, where it mixes with air. This is called gravity feed because of the free fall of the paint from the reservoir to the airbrush body.

Suction airbrush. When the air is applied, the Bernoulli principle causes the ink to be sucked into the interior of the airbrush; the liquid is siphoned up in the same way as when you drink a liquid through a straw. Once the ink is inside the airbrush, it is mixed with air.

SUCTION AND GRAVITY

There are two types of airbrushes based on the location of the paint supply relative to the body of the brush.

The ones fed by suction have the paint reservoir located underneath the body of the airbrush in such a way that the paint is siphoned upward to mix with the air.

Airbrushes fed by gravity have the reservoir located on top of the body, so that the paint descends through its own weight to be mixed with the air. Both styles of airbrush are equally satisfactory.

Gravity-fed airbrushes tend to have fixed reservoirs, while those that are fed by suction usually have interchangeable reservoirs, since the cover is part of the airbrush body.

INTERNAL AND EXTERNAL ATOMIZING

Depending on where the air and paint are mixed, we speak of external and internal atomizing. The former are the simplest, and are based on the same principle as mouth sprays. The air and the paint combine outside the airbrush. Airbrushes that have no needle are extremely simple. Most air guns belong to this category. There is no air or paint control on the air guns, and they are used to paint large areas with a flat color. There are some models where the flow of air and paint can be controlled with nuts located on the nozzle and the intake from the reservoir,

which allows a very rudimentary control of the spray. Airbrushes with exterior atomizing and a needle are a little more complex than the foregoing type. Nothing but air circulates inside the body; it is controlled by a lever, and the paint is mixed with the air by means of a tube with a needle that can be modified to create the ideal conditions for the spray. They are more versatile than air guns, since they can be used to do very detailed work. Airbrushes with internal atomization are the most common type. With them, the air and paint are mixed inside the body of the tool, and the quantity of both is regulated with an operating lever that provides the painter with absolute control over the tool. There are many models, depending on how the lever is used.

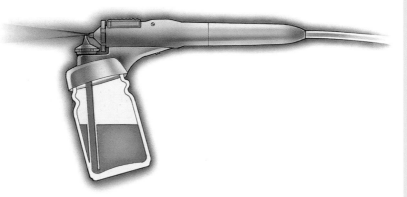

Schematic diagram of a Badger 250 air gun. It uses external atomizing and has no needle. It is the embodiment of simplicity, and it is capable of very little precision; as a result it is used to paint three-dimensional objects and fill in backgrounds.

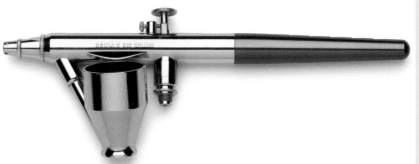

Badger 250 single-action airbrush. It is a suction device with a fixed reservoir and a 0.5 mm nozzle. The small aperture produces a solid line when you hold the tool close to the surface; conversely, if you move it further away, you get a broad spray.

USING THE AIR GUN

Airbrushes that use external atomization are the simplest ones there are. They are also known simply as air guns; they aren't very precise, so their use is limited to filling in backgrounds and industrial processes in which series of parts that don't need much detailing are sprayed. If these pistols are equipped with a needle, they allow a certain degree of control over the paint in accordance with the needle position, which is controlled manually. In general, these airbrushes are used as aids to the illustrator and as an accessory for filling in backgrounds and large areas; a more sophisticated model will be needed for more delicate parts of the work.

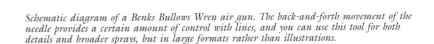

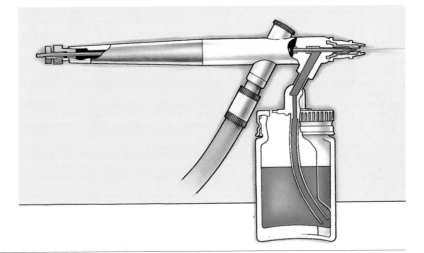

Schematic diagram of a Benks Bullows Wren air gun. The back-and-forth movement of the needle provides a certain amount of control with lines, and you can use this tool for both details and broader sprays, but in large formats rather than illustrations.

Schematic diagram of a Badger Zoo, a single-action airbrush with interchangeable glass reservoirs. The precision of lines is controlled by the quantity of air supplied; low pressure makes a finer line when the airbrush is held very close to the surface being painted.

SINGLE AND DOUBLE ACTION

Depending on the action of the lever, there are several types of airbrushes. With single-action airbrushes, the air supply valve is opened when the lever is depressed. This type of airbrush atomizes the color and expels it through the opening in greater or lesser quantity, according to the position of the needle. In this type of airbrush, only the air is controlled by pressing down on the lever. In order to regulate the quantity of paint, the barrel of the airbrush is opened and the retaining nut on the needle is loosened.

Schematic of an Efbe Hobbyist airbrush Model C-1. Backward movement of the operating lever makes every imaginable type of line, from the finest to a generous spray. Even though it has nonadjustable air pressure, that has no bearing on the lines, since the controlling factor in this is the quantity of paint that passes through the orifice.

Moving it toward the front or the rear creates a finer or a coarser spurt of paint. In double-action airbrushes, the amount of color is controlled by moving from front to rear the lever that moves the needle and allows the color to escape. This group has two variations according to whether or not there is an air control.

NONADJUSTABLE DOUBLE ACTION

Nonadjustable double-action airbrushes are ones in which the artist uses the lever to control the

quantity of color, but the air pressure is nonadjustable. The lever moves only from front to rear. When it is moved to the rear, it opens the airflow

and presses on the needle mounting. In these models, the relationship between the flow of the air and the pulverized paint is nonadjustable.

A SLIGHTLY UNCONVENTIONAL AIRBRUSH

Single-action airbrushes are not easy to classify in the spectrum of airbrush tools; they fall between air guns and complex airbrushes. Obviously, the air guns have many more uses, especially in large-scale works. This type of airbrush, on the other hand, is much more complex. Its radius of action is small, so it is not suited to large works. Its structure allows for controlling air pressure, but the quantity of paint has to be controlled by retracting the needle manually, which slows down the illustrator's work when the time comes to introduce different types of lines; therefore, it is a useful aid with sculptural forms, backgrounds, and sufficiently large images that do not require many changes in how it is used.

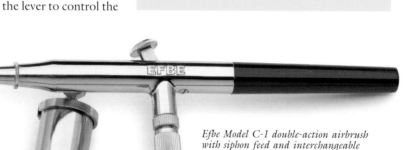

Efbe Model C-1 double-action airbrush with siphon feed and interchangeable metallic reservoir.

A PROFESSIONAL AIRBRUSH

Nonadjustable double-action airbrushes are of professional quality. The air pressure is nonadjustable, but that is no obstacle to doing very precise illustrations. The backward movement of the lever releases a certain amount of paint, appropriate for every type of line; the pressure is scarcely a factor in these actions, and the lack of adjustment is no drawback. On the contrary, it may make the airbrush easier to use in untrained hands that find it difficult to control tools. The German brand Efbe is the main producer of this type of airbrush, a professional tool of superior quality.

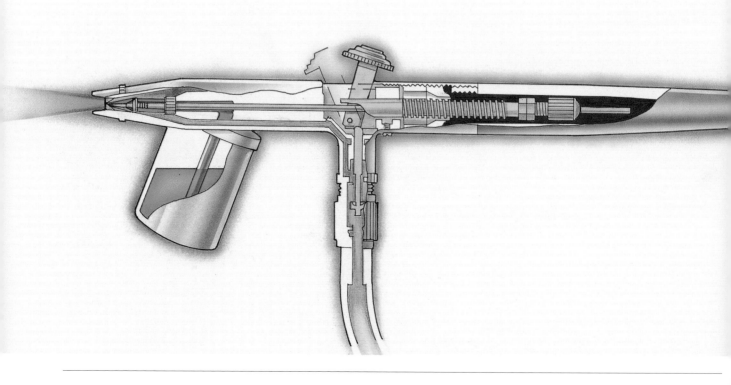

INDEPENDENT DOUBLE ACTION

Independent double-action airbrushes are the most versatile and most commonly used type. The lever moves in two directions: from front to rear to control the quantity of paint, and downward to control the quantity of air. This tool has every combination necessary for doing any kind of line. Air and paint are controlled independently. The ratio is variable rather than constant, and it is adaptable for both gradations and fine lines.

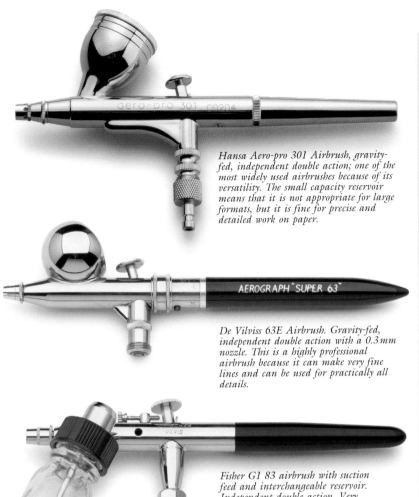

Hansa Aero-pro 301 Airbrush, gravity-fed, independent double action; one of the most widely used airbrushes because of its versatility. The small capacity reservoir means that it is not appropriate for large formats, but it is fine for precise and detailed work on paper.

De Vilviss 63E Airbrush. Gravity-fed, independent double action with a 0.3 mm nozzle. This is a highly professional airbrush because it can make very fine lines and can be used for practically all details.

Schematic drawing of the Vilviss Super 63E airbrush. In this airbrush, as with all independent double-action tools, the lever moves backward and downward. The most important factor in the line is the quantity of paint, so illustrators commonly keep the pressure at a constant level and work more with the retraction of the needle.

Fisher G1 83 airbrush with suction feed and interchangeable reservoir. Independent double action. Very appropriate for working in large formats because of the capacity of the reservoir; it allows spraying large areas without constantly having to fill the reservoir.

THE MOST COMPLETE AIRBRUSHES

Controlling the airbrush is best done when air and paint can be manipulated at the same time. In these tools, the movement of the lever allows that, and illustrators have complete liberty to express themselves. The independent double-action airbrush is the most widely sold, to the extent that the ones previously discussed are used very rarely for artistic works on paper. Siphon airbrushes are just as common as gravity-fed ones, with either integral or interchangeable reservoirs. They are available in various materials, from metals to plastic. What they all have in common is the working of the operating lever downward and toward the rear, which places them into the category of independent double-action airbrushes.

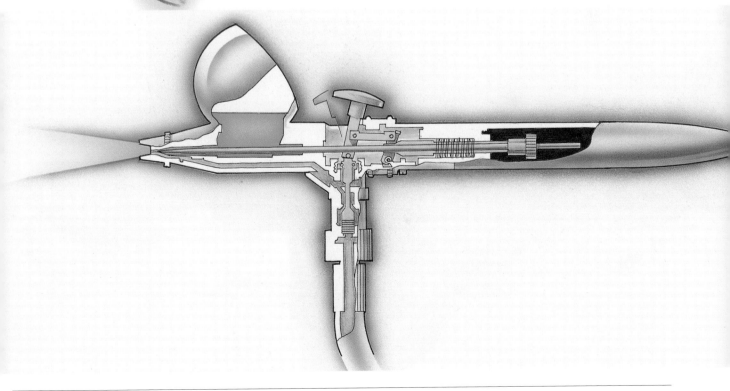

AIRBRUSH CLEANING AND MAINTENANCE

An airbrush is a delicate tool. The small parts inside are exposed to the continuous passage of paint, so they easily become dirty. If the airbrush is not adequately cleaned, it can become obstructed and unusable. An airbrush in continuous use commonly needs constant cleaning. This is done every time the color is changed and at the end of a work session. It is also a good idea to clean it at the start of a job to be sure that there's no residue.

CLEANING FOR COLOR CHANGES

How thorough the cleaning needs to be depends in large measure on the type of color change. If you change from a light color to a dark one, the cleaning may be done with only water, but if the change goes in the other direction, or if a thick paint such as white has been used, you may need to use alcohol as a solvent.

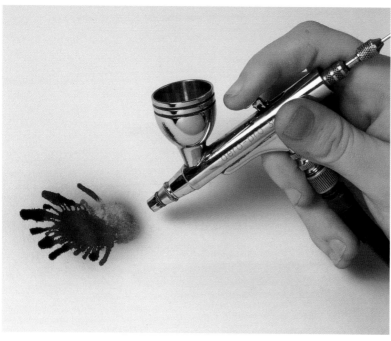

1. First of all, you have to press down on the lever until the airbrush releases all the leftover paint inside it. Press the lever down several times until no more traces of paint come out.

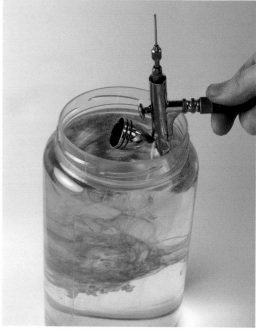

2. Submerge the reservoir in a large container of water so that any traces of paint remaining in it are dissolved in the water.

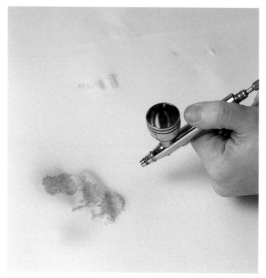

3. Empty all the liquid out of the reservoir. Most airbrushes can be damaged if excessive force is used on the lever, but all the paint has to be removed in cleaning. We recommend doing that with the needle; loosen the mounting nut and pull it back. All the paint will come out without having to hold back on the lever.

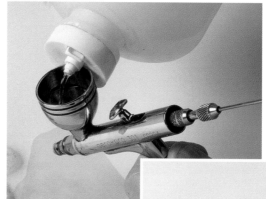

4. Once you have cleaned the reservoir with water, fill it up with alcohol.

5. Use a paintbrush to stir the alcohol around in the reservoir and dissolve any traces of paint.

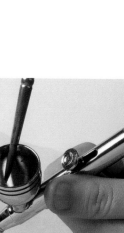

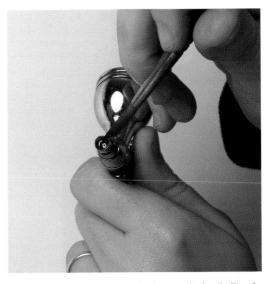

6. *The nozzle has to be cleaned using a paintbrush dipped in alcohol. If they become dry, traces of paint in this area can taint the new color or obstruct the stream of new paint.*

THOROUGH CLEANING

The foregoing will assure that the airbrush is completely clean and ready for subsequent sessions. If all those steps are done correctly, no other measures will be needed. You may still occasionally encounter very dirty or obstructed airbrushes, and alcohol may not be adequate for cleaning. In such cases you have to submerge them in a container of very hot water and detergent, and unscrew the needle to allow the soap to penetrate to the interior and clean the inner parts. Leave it submerged for several hours and, if necessary, replace the water and soap until the airbrush is good and clean. If this does not produce the desired cleanliness, you will have to dismantle the airbrush piece by piece and clean every part separately.

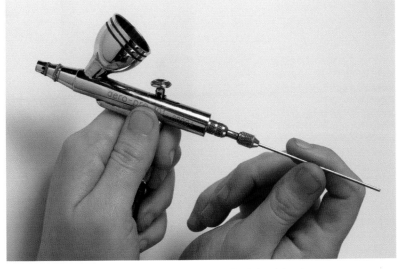

7. *Finally, carefully remove the needle from the inside of the airbrush.*

CLEANERS

Water and alcohol are the primary cleaners; they will generally be sufficient. Of course, there are specific cleansers that some companies manufacture for cleaning airbrushes effectively. They work like metal cleaners—they protect the tool and clean it without causing rusting or other damage.

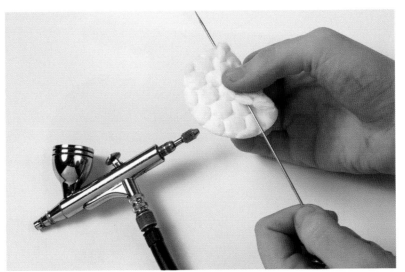

8. *Use cotton moistened with alcohol to clean the needle of all impurities and traces of paint; then use the same care in replacing and securing the needle with the retaining nut.*

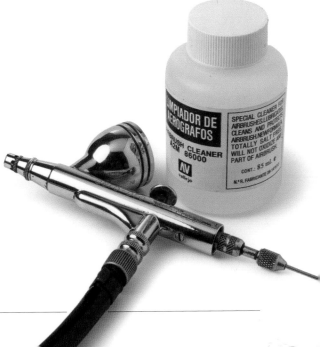

The Air Supply

The air supply is as important as the tool itself; without it, there would be no spray. Even though airbrushes are practically the same as when they were first invented, there has been a lot of evolution over time with respect to the air supply: The old mechanisms were very cumbersome, and nowadays they are lighter. Buying a modern compressor requires a substantial outlay of money, but in the long run, it is the most profitable and practical route for a professional. Take a look at the various kinds of air supply, from the simplest and most economical to the most complex.

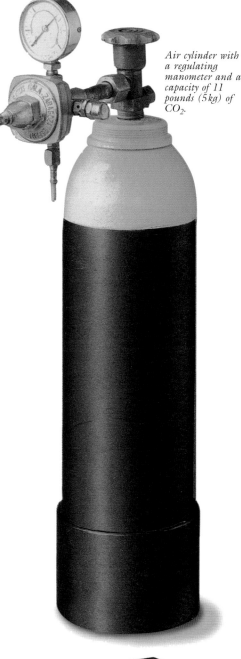

Air cylinder with a regulating manometer and a capacity of 11 pounds (5 kg) of CO_2.

CANS OF COMPRESSED AIR

Cans are small in size and easily transported anywhere. Their outer shape is similar to aerosols, but they have a valve in the top to which the airbrush connects. Inside there is propellant air that is released when the valve is pressed. This is a fairly new product, and it is adequate for trying out the technique. The cost is low, but canned air can be used only sporadically; it is not up to the task of regular work. The main inconvenience with cans is their small capacity. They won't last through very long sessions, and as they get used up, the pressure falls, which involves the inconvenience of an interruption to the work.

CYLINDERS OF COMPRESSED AIR

For many years cylinders of compressed CO_2 have been the principal means of supplying air to airbrushes. They are freestanding sources that don't need to be adapted to electrical current, and they are very silent. They provide a steady flow of air without fluctuations, and they are regulated with a manometer. At first, there was a difficulty with the air supply quitting suddenly when the tank became empty, and you never knew when it was going to happen; subsequently, a level indicator was added to show the conditions inside the cylinder. The tanks can be refilled at special facilities. They are still manufactured, and they are an alternative to compressors, but considering the advantages that compressors have, tanks are a fairly primitive tool.

Can of compressed air with 500 cc of propellant.

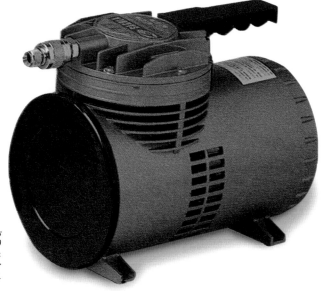

Sagola 777 diaphragm compressor. This apparatus supplies an airflow of 120 gallons (450 liters) a minute at a pressure of about 44 pounds (20 kg) per square inch (3 atmospheres).

COMPRESSORS

Compressors are devices that suck in atmospheric air, compress it to a certain pressure, and then release it through a hose. Some compressors have reservoirs; others have none and are direct. Some have tanks or diaphragms, and some are silent. There are many accessories to improve the usefulness of compressors: regulators, purifiers, filters, manometers, and so on. The characteristics and the usefulness of a compressor are evaluated according to two factors: their intake capacity, which is measured in liters per minute, and the maximum pressure that the air can reach inside them, which is measured in pounds per square inch, or atmospheres. In the field of art and illustration, it is common to work at 29 pounds per square inch / two atmospheres, but for larger projects more pressure is needed.

DIAPHRAGM COMPRESSORS

These are the simplest compressors; they are limited to air intake

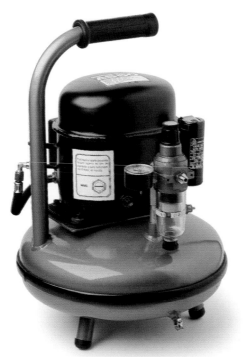

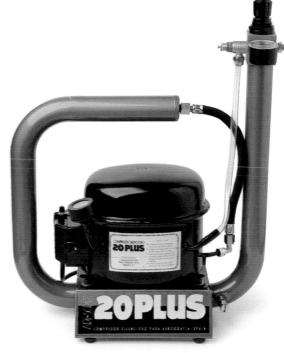

An AS 50 compressor with a 2.6 gallons (10 liters) capacity and an intake of 13 gallons (50 liters) per minute.

A 20 PLUS compressor with a tubular reservoir that holds four-tenths of a gallon (1.5 liters) and had an intake of 5 gallons (20 liters) per minute.

through an intake hose, compressing it in an inner chamber, and releasing it through another hose that commonly has a regulator valve. Air cannot be stored up in these machines; they simply create a certain amount of pressure before releasing it. They work when the compressor is turned on, but once they are empty

the pressure decreases, and they have to be filled again.

These are simple and economical machines that are small in size and are a good choice for beginning to work with the airbrush. On the other hand, they are quite noisy, and the air pressure is not very reliable, since it varies as the machine empties, and that may

produce an irregular spray.

TANK COMPRESSORS

These are compressors that incorporate a storage tank for the compressed air. They have a regulator valve that guarantees that the air will be released at a consistent

pressure, and an automatic mechanism that sets the pressure in the tank. They all have a manometer that constantly indicates the pressure, a humidity filter to extract the water vapor from the air taken in, and an oil level check so the operator can be sure that the motor is getting the right lubrication and cooling.

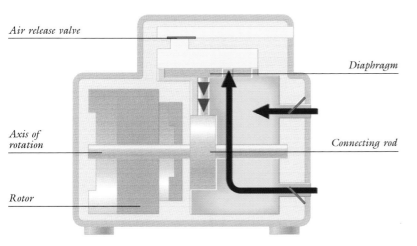

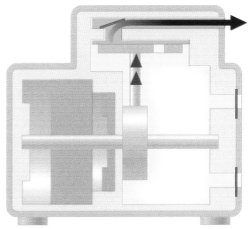

Air release valve

Diaphragm

Axis of rotation

Connecting rod

Rotor

Schematic diagram of a diaphragm compressor during air intake (left) and release (right).

Until recently compressors were large, heavy, expensive, and noisy. The motor kept running until the tank was filled with air to a certain pressure. The compressed air would pass from the tank to a hose until the pressure in the tank got low enough to cause the motor to kick in once again. Just a few years ago these were found only in graphics studios and workshops.

Presently there are tank compressors available that are light and quiet, and that work perfectly, but the smaller ones have a tendency to heat up. When the compressor motor starts up, the tank fills with high-pressure air and a regulator releases the air to a hose. In the old models, the pressure falls off as the tank empties. In the new ones, the pressure in the tank is always greater than the pressure that is fed into the hose, so it comes out at a consistent pressure. They are more convenient, cleaner, and reliable. They have valves that keep the air from backing up from the tank to the compression system, and a safety valve in case the pressure gets too high.

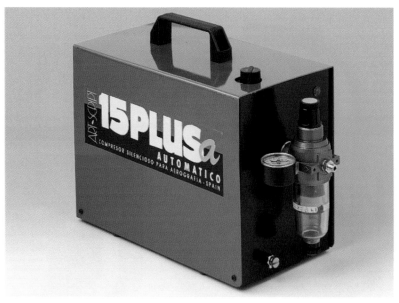

A 15 PLUSa automatic compressor with a 1.5 liter tank and an output rate of up to 15 liters per minute.

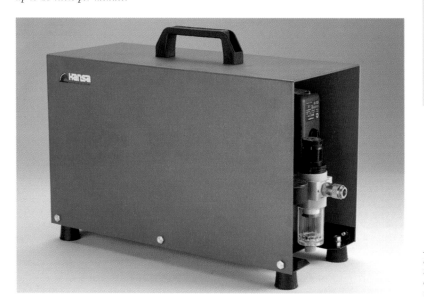

COMPRESSOR ACCESSORIES

Between the arrival of the first compressors and today there have been many changes and innovations, mainly in decreased bulk and weight, but also in greater silence of operation. There are compressors with a tank and without a tank, and direct with a tank or a diaphragm. In general, there is a good assortment for artists to choose from. There is also a broad selection of accessories and components: regulators, purifiers, filters, manometers, adapters for various hoses, and so on. The purpose of all these accessories is to improve the usefulness of the devices.

Automatic Hansa compressor with a 1.5 liter tank and an output rate of up to 20 liters per minute.

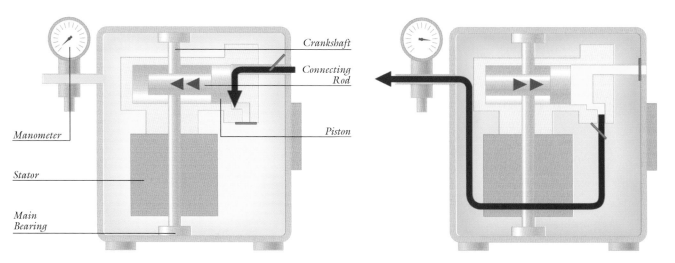

Crankshaft

Connecting Rod

Manometer

Piston

Stator

Main Bearing

Schematic diagram of a tank compressor during air intake and storage (left) and release (right).

HOSES

Hoses are tubes that go from the air supply to the airbrush. The length varies from about 3 to 9 feet (1 to 3 m). They are made of various materials such as vinyl, belted rubber, and articulated rings. At both ends they have a threaded section that can be attached to the compressor and the airbrush, and that has a small orifice that mates up with the closing valve of the airbrush and blocks it. When the activating lever is pressed downward, the valve is opened and air is admitted to the interior of the airbrush.

ADAPTERS

Hoses don't screw directly into the compressor, which has an adapter that is used to connect to the air release. In simple jobs it is common to use simple adapters for a single airbrush, but if the work requires using more than one airbrush due to continual changes of color, multiple adapters are used. These are common in graphic design and advertising studios and in training schools where one compressor has to serve several people. The more airbrushes that are connected to a compressor, the less pressure will pass through the hose, since the air is divided among the different outlets of the adapter.

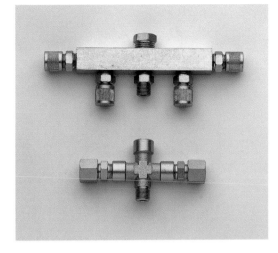

Two types of adapter for connecting to the compressor—one for use with five airbrushes, and the other for three.

Airbrush racks are supports that hold airbrushes in a stable position and keep the paint in the reservoir from spilling. Most consist of a double cradle to hold two airbrushes. If you do not have an airbrush rack, the alternative is to attach a couple of horizontal hooks on the edge of a table and hang the airbrush between them so that it is held securely.

Valves of belted rubber or vinyl are light, but they are not very durable. Over time they may develop a leak or split and cause a loss of air. The ones that have articulated rings are equally light, but much more durable.

MAINTAINING THE COMPRESSOR

In dealing with a technical device, there is no need for artists to know its internal function as if they were mechanics. It should be enough to follow the instructions for use and maintenance in the owner's manual.

To begin with, you have to consider that compressors are always connected to an electrical source for long periods of time, and as a result they may often heat up, especially diaphragm compressors. Tank compressors can remain plugged in for a long time, but it is still a good idea to shut off the compressor once you have finished the work session and cleaned up the airbrush. You don't have to unplug it; all you have to do is turn it off with the switch.

The most important thing with compressors is to check the oil level from time to time. The oil lubricates the motor and keeps it in good condition; if the compressor is not maintained properly, it can freeze up, and will have to be taken to a repair shop.

Compressors have a valve that needs to be activated to release the pressure after a long work session. This involves emptying the water vapor that has accumulated in the tank so that it is in perfect condition for the next time the compressor is turned on.

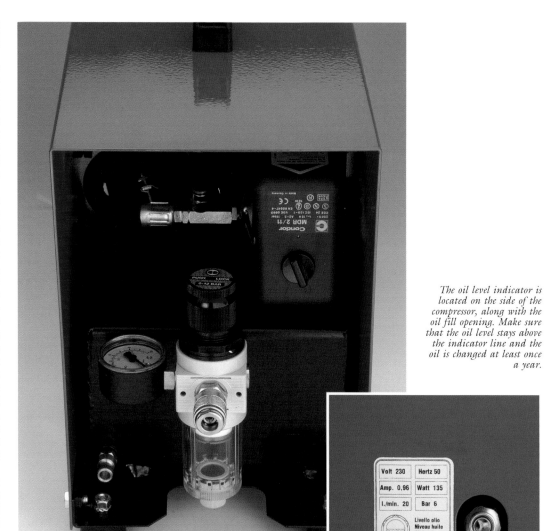

The oil level indicator is located on the side of the compressor, along with the oil fill opening. Make sure that the oil level stays above the indicator line and the oil is changed at least once a year.

Front view of a Dalbe 150 compressor. It is important to be familiar with the parts of the compressor that indicate its condition. The manometer deals with air output, which is regulated with a control that adjusts it to our needs.

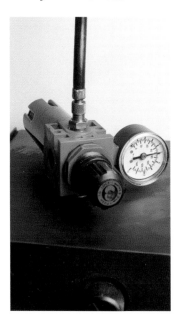

The manometer indicates current air pressure; for small format projects, a pressure of about 29 pounds per square inch (2 atmospheres) is adequate; for large ones, you need 44 or 59 p.s.i. (3 or 4 atmospheres).

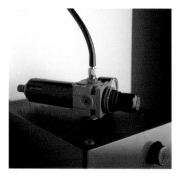

If air leaks from the connection to the compressor, you have to tighten it or replace it with a new regulator.

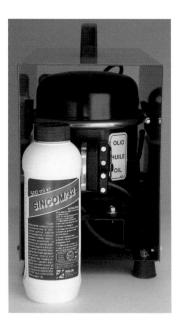

If the compressor gets too hot, it may need lubrication. In that case, add some oil to the proper level.

AEROSOL CANS

Aerosol or spray paints are a relatively recent invention. They mix paint and air, and the spray can provides all the conditions needed for spraying; no further tools are necessary.

The inside of an aerosol can contains dissolved paint and a propellant gas that forces it out. This gas is pressurized and is very volatile. The internal functioning of aerosol cans is also based on the Bernoulli principle, just as airbrushes, air guns, and breath atomizers are. This tool is thus very similar to all of those. The paint in these cans is enamel dissolved in ketones and nitro solvents, and that produces the shine and the covering qualities that enamels applied with brushes have. The propellant gases can be CO_2, xylene, toluene, and others. To put those gases under high

pressure so that they come out with force, they have to be shaken for at least two minutes before they are used.

GRAFFITI

Mural painting attains its greatest popular diffusion in the form of graffiti. At first, this type of painting was condemned as vandalism and delin-

quency, but as time went on it has been transformed into a type of modern urban art. Graffiti appears on walls and streets of large cities, as well as on vehicles. The "decoration" on the New York subway cars is particularly well known, but that occurs in other cities of the world as well. At first, this was a sign of rivalry among young, rebellious elements of society, but soon there appeared some true masters of drawing and coloring who changed this practice into a real pictorial technique by using spray paint. Graffiti covers a number of themes, all of them very modern in content and related to the latest social tendencies; however, there is one characteristic that prevails in these street paintings, and that is the graphics of the lettering, whether pertaining to a name, a musical group, or

an actual message. The colors and their distribution are an indication of whether you are looking at a work by a professional or a mere doodle applied with a spray can.

Some graffiti are real works of art. They are well-planned and structured works that qualify as works of art. Their location right in the middle of a city makes them accessible to many people, without having to visit a museum. This work of art shows real virtuosity in spray painting with aerosol cans.

We recommend spraying at a distance of 10 to 12 inches (25–30 cm) from the surface to guarantee the right color intensity. Drawing precise lines is possible only when you work in large formats, since it is not possible to draw very fine lines with spray cans.

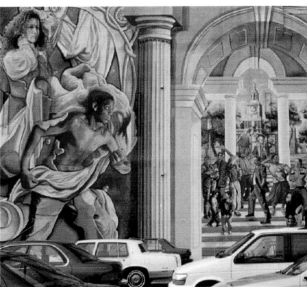
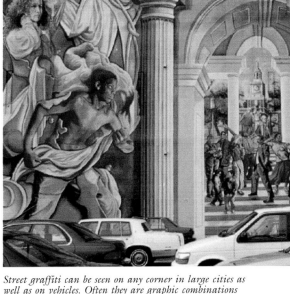

Street graffiti can be seen on any corner in large cities as well as on vehicles. Often they are graphic combinations done by various young artists, so a number of different images, colors, and styles can accumulate on a single wall. The noteworthy features are the shapes and coloring, which form the basis for this interesting display of urban art.

The Artist's Studio

The space set aside for working with an airbrush has to have a certain number of accessories and work conditions to make it possible to work comfortably. A large area is always appropriate for any type of artistic work, but in this case we will almost always work in smaller formats for illustrations, and there are other factors to consider as well.

WORK SPACE

When you do illustrations, you don't work in very large formats; however, the airbrush can also be used to work in large formats, and in that case you will need the same space as a conventional painter working with conventional techniques. About 15 square feet (4.5 m²) should suffice to keep the air in the room from becoming saturated and provide enough room for all the accessories that are used with this technique. You have to keep in mind that as the work becomes more professional, you will acquire more accessories, paint supplies, and files of your work.

The main piece of furniture in the studio is the worktable. It should be large, at least 3 feet by 5 feet (1 m × 1.5 m). You will need room for the illustration, alcohol for cleaning the airbrush, and the paints that you will use in progression. The more space you have, the more comfortably you will work. The design and solidity of the table may vary according to budget; the surface can be horizontal or slightly inclined at about ten degrees. You cannot place any bottle of liquid or paint on an inclined table, so in this case you will need another small table to hold everything you need on a level surface.

WORK CONDITIONS

We have already mentioned the need for space so that the air in the room does not become saturated; this is due to the suspension of sprayed substances that remains in the air and that may be harmful to your health. Some paints may produce toxic gases, which is compounded by the products you use

An auxiliary table makes it possible to keep the compressor and the airbrush together, plus other equipment such as masks, paints, and so on. This is a good thing to have when you work on an inclined table where you cannot place anything but the paper you are working on. Auxiliary tables often have wheels so they can be moved around easily when you are working at a table, an easel, or some other place.

to clean the airbrush, especially if you are using enamels. In the case of a small room, good ventilation is very important; it will be necessary to keep a window open, or if that is not possible, an exhaust fan will be needed.

You will also need to have a faucet nearby for cleaning brushes, filling jars, and so on. It is best to have a sink and water in the same room, but if that is not feasible it is a good idea to work near a bathroom sink or kitchen.

Illumination is extremely important in any kind of work, all the

Here is a room that has been turned into an airbrush studio; it contains the right arrangement of furniture and various accessories.

A light table is a very important accessory in the studio of any illustrator; the larger it is, the better it will be to work with. If it is too small, it will require tracing in parts, and that is difficult and a hindrance to the work.

more so when working in detail and precision. Natural light is the best for judging colors, so it is important to place your worktable in front of a window. In case you have to draw in a light that comes in from the side, it is better to have it come from the left so your drawing hand does not create a shadow; left-handed people will of course want the light source on their right.

An opaque projector is a machine that makes it possible to project any type of printed image within a certain size limit. It is very useful in the absence of slides; it is not as bright as a slide projector, but the quality is adequate for tracing onto drawing paper.

LOCATING THE COMPRESSOR

The compressor should always be set up close to the worktable to give you room to work with the length of hose. You should never have to pull on the airbrush; the hose should always remain loose through all your movements. The compressor can be kept in a sufficiently large box with outlets for the hoses. The box should be well ventilated to keep the compressor from heating up as you work with it. Another option is to use an auxiliary table to hold the compressor and the racks for the various airbrushes. It is best for the compressor to have lots air circulation around it and for the hoses to be long enough so that you don't have to pull on them.

SETTING UP THE EQUIPMENT

Your studio should have all kinds of conveniences for working and storing all the equipment you are going to need. You will need paints, rulers, alcohol, soap, pencils, markers, brushes, paper, rags, and more. All these basic utensils have to be kept on shelves and in boxes, so you will need some auxiliary furniture in addition to the worktable. We recommend keeping paints on shelves close to the work area. It is important to have a container of alcohol nearby to use in the continual cleaning of the airbrush. Next to the desk you will need a wastebasket for pieces of unusable masking, pieces of paper, pencil shavings, and other trash.

We must not forget to mention the quantity of reference material that every illustrator needs: books, magazines, brochures, photographs, and so on.

White paper and completed works should be kept in folders where they will remain flat and protected. Completed originals or works in progress should be kept covered with thin tracing paper or in a special folder. It is important to have folders of all sizes so that the paper does not stick out, as otherwise it will get damaged and turn yellow.

OTHER UTENSILS

One fairly basic thing to have in the studio is a light table. This type of table makes it easy to do good tracings onto the drawing paper.

You also need to cut lots of paper, and for that purpose you can buy plastic surfaces with a grid on them that are very useful as they help keep the cuts straight and keep you from damaging the surface of the table.

Illustrators also need to do many photocopies of their drawings and other images, so access to a photocopier is important. Obviously, not everyone has a copy machine in the studio; most people take care of that in a nearby copy center. Originals can also be magnified using a slide projector. If you don't have slides, you can use an opaque projector on all types of photographs, drawings, pictures, and so on.

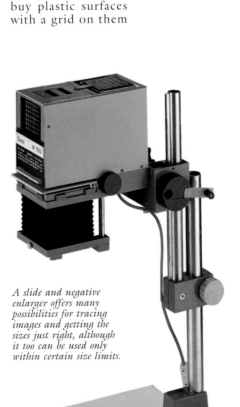

A slide and negative enlarger offers many possibilities for tracing images and getting the sizes just right, although it too can be used only within certain size limits.

Paints

Since the orifice the paint passes through is so tiny, the airbrush is a very delicate instrument. The thicker the paint, the more carefully you have to clean the airbrush after using it. In general, any type of paint can be used in an airbrush, provided it is liquid or there is a solvent that can be used to thin it. The toughest paints, such as enamels and oils, may present difficulties in forming a spray, so they have to be thoroughly dissolved to create the most liquid texture possible. After using an airbrush, you have to clean it thoroughly to be sure that the air can flow out of the nozzle freely and without obstructions. Ink should never be allowed to dry inside the tool.

Anilines easily tint water, and it does not take much. Watercolors, on the other hand, are more transparent and easier to control. In working with anilines, you continually have to change the water.

An assortment of liquid watercolors for use with an airbrush.

Anilines have very strong colors if they are used in pure form without watercolors. In mixtures, the colors tend to be more subdued than the ones you can produce with watercolors. Remember that anilines are used more in industry and are commonly used straight from the tube.

LIQUID WATERCOLORS AND ANILINES

Watercolors are one of the best ways of working with the airbrush, especially for beginners. They are economical and they don't clog the airbrush, since the pigment is entirely dissolved. Liquid watercolors are available in a broad range of colors, and they are sold in bottles of 29 to 35 ml and in larger sizes. Even though this is a very liquid medium, the colors are sufficiently bright. The quality of the pigments is guaranteed, and so is the purity of the color.

If you want a lighter shade, you can dilute the paint with water. When liquid watercolor is atomized, it rarely produces blotches. The less dense the paint, the finer the spray.

Anilines are liquid inks pigmented with synthetic color. They are soluble in water and in alcohol and are often used in the field of design and illustration. There are flat and glossy anilines, and they are well suited to applying layers of a single color, since they are colorfast and bold in color.

The difference between these two types of paint is rooted in their performance in mixtures. The pigment of the anilines is so strong that there aren't as many shades as with liquid water colors. With regard to the cleanliness of the airbrush, cleaning can be done simply with water after using these tints because they do not clog the tool. However, cleaning with alcohol is still a good idea.

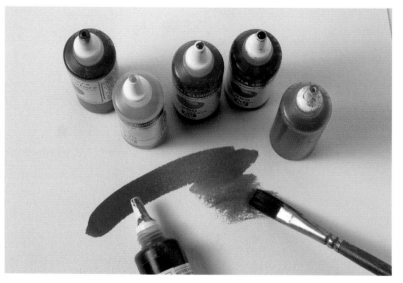

Anilines are completely liquid paints, so brushes easily become totally impregnated; still, the colors are overly strong, and most of the time they will have to be diluted with water.

ACRYLIC PAINTS

These paints are the result of much research to discover the ideal medium for the airbrush. These are relatively modern paints. There is a whole spectrum of nontoxic acrylic solutions, with a high concentration of ultrafine grained pigments that won't clog the airbrush. They dry quickly without causing the paper to curl, unlike what sometimes happens when watercolors are used, especially when a lot of a single color is used. Another advantage is that acrylics are colorfast once they dry, and even if water spills onto them, the paint won't change, since it forms a protective film. Watercolors, on the other hand, will bleed under the same conditions.

After using acrylics, a little water can be used to dissolve them, since the color is very intense. Not all colors behave similarly—some are more liquid, others are more dense, opaque, or transparent. In any case, with all of them a sediment tends to settle to the bottom of the container, so it is necessary to shake it well before using. The vivid colors are very liquid and transparent, and their performance is very similar to that of liquid watercolors. The earthy colors are a little denser; the pigment often colors less effectively than the pure colors. You need to use more of them, and that makes them denser.

White is the densest and most opaque color in the spectrum and the one that is hardest to clean from the interior of the airbrush.

Every manufacturer has a different way of packaging acrylic paints. The best containers are the ones that have a dropper as part of the cap, which is helpful in preparing mixtures.

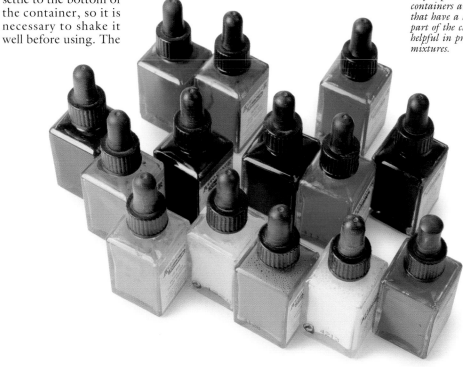

Acrylic paints are ideal because of their hold and their liquidity, which is perfect for the airbrush. Some colors, though, can be made only in a thicker consistency; one obvious example is white, a totally opaque color that requires a stronger consistency than the others so that it can cover them adequately.

Most acrylic hues are completely liquid, but they need to be shaken well before use to keep the pigment from settling to the bottom of the container. Once it is thoroughly dissolved, acrylic paint is comparable to using liquid watercolors, but once it is dried, it cannot be erased even by applying clean water.

OILS

We have already observed that many types of paints can be used with an airbrush, as long as it is cleaned properly. This also applies to oils. Even though you are accustomed to using them to paint on canvas using a brush, you can also use them with an airbrush if they are diluted significantly with refined essence of turpentine. You can use them to paint canvases, woods, ceramics, and glass, and create very fine and precise shading. The only surface that oils are not well suited to is paper, which may be damaged and soiled by the varnishes and solvents. When oil paints are dissolved with turpentine, it is a good idea to add a few drops of dryer to speed up drying time.

Most oil colors are opaque, but some of them can be fairly transparent if they are properly diluted. These

Tubes of oil paints. This medium can be used with the airbrush as long as it is prepared properly.

colors appear in some catalogs as lacquers, and they can be used to create glazes, transparencies, and effects normally associated with liquid paints.

CELLULOSE PAINTS

Also known as enamels, these are pigmented materials in lacquers and cellulose solvents. Their applications are almost always industrial, and they are ideal for painting toys, models, and other items, especially nonporous plastics. The air gun is the ideal way to pulverize enamels; however, the cleanup process at the end is very laborious—it has to be taken care of before the paint dries, and strong nitro-type solvents, which are highly flammable and toxic, must be used. As a result, when these paints are used, you must use a protective mask. Enamels cover very well and very quickly, and the cleaning process is continuous.

Essence of turpentine or linseed oil is essential in thinning oil paints to the right consistency.

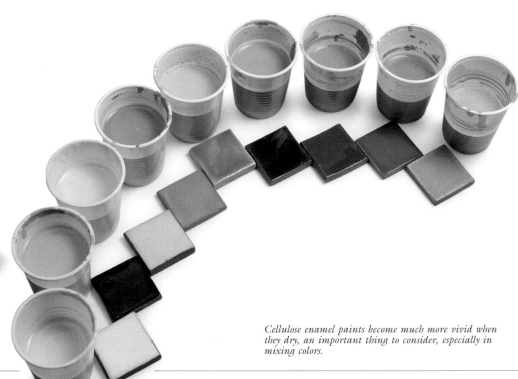

Cellulose enamel paints become much more vivid when they dry, an important thing to consider, especially in mixing colors.

PAINTS FOR USE ON CLOTH

Inks for use on cloth need certain special characteristics. There are several fixatives that are incorporated into their composition; the fabric must not change when water or detergents are used to wash it. The paints are usually soluble in water so that even though they are already liquid, they can be thinned as much as necessary when they are put into an airbrush. They are easy to mix with one another, and you can use them to create all kinds of very pure colors. They can be washed at a temperature up to 140°F (60°C) and in a washing machine. The process of creating an illustration on a T-shirt is the same as on paper, but it is a good idea to leave the drawing alone once it is done so it can dry thoroughly. Then you have to turn the shirt over and iron it for a couple of minutes with a very hot iron: the heat will fix the paint to the fabric permanently.

Equipment needed to paint a T-shirt. The inks tend to be expensive, so you can get by with the primary colors plus black in order to create any mixture.

PREPARING THE FABRIC

For painting T-shirts with an airbrush, the garment has to be stretched on a wooden frame or stiff cardboard so that it is flat and free of wrinkles. The frame needs to be the right size, and the fabric should not be too taut or the drawing might look distorted when the tension is removed. As far as applying the paint is concerned, the colors used on cloth dry very well, and the tightening dries the fabric and makes it appear starched. In order to open up the weave of the fabric and restore its softness and elasticity, place a damp cloth over the garment and iron it.

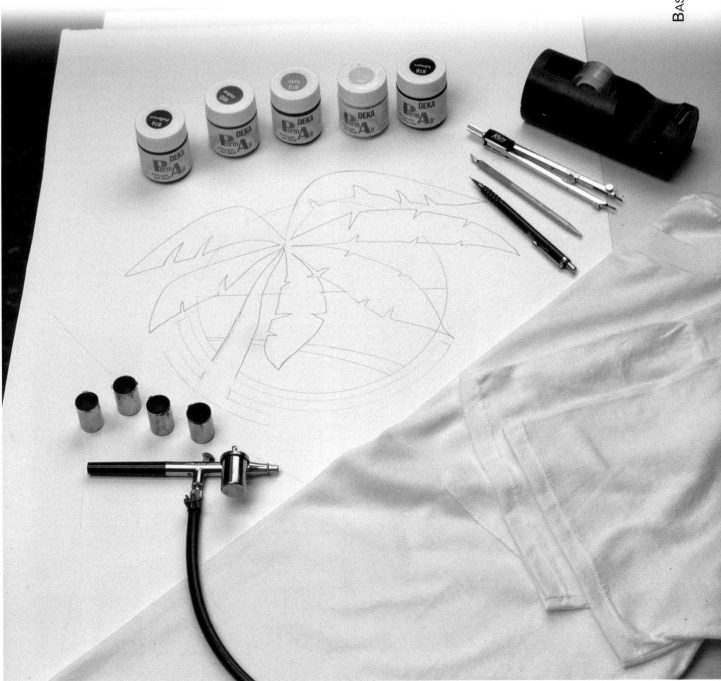

OPAQUE AND TRANSPARENT COLORS

Here we are talking about the very nature of color, not about the fact that the medium is one thing or another. Liquid watercolors, anilines, and paints for fabrics are essentially transparent. Enamels and oils are opaque. Still, if we speak of mediums such as acrylic paints, the ones that are most often used in airbrushes, we see that there are two classes of colors—opaque and transparent—even though both contain very fine pigmentation in order to avoid clogging and to create a finely detailed product.

The transparent colors are worked in greater or lesser intensity; color saturation is achieved by applying successive layers. Errors are not easy to correct when working with transparency; as in painting with watercolors, the colors have to be carefully planned out. They offer some great advantages in creating nuances, from the most dramatic to the most subtle, by making it possible for one color to modify another with a single pass. This is what is referred to as *velatura* or glazing: the new color does not cover the first one, but modifies it.

Opaque colors make it possible to cover a dark surface with a light color.

All colors, including transparent ones, show their maximum intensity on a white background; the white stripe that goes across the colors could just as well be an area that was blocked off. The superposition of transparent colors clearly results in mixtures; yellow and magenta produce orange, and greenish blue and magenta, which are complementary, produce an intermediate color.

We chose a blue background color to see how it acts on the colors of the composition. The dark blue, the white, and the black are shades that look the same even with the change in background color. But the transparent colors certainly do look different on the blue background: the blue is reinforced by the background, the magenta turns to violet, and the yellow changes to a greenish tint.

Opaque colors have to cover well and be relatively thick. Opaque acrylics are often identified as such on the label, and they are easy to recognize—when you shake the container, they appear a little denser than the transparent paints. Acrylic paints can be made more transparent by adding sufficient water. If they are used straight from the container, they are completely opaque. One problem that opaque colors pose is their longer drying time; you need to use more paint to cover the area, and that means it takes longer to apply and remove any masks.

Transparent colors yield new colors when they are mixed, so you can produce many shades with a limited number of paints.

A yellow background gives the whole composition a feeling of warmth. The black, dark blue, and white are totally opaque and unchangeable. On the other hand, we see a blue that has turned very greenish with the yellow transparency, a magenta that has turned to red, and the yellow that practically disappears because it is so similar to the background.

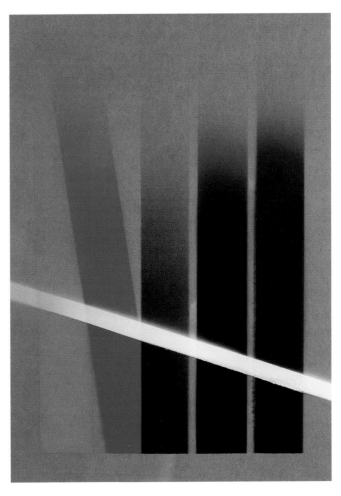

Finally, with a pink background we totally change the color of the greenish blue, which is converted into a very uneven lilac; the magenta remains the same but more intense, and the yellow doesn't disappear, but rather it picks up a new orange hue.

Papers and Other Surfaces

Depending on the nature of the ink or paint, a specific type of surface (or base) will be required, whether it is to be worked with an airbrush or a conventional artist's brush. It's also important to consider if the drawing involves filling in backgrounds or color planes, or something more detailed and intricate. For detailed and precise illustrations, it is a good idea to use very smooth, untextured papers; for more rudimentary works, the surface can be coarser and rough.

a) Very fine-grained glossy paper.

b) Textured paper.

TYPES OF PAPER

Paper is the best surface for airbrush work, but it needs to meet certain requirements to produce a good finish for shapes and colors. First of all, it should have little or no grain, since air-brushing uses a moist and liquid medium that dampens the paper. It should be sufficiently heavy to avoid becoming wavy, especially in working with watercolors; therefore, it should be thick, heavyweight, over 300 g, or a cardboard with a surface and a finish similar to those of high-quality paper.

In order to evaluate the quality of a paper, you merely need to look at it against the light. If it is completely smooth, it is of high quality; if there are lumps of pulp in certain places or the coating is not even, the quality is inferior.

c) Coarse-grained paper.

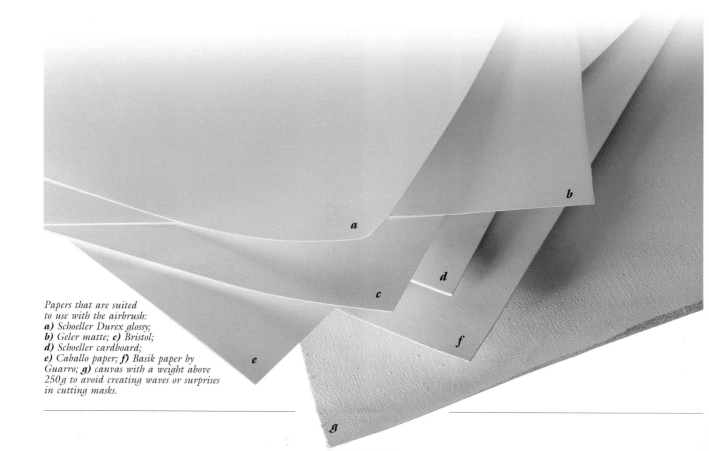

Papers that are suited to use with the airbrush:
a) Schoeller Durex glossy;
b) Geler matte; c) Bristol;
d) Schoeller cardboard;
e) Caballo paper; f) Basik paper by Guarro; g) canvas with a weight above 250g to avoid creating waves or surprises in cutting masks.

EFFECTS OF GRAIN

The grain of the paper constitutes a fundamental consideration for the nature and the finish of the painting. Illustrations that require lots of detail and information need to be retouched with supplementary materials such as pencils and gouaches; fine lines need to be added with great care. The ideal paper in this instance is a glossy one with a very fine and nearly invisible grain devoid of irregularities of any size, which assures a flawless line.

In order to do more artistic works where original effects and different textures are desired, you can use papers with different characteristics provided that they are heavy enough. Papers with special textures are ideal for freehand airbrush compositions without great detail, but they are also suited to more rudimentary work with brushes. Papers with a coarse grain, such as those intended for watercolors, and textured papers that imitate the weave and texture of canvas, are very adequate for free and high-quality works.

SPECIAL SURFACES

In addition to papers, there are many other surfaces that can be used; often they require using special inks.

Canvases for oils and acrylics, on a stretcher or cardboard, are common in free artwork. Canvases for airbrush paintings are similar to the ones that are used with brushes. You have some latitude in choosing the type of cloth, as long as the weave is not too strongly textured, since the airbrush is generally used flat and cannot create relief or fillers.

Pieces of solid wood or plywood can be good surfaces for airbrushing, provided that they are very smooth. Still, you have to apply one or more coats of primer and a fine sanding to waterproof and smooth out the surface.

Metals and plastics are fine for airbrushing, and the result is very effective since these are clean, smooth surfaces with no imperfections. Enamels are the ideal paints, since they adhere perfectly to this type of nonporous surface. The most common surfaces are pieces of aluminum, copper, and brass, plus plates of acetate, polyvinyl chloride, and methacrylate.

Flat or glossy photographic paper is sometimes used in advertising illustrations, especially when it is done directly onto photographs. In general, gouache adheres perfectly to this type of paper. The coarsest papers are fine for large-format works; they retain their shape, and they even permit the use of scratch techniques for creating special effects.

Ceramic materials are worked exclusively with enamels and then are fired in a kiln. The airbrush is also used for restoring this type of object and for decorating white china. The medium used in these cases is a special cellulose enamel that becomes very hard and durable when it dries.

Surfaces that are commonly used for airbrushing. These include papers, which are used especially in illustrating; glass for some types of decorating; metals and plastics, used most commonly in modeling; canvases for airbrushing as a means of artistic expression; woods for models and furniture that are normally treated with industrial air guns; weavings used in the fashion world and creating motifs for clothing; and ceramics that are kiln-fired and enameled with an air gun.

CERAMICS

Ceramicists use an airbrush or air gun for covering ceramics that are intended to be baked in a kiln once they are dry. Still, in addition to this industrial work, the studio airbrush is used for restoration of ceramic pieces and cold decorating pieces of white china. The medium used is commonly a special cellulose enamel that becomes very hard when it dries.

Every one of these surfaces requires the use of special paints. In general, water-base paints (gouache, watercolors, acrylics) do not stick to nonporous surfaces and have to be replaced by cellulose or special paints. Don't forget that a thorough cleaning of the airbrush is required after using such materials.

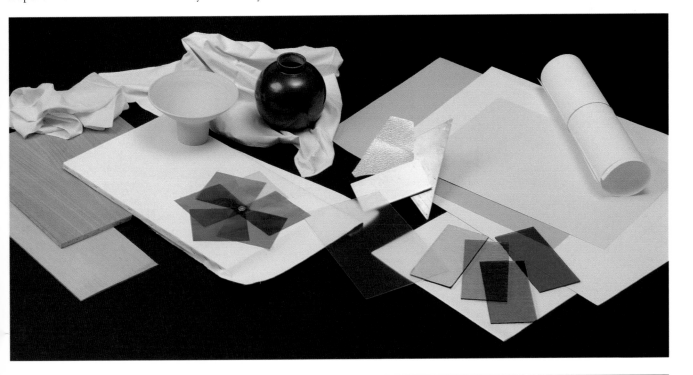

Masks

There are two types of masks that are used: fixed and movable ones, and stencils. Their function is to block off the areas of the paper that we want to protect from the sprayed paint.

WHAT IS MASKING?

A mask is a type of protection, a way of covering the paper to keep the paint spray from reaching a particular area. This forms the entire basis of the airbrush process—working in areas of color, protecting the remainder from the spray, and constantly limiting the color. The masking technique is an art unto itself that requires planning out the work and dividing it into different stages. This is a very precise task that requires great mastery, even more than the skill with the tool. This is where the illustrator's cleverness comes into play. Areas on the paper can be blocked off in different ways. In the case of straight shapes, you can use a ruler or the edge of another piece of paper; for simple shapes you can place prefabricated stencils in the shape of circles, arrows, curves, and so on, while other masks have to be cut out in specific shapes. These involve contours that form part of the illustration, and areas of color can be separated only through stencils that you make yourself. Some can be cut out of tracing paper or cardboard; others require self-adhesive masking film. Self-adhesive masks are totally transparent, and allow you to cut very fine details. The masking process is set up in different ways depending on the project; sometimes background and figure are separated and colored one after the other. It is usual to separate areas by color and fill them in progressively. You also have to know how to manipulate the transparency of the paints so that if you start with dark colors it won't be necessary to mask with the light ones. Opaque and dark colors cover the other colors. As a result, when you use them you have to protect the remaining areas.

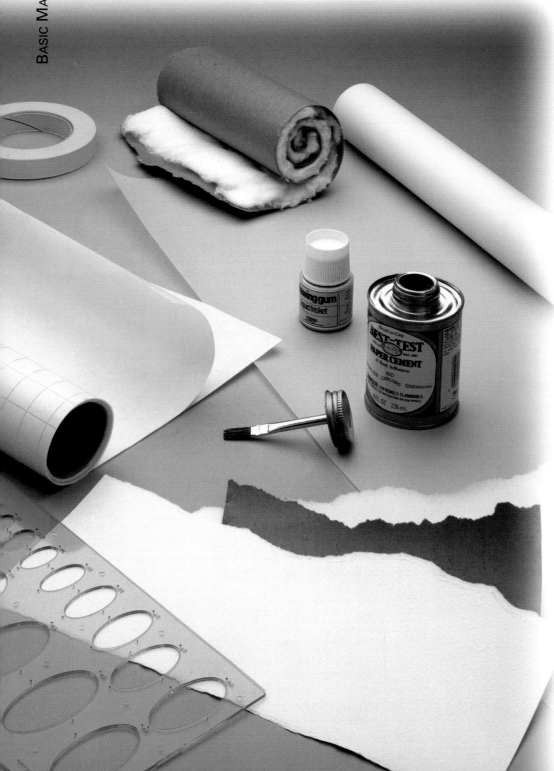

Airbrushing involves the use of fixed masks (self-adhesive film, masking tape, polyester paper, and rubber cement) and loose or movable ones (paper cutouts, cotton, and straight and curved stencils).

1. *Once you have sprayed the color of the letter and you are sure it has dried, go over it with a brush saturated with rubber cement.*

2. *Cut out the form of the letter from tracing paper and place it over the letter using rubber cement before it dries so that it is easier to center the shape.*

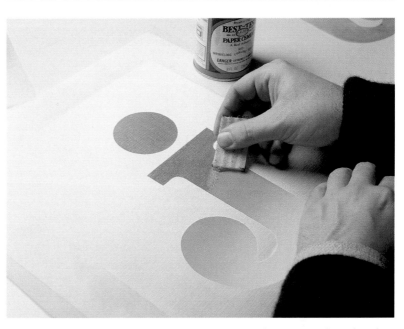

3. *Once the background has been sprayed, you can remove the tracing paper that has served as a mask.*

USING WEIGHTS

Some other techniques were used before artists began applying the rubber cement and tracing paper for masks. They involved using small weights that held the mask made of tracing paper to the work paper; the weights were made of lead and came in various sizes. Small coins could also be used, provided they were heavy enough. The point was to keep the stencil immobile during the process of spraying. Here is how it worked: The shape to be blocked off was drawn onto tracing paper and cut out with a knife; this was superimposed onto the drawing and the weights were put into position very close to the edges to keep the paint from getting under the stencil. The more weights that were used, the better the area of the paper was protected.

4. *Use a rag or a soft rubber eraser to remove the extra rubber cement and note how the color of the letter has remained unchanged.*

OLD WAYS OF MASKING

Self-adhesive masking film is a relatively recent invention. Before that, artists used masks made of polyester, a transparent paper that is held in place with rubber cement. This is a very good adhesive; it does not harm the paper or the paint when you remove the masking. The process is the same as when using self-adhesive masking: Attach the paper to the illustration, cut out the area you want to block off, and apply the color.

Polyester masking is still used with paper that has a grain. Self-adhesive masking can lift the paint, but that is not a problem when masking is applied using rubber cement. Once everything is dry, the rubber cement is removed with a soft eraser.

SELF-ADHESIVE MASKING FILM

Fixed masking is used when the artist wishes to block off specific and very precise shapes; their outlines are cut out using a craft knife or a razor blade. This masking adheres to the surface in the same way as cellophane tape, except that it will separate from the paper without damaging it in any way. Self-adhesive masking film is sold in individual sheets and in rolls. The former are for infrequent work with the airbrush. The rolls (from 10 to 30 yards/meters) are for more professional work, and they are more economical. Self-adhesive masking keeps the paint from getting underneath it, since it has very good sticking power. It provides a very fine masking that avoids color buildup at the edges, which remain very clear. Since it is transparent, it allows you to see the area of the illustration that is hidden and to draw on the film.

Self-adhesive masking film has a protective paper that needs to be removed from the plastic. When it is applied to the paper of the illustration, you have to keep smoothing it out with your hand to eliminate all bubbles.

RISKS INVOLVED IN USING SELF-ADHESIVE MASKING FILM

The main problem that can arise in applying the masking is the same one that occurs in lining a surface with self-adhesive film; that is, the formation of air bubbles that make it harder to cut out the pattern and to view the drawing. What happens in such cases? If there are only a few bubbles we can keep smoothing out the surface until we get them to disappear, which is the best-case scenario. However, sometimes you will encounter a situation in which the masking has gone very badly and you have to take it off entirely and apply it again. This is not as easy as it seems; the drawing on the paper remains in the sticky part of the mask and doesn't let go. If you take off the entire mask, you can see how the drawing has copied itself onto it, and if you put it back into place, you find a great confusion of lines that increases in proportion to the complexity of the drawing. The best thing to do in these cases is to use new masking since the first one is unusable.

USING REMNANTS

Self-adhesive film is a very specific type of material, so it is not economical to buy. In many cases you have to cut large pieces that can serve perfectly well for new applications in smaller spaces. For example, when you have a silhouette covered and you have to have a clear background, you will see that most of the mask is clean and smooth. It is a mistake to throw it away, since it can be used later for small parts inside the silhouette. In using leftover masking, assume that it hasn't been drawn on with a pencil. If there are any marks on it, it has to be thrown away, or it will prove confusing.

USING MASKING FILM

In illustrations that are done freehand and don't need much masking, we need only to protect the margins of the paper. There's no need to use self-adhesive film, a little common masking tape is all that's needed. It is much more economical to use and it is sold in stores that don't specialize in fine arts. The only requirement is that it not be too sticky, or it will pull away part of the sheet to which it is applied. Plastic adhesive tapes usually don't work very well because they're too sticky.

Go around the paper with the tape, keeping it nice and straight; otherwise, the drawing will appear off kilter.

Now you can spray with paint and go into the margins without hesitation; the results of the spraying will be very fine and straight.

One of the main doubts that you may have in masking an illustration is the order in which the masks should be applied. This depends on where you begin—with the background or with the figure. When you don't want one color to be influenced by the spraying of another, it has to be blocked off. In exchange, if the new color is similar to a previous one, or if you want to create a glaze, it is not necessary to block off that area.

Now look at a logical order for masking this illustration of a handshake.

Begin by spraying the background; use masking to block off the silhouette of the hands and arms.

In uncovering the area blocked off for the hands, you will see that it is still white and that the paint has not gotten in where it does not belong.

Block off the entire background with masking and color the hands appropriately, making sure that the remainder of the picture is protected. You can use the airbrush on the area blocked off and try to find the type of spray you want before applying it to the area.

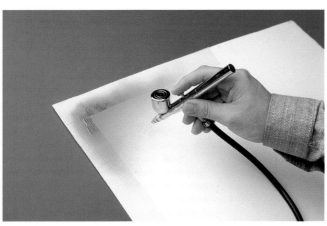

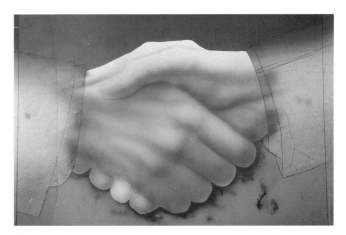

Templates

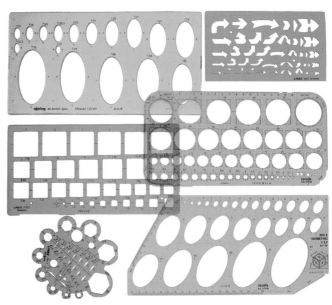

Templates or movable masks are also frequently used. They are easier to use than fixed masking, since they tend to be very simple silhouettes that you can make yourself or buy in standard shapes. Movable masks are used as frequently in airbrushing as fixed ones, and they make many projects easier. Everything you can do using these masks will save you lots of time and energy.

There is a wide variety of stencils, and all kinds of shapes can be created without resorting to self-adhesive masking.

Plastic templates of various sizes and different curves. The different and gradual radius incorporated in each one makes them very practical as movable stencils.

In order to use the airbrush with one of the forms of the template, to the exclusion of the adjacent shapes, you have to cover the other holes with masking or adhesive tape so that the color gets inside only the shape where it's needed.

The templates are used as direct masking for airbrushing. They are the easiest way to create geometrical shapes for spraying without previous preparation. Prefabricated templates can save you lots of work if you know how to use them at the right time and in the right way.

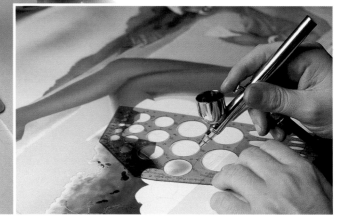

PREFABRICATED TEMPLATES

In order to airbrush curved and regular straight shapes, you can buy rulers and curved templates that can be used as movable stencils or for drawing and cutting out precise silhouettes. There is also a broad range of templates in the shape of ovals, triangles, circles, squares, arrows, numbers, letters, and more.

PAPER FOR MAKING TEMPLATES

Sometimes you don't have to resort to using fixed masks. When you have a fairly simple shape to spray, you can cut a piece of paper and turn it into a loose template that you hold in place with your hand. This can be done conveniently with any type of paper, but for certain shapes, when working on a picture that is already far along, you can use tracing paper that will let the image show through perfectly.

TRACING PAPER

This type of paper is perfectly adequate for creating templates in the precise shape you wish to block off. Its transparency facilitates drawing the silhouette precisely, tracing it, and cutting it out for application to the area to be blocked out, whatever the shape—even very complex ones. Still, there is one small inconvenience: Tracing paper is very light and can move under the pressure of the spray. You need to weight it down to keep it in place, and the weights should be placed as close to the edge of the cutout as possible to keep the borders sharp and clear. Also, when you spray this paper you'll see how the paint can dampen it and cause it to curl; you have to be careful to avoid soaking the paper and damaging the blocked-off area.

You can use some simple strips of cardboard to make a grid.

The result is a checkerboard where the darkest squares are the ones where more paint was applied and the lightest ones were kept masked until the last moment.

When you need to trace concave curves, it is a good idea to cut out the silhouettes yourself. The curves on the templates that are sold commercially don't always have the shapes you will need, and they often are more useful for outside than inside curves used for concave shapes.

IRREGULAR TEMPLATES

For creating abstract effects or shapes like distant mountains or uneven ground, you can use movable templates made from torn paper. Don't cut the paper with a knife, but rather tear it randomly using your hands; that way the contours will be imprecise and irregular. The thicker the paper for the template, the more uneven the effect of the spraying, since thicker paper doesn't lie as flat on the work surface and the paint will creep under it.

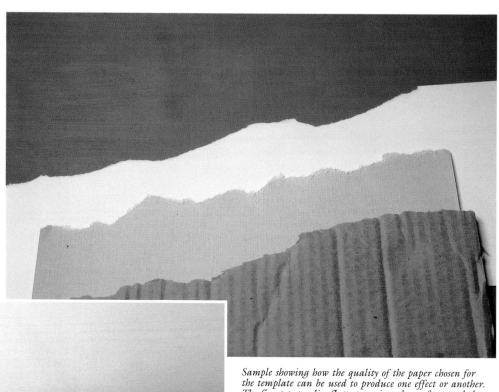

Sample showing how the quality of the paper chosen for the template can be used to produce one effect or another. The finest paper lies flattest against the surface, and the outline of the spray pattern is fairly well defined. Since this template was made from dense paper, the tear is a lot cleaner than with lesser-quality papers. The yellowish paper is not very dense, so when it is torn it forms ridges and valleys that will yield a fuzzier silhouette when it is sprayed.

Due to the thickness of the cardboard and its low quality, very imprecise contours are produced.

AERIAL TEMPLATES

Aerial or suspended templates are those that are held at some distance from the surface, or that are held in place by rubber cement or pieces of adhesive tape. The precision of the outlines is not the same as with fixed or loose templates. The further the aerial template is held from the surface, the fuzzier the outlines. If you wish to obtain a more or less clear outline, it is necessary to hold the template down well, otherwise the air that comes out of the airbrush will move it and produce an odd and imprecise effect.

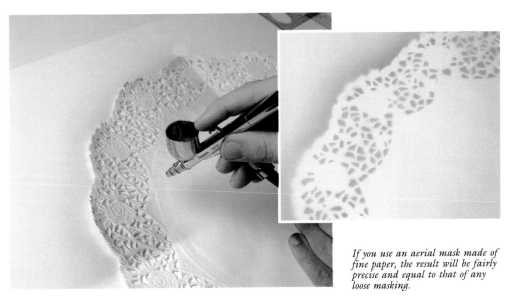

If you use an aerial mask made of fine paper, the result will be fairly precise and equal to that of any loose masking.

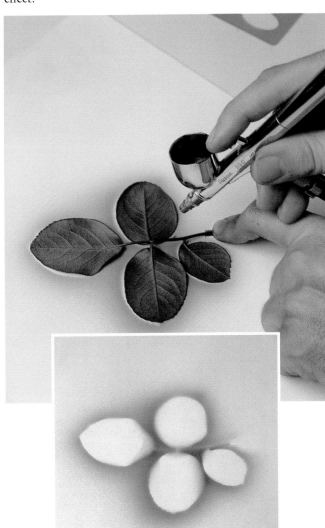

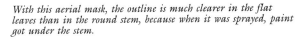

With this aerial mask, the outline is much clearer in the flat leaves than in the round stem, because when it was sprayed, paint got under the stem.

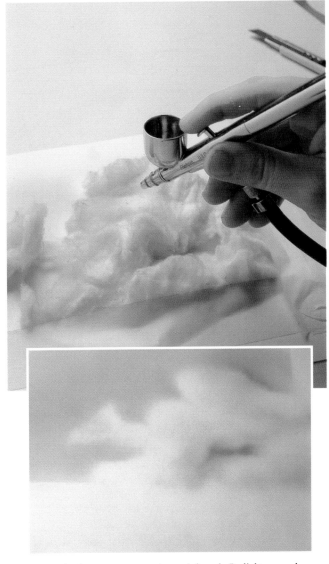

Cotton may be the most representative aerial mask. Its lightness and fragility mean that it is in continuous movement when the air is directed onto it, which makes for very soft gradations that are often used to represent cloudy skies.

Blocking Off Details

L iquid glue is used to block off small blank areas that cannot be covered with self-adhesive masking film or templates because of their small size. Some linear shapes, mottling, dots, and very fine details can be created easily by using liquid glue applied with a fine brush.

USING LIQUID GLUES

Blocking glue or liquid masking is a substance that sticks to the paper when it is applied with a brush. It contains rubber and ammonia, and it sticks well to the paper. The texture is liquid, but it thickens as time passes. When this happens, add a couple of drops of ammonia and shake the container until the glue thins. The color is always yellowish or grayish, since it is important for the painter to distinguish from the background the details done in the masking. Concerning the brushes used to apply the liquid mask, it is a good idea to use those that have synthetic bristles, since the glue is a very corrosive product that can damage natural bristles. Once the liquid masking is applied, you have to clean the brush thoroughly with solvent.

1. *You have to be sure that the liquid masking stays tightly covered, otherwise it dries and quickly deteriorates.*

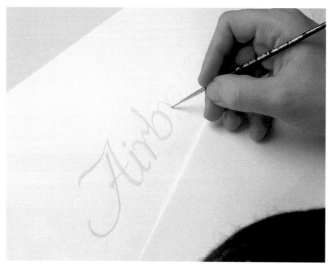

1. *Liquid masking is used to set aside small shapes and profiles. In this instance the glue is being used to profile the entire heading in well-defined shapes. Next it is sprayed with paint and set aside to dry.*

2. *In order to get rid of the masking you first have to wait for the spray to dry thoroughly, especially the paint on the liquid glue, which can take long to dry. The glue can be removed using a rag or a soft eraser.*

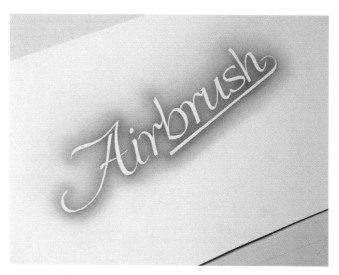

2. *Once the glue is removed, the blocking is perfect.*

3. *The contours are perfectly delineated by the strokes applied with the paintbrush.*

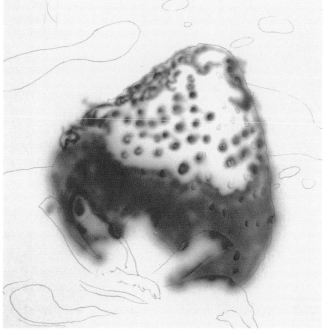

1. Blocking glue is used to set aside small parts of a drawing, like the seeds of this strawberry.

2. The masked areas are surrounded by little red patches of color to indicate the recess in which the seeds are found.

PRESERVING LIQUID GLUE

Liquid glue for blocking is a very unstable substance; it has a very viscous consistency, and it can be applied by brush as if it were a fairly thick paint like oil. Just the same, after a few seconds, the glue dries and solidifies, and it is easy to remove from the paper. A substance with these properties is hard to keep fresh, and if the cover is not put back on tight, the substance disintegrates completely. It can dry and form a film that can't be salvaged at all; even if you add a little ammonia, it won't be the same as fresh glue. In the worst case, the glue can go bad and rot because of the rubber content in its chemical composition. In that case, it emits a very strong odor, loses all its adhesive power, and has to be thrown away. The best advice for keeping the glue in good condition is to put the cap back on tight every time to form an airtight seal, and leave it in a cool, damp place to keep it from drying out.

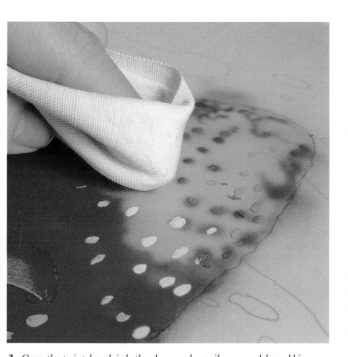

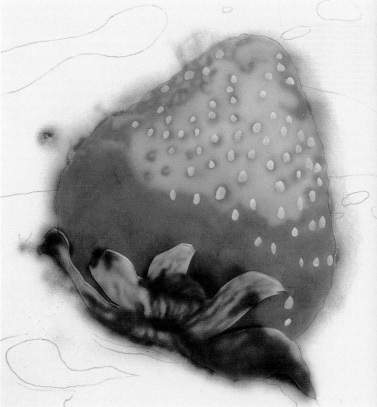

3. Once the paint has dried, the glue can be easily removed by rubbing gently with a clean cloth.

4. When all the glue is removed, a yellowish ochre is added to represent the color of the seeds.

Masking Cutters

Self-adhesive masking and the assorted loose masks that you need can be cut using various tools, depending on the shape you wish to obtain. For straight shapes you can use any type of craft knife, but for more complex outlines, with ins and outs, you'll need a scalpel-type craft knife; they are easier to cut with, as if you were using a pencil. Scalpel-type knives are made of different materials; the most popular ones are made of ceramic, since they don't wear out or break. Knives with rotary heads are ideal for cutting curves, especially tight ones. There are all types of replacement blades for craft knives, with the exception of the ceramic ones, in which the blade is an integral part of the tool.

*Sampling of the different types of cutters that are available in the marketplace: **a)** scalpel-type knife with ceramic blades and two tips, one large and one very small one for very precise details; **b)** knife with rotary head; **c)** paper or box cutter; **d)** large cutter for cardboard and other thick materials.*

A KNIFE FOR EVERY PURPOSE

It's not advisable to try to do every kind of job with the same cutting tool; for example it is a bad practice to cut thick cardboard with a scalpel, since that will dull it quickly, and may damage it; that type of knife is suited only to fine papers such as tracing paper and self-adhesive masking film. In the latter case, you have to exert very little pressure to avoid damaging the paper of the illustration. On the other hand, larger cutters are not suited to fine papers, since they are harder to control by touch and you may spoil the masking. In regard to shapes, there are a number of factors that come into play; you can use a scalpel to trace around all kinds of straight and curved silhouettes in all sizes; large cutters, on the other hand, are fine for straight lines, but they are hard to use in cutting curves, are suitable only for very gradual curves, and are never appropriate for small, tight curves. Never use a knife with a swivel head for straight lines, as it does not track straight. Compass cutters are limited by the size of the circle; if you need extremely large spheres or arches—or extremely small ones—you have no choice but to trace it and cut it out freehand using the scalpel.

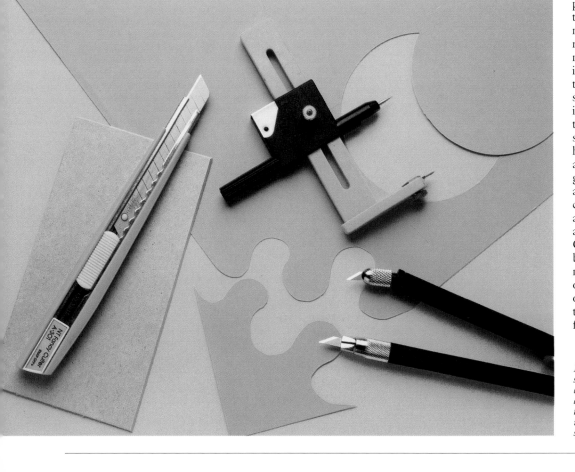

Every shape and material is suited to a different type of cutter. A professional in airbrushing will need to have the greatest possible variety and use them all correctly in every specific instance.

COMPASS CUTTERS

Circumference cutters serve the same purpose as compasses, but they are equipped with a cutting blade instead of a lead. Their shape is different, since they have a thumb screw to adjust the radius to be cut out, which keeps them from changing under the pressure applied in performing the cut. The blades for this type of cutter wear out quickly and need to be changed frequently. It is very important to keep them in perfect condition; if you have to push down much on the compass, you will leave a mark from the point in the center of the circle. To keep this from happening, put a small piece of paper in the middle so that you poke a hole in that and not in the surface of the work paper. The only difficulty you're likely to encounter with this device is that there are a minimum and a maximum size that they can be used to cut out. Very small circles have to be made with the help of a template; large circles will have to be cut out freehand.

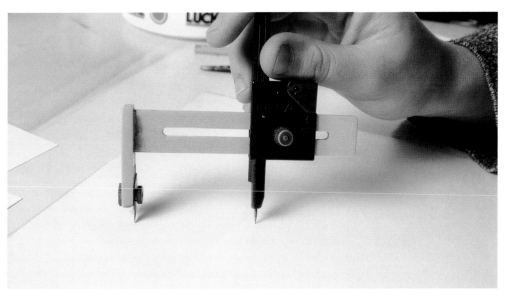

The proper cutting position involves keeping the axis perfectly perpendicular to the paper. You can see the thumb screw that's used to set the distance to be cut.

If the blade is sharp enough, a single pass should be enough to cut the shape from the paper.

Look how easily and neatly this cutter with a rotating head and a ceramic blade cuts curves.

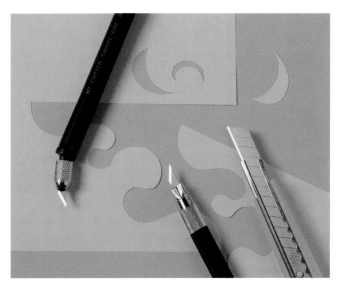

Straight lines and curves made with regular cutters and a knife with a rotary head, respectively.

Materials for Retouching

In the field of illustration, we almost never limit ourselves to the use of the airbrush; rather, we also use other techniques for applying finishing touches, outlines, and the final shines and contrasts. The airbrush is the tool for filling in backgrounds and large spaces quickly, and allows a progressive process of adding details up to a certain point. In order to do the final touches, other illustration techniques are very useful. Let's look at a few instances.

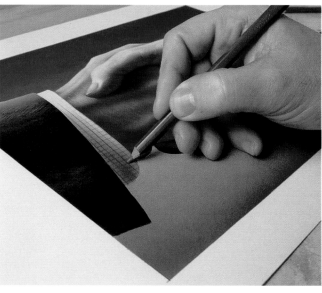

In this case, colored pencils were used to draw the lines that would be very difficult to apply with an airbrush. This is one way to save time and effort, and the texture of the pencil line is practically imperceptible.

COLORED PENCILS

These are a resource that is often used in airbrushing to add details and linear shapes that would be rather imprecise if done with the airbrush, even if it were held close to the paper. Colored pencils can also be mixed almost imperceptibly with the sprayed paint, since they allow gradations and gradual blending of colors. When fine lines are needed, the points have to be very sharp, as they can provide a lot more precision than the airbrush can. Colored pencils can also serve to establish a more complete basis for the drawing than a graphite pencil can; afterward, the spray blends in with the colors.

MARKERS

Markers are used much like colored pencils, but they are used only for certain shapes. They are not suited for creating gradations, as every stroke would be visible. One advantage they have over pencils is their strong color: you need just one stroke to create a very dark color for any needed detail.

Markers should always be used as a last resort, as once they are used, there is no way to erase or disguise the line, so you have to plan their use very carefully. It is appropriate to have a good selection of colors with medium and fine points, never broad points.

Colored pencils must be of good quality. If you are going to use them for drawing lines, they do not have to be watercolorable. On the other hand, if you intend to spray over them, it is better that they be watercolorable so that the strokes will blend with the liquid color.

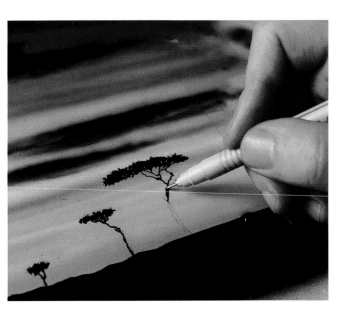

A black fine-tipped marker is used to draw the silhouettes of the trees. They really stand out against the oranges of the clouds.

MARKER INK

The ink in markers may have a water or an alcohol base. The former dry more slowly, and the ink can blend in with a color over which it is applied. Markers are a fine choice for use along with the airbrush when you wish to mix mediums or shade small areas, because the ink becomes perfectly integrated. Alcohol markers evaporate very quickly. Their color is indelible, and it won't mix with water-based colors, but rather only with other alcohol-based markers. They too are used in airbrushing projects, but they produce very concrete results; there is no shading or gradation, so they are used for very firm and clear lines that you want to stand out from the background. In addition, their colors are very strong, which makes for clear, clean lines.

GOUACHES

Like other mediums, gouache contributes to the finish and the final appearance of the picture. You'll need a good selection of brushes, especially fine ones, in order to draw lines, as you would with markers and colored pencils. The main advantage of gouache over the other mediums is its opacity: It covers any color beneath it, and that is something that can't be done with markers, which can be used only for dark over light. It goes without saying that details done with a brush require a much steadier hand than with other techniques. The quality of gouache colors varies a lot. Our advice is to buy the best ones, which provide the best coverage, make firm lines, and keep the color beneath from showing through. Gouaches are sold in tubes or tablet form. They can even be used in airbrushes if they are diluted adequately and the brush is cleaned thoroughly after use.

One of the main advantages that gouaches have over markers and colored pencils is the possibility of making your own mixtures and creating new colors.

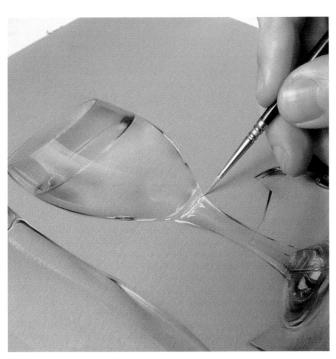

Gouache is a good choice for the lightest colors, such as white. It is easy to get the pure reflections to stand out against the background.

OTHER MATERIALS FOR RETOUCHING

Razor blades are used more frequently than people commonly believe. They are a tool that can be used for all kinds of retouching and corrections. Once the paint is dry, it can be scraped with a razor blade to remove it completely. If the paint gets underneath the self-adhesive masking film and the edges aren't precise, you can touch it up by scraping the paint with a razor blade. Similarly, when you want to create a very fine, linear sheen, you can use the edge of the blade; you will see how a white line appears as if it were done with a brush, and it is a lot bolder than a line that you could create using an eraser.

Razor blades can also be used to create certain textures. Scoring the paint can help you simulate rocks, tree bark, and other textures. You can use small scratches to represent grass, leaves, and even the plumage or the fur of animals. When using razor blades, you have to be very conscious of the pressure you exert on the paper; if you push too hard, you will dull the blade, and you may damage the illustration; you have to proceed gently and apply progressive pressure until you remove the paint. If you want fine lines, use the edge of the blade; to remove paint and clean up borders, use the entire blade edgewise. In either case, you have to be sure that the blade is in perfect condition and very sharp or you will lose the detail and will surely damage the paper.

Another implement used for retouching is the blending tool, but this is not directly linked to the use of the airbrush, since that paint sticks to the paper and is unalterable. This is a tool that you can use if you subsequently work with colored pencils. When you use pencils to do retouching on a surface that has been sprayed, you can effectively blend the strokes together and make them merge perfectly with the background by using a blender. It is used for very small nuances of color that may be quite difficult to create with the airbrush; using colored pencils and a blender makes those nuances much more accessible.

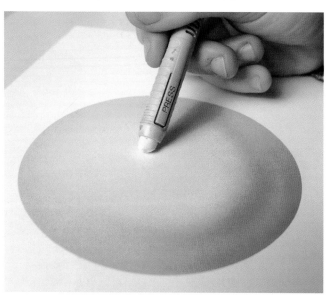

Erasers are very useful for the final result of a work. If you use a common or a broad eraser, as in this case, you subtly lighten the color and create perfect gradations of reflected light.

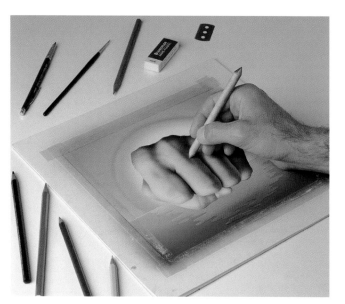

In this case colored pencils have been used to create the furrows and cracks in the skin. When you need to attenuate the intensity or blend in the lines completely with the background, the blender is the ideal tool.

DRAWBACKS OF BRUSHES

For a finishing technique, we recommend using gouache for final retouching that requires well-defined lines. In this case you are going to have to establish some fine lines and precise outlines that are easier to do with pencils and markers. Retouching with a brush requires a very steady hand for fine, precise lines. You will need a good selection of very fine brushes starting with number 0 so you can do the same things as with a sharp pencil. We recommend using easier techniques to master for outlining in dark and using gouache only where needed, such as for light colors (whites, yellows, and all the pastel colors) destined to cover the background.

Shiny areas and reflections can be done with white gouache or with the edge of a razor blade. The advantage of the second method is that the painter has a closer contact with the image and the point of the blade is finer and more precise than the point of a brush.

ERASERS

The best way to lighten a surface, aside from spraying with white, is to use an eraser. Erasers are commonly used in airbrushing for correcting errors and for erasing lines to lighten colors that have turned out too dark. Erasing can be done only with transparent colors. The only way to lighten opaque colors is to spray over them with white. Erasers are used much like airbrushes, and they are available from soft, light colors to pure white. That will provide a broad selection of erasers.

Pencil eraser with wooden casing that can be sharpened when the rubber gets worn down, and a refillable pencil eraser made of softer rubber.

Several types of common erasers. They need to be fairly hard in order to remove the color.

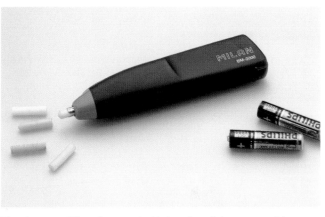

Electric eraser. When the eraser inside is activated, it rotates and is very effective in removing paint. Refills are available in different degrees of hardness so that even the most difficult inks can be erased.

Look at the effect that the different erasers have on a spot of color: With a common eraser there is a broad gradation in the erased area.

With a refillable pencil eraser, the lines from the eraser are clearer.

The electric eraser produces a clear line, and the white of the paper is completely recovered, since it eliminates all the paint wherever it is used.

Glazes and Color Mixes

For most artistic work, the colors used in airbrushing are transparent. This characteristic makes it possible to create mixes of color by superimposing them—chromatic films that yield a new color on the paper without having to mix them directly in the reservoir of the airbrush. But whether a direct mix or one that is done through transparencies, artists have to know the logic that governs mixes of color; in other words, the color theory.

Sample of how the color is intensified by pulling back on the operating lever.

COLOR MIXES AND GLAZES

The colors that are used for airbrushing can be obtained through various means. One is to mix the colors directly in the reservoir; for that purpose, the paints come with an eyedropper that can be used to establish the proportions for the needed mixes.

The second way involves working with glazes, in other words, the super-position of one color on top of another so that it affects its tone and creates a different nuance. Glazes involve transparent colors. For working with opaque colors, the mixes have to be done in the reservoir.

The tremendous number of color shades that are manufactured means that you can simply buy whatever you need without resorting to mixing. The quantity of secondary, tertiary, and other fractional shades is so broad that it may not be necessary to do any mixing at all.

In this instance the intensity of the color was created by moving the airbrush further away from or closer to the paper. When the airbrush comes close to the paper, the color intensifies, but it covers a smaller area.

Gradations may involve one or more colors. This gradation in blue is just the first phase in which two colors superimposed over one another (red on blue) give rise to a third because of the transparency effect.

Note how violet is produced by applying a glaze of magenta over blue. The quantity of carmine that is added makes it possible to set up a spectrum that goes from the coldest lilacs to garnets.

DARKENING AND LIGHTENING A SHADE

One virtue of sprayed paint is that it can be intensified easily with the airbrush by holding the tool closer to or further from the paper, or by increasing or decreasing the amount of paint released. In both cases, you are manipulating the transparency of the paint in such a way that a gentle spray of paint yields a light color, and a prolonged spray makes a dark one. All these factors can be helpful when you are working on a certain shape; in other words, by using a single color you can set up all the light and shading possibilities that confer relief on any form. Some colors, on the other hand, are not suited to expressing darkness through saturation and must be combined with other colors that reinforce them; this is the case with yellow, the oranges, pinks, and all pastel colors in general. With these light colors, it doesn't matter how intensely they are applied; they will never contrast satisfactorily with the luminous part. Generally speaking, all colors can be darkened by combining them with dark tones, but you have to remember the nature of these tones before adding shadows. Usually, all the warm colors combine very well with umber and sepia; you merely need to apply a soft glaze of these colors to achieve a very potent effect of volume. The cold colors, on the other hand, don't combine well with sepias; they appear dirty. Blues, cold greens, violets, and grays combine very well with black. This last color is very intense, though, and you have to control the intensity of the spray to keep the shadows from becoming too abrupt. With respect to lightening a color, the best advice we can offer is to use the transparency with the paper; any color applied with a soft spray creates a very clear and clean view of itself, and if you have to add white, the effect will never be the same. White applied on another color modifies it a little, especially if it is applied to warm colors. If you spray it onto another color, it appears to have a slightly bluish hue, and it loses its warmth.

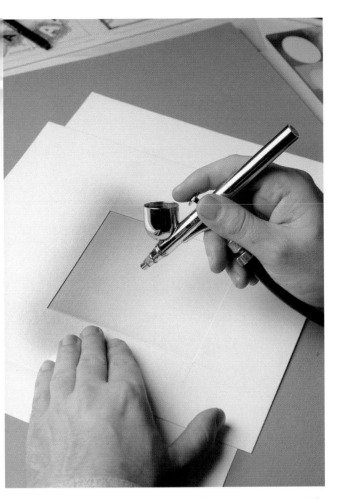

In this instance we have created a raised mask by cutting a square out of the middle. Create a preliminary value by spraying with black paint, then a second coat is sprayed on to create a darker value in the area of intersection between the two squares.

INTENSITIES OF A SINGLE COLOR

In airbrushing, the intensity of a color is measured and controlled directly through the use of the operating lever. Moving the lever to the rear releases color. The greater the quantity of paint, the greater the intensity. You can create different results by varying the distance of the airbrush from the paper. The farther away you hold the airbrush from the surface, the less intense the color. The area sprayed will be broad, but the color will appear diffused. As you bring the airbrush closer, the color intensifies and the spray is more concentrated.

COLOR LOGIC

Ever since the English physicist Isaac Newton formulated his color theory in 1704, many artists and scholars have tried to apply the laws of optics to mixing colors and thus to art. The only problem that has cropped up with these attempts is that Newton's principles are valid only for visible light, in other words, for colors of light and not for colors of pigment.

Newton's optics are based on the elementary principle that a mixture of different lights produces more light, more clarity, but every artist knows that the more colors that are mixed together, the darker the resulting tone.

THE COLOR CIRCLE

The famous experiment by Newton, in which a ray of sunshine passed through a glass prism and was broken down into a fan of colors, made it possible for the English physicist to create a circular order among the colors of the solar spectrum. Newton's circle of colors is comprised of these colors: red, orange, yellow, green, blue, dark blue (or indigo), and purple. The step from one color to another (in the order given) is continuous and gradual, including the step from violet to red.

This color distribution is the one that has been adopted by most artists and scholars since Newton's time, but we have to keep in mind that when the colored lights of Newton are mixed together, the result is white light. However, when we mix pigments that correspond to these colors, we get a color very similar to black.

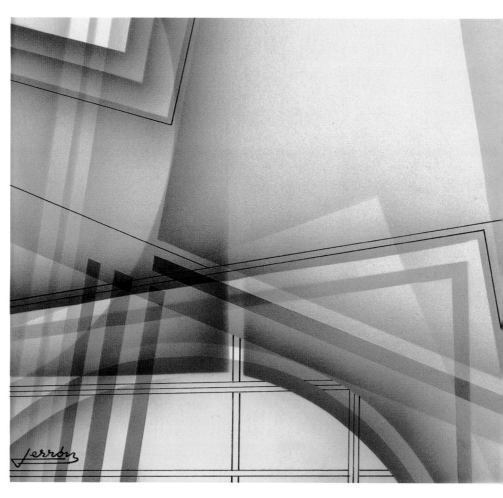

Exercise by Miquel Ferrón in which the different effects of glazes and transparencies made with the airbrush are demonstrated.

TRANSPARENCY OF AIRBRUSHING

Like no other procedure, the airbrush can create the illusion of using colored lights rather than pigments. The softness and the transparency of the sprays make it possible to imitate light effects that even approach photography. Just the same, we always have to remember that whether colors are combined through glazes or directly in the reservoir, color combinations for the airbrush are governed by the laws of pigment colors rather than the laws of light colors.

Note the circle of colors that contains all the colors previously mentioned. We have indicated the primary colors with a P, the secondary with an S, and the tertiary with a T.

The colors that are opposite one another in the circle of colors are complementary to one another. One color complements another if they have nothing in common, in other words, if neither is used in forming the other. The complementary relationship between primary and secondary colors is as follows: Bright red is the complement of cyan, since when it is formed, magenta and yellow are used; green is the complement to magenta, since the primary colors yellow and cyan are used in its formation; dark blue is the complement of yellow, since when it is formed magenta and cyan are used. You can find other complementary relationships in the circle, such as light green and violet, orange and ultramarine, carmine and emerald green, and so on. Mixing complementary colors yields a dark color, nearly black, as long as they are mixed in equal quantities. When the mix is done under controlled conditions with unequal proportions, the result is what is known as fractional colors, to which the browns, maroons, and grays belong.

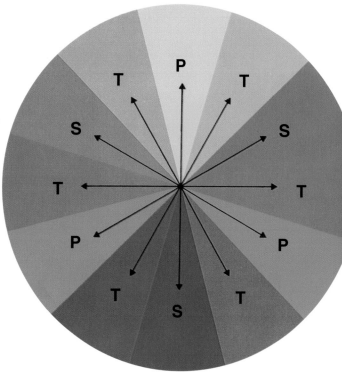

The experiment in the breakdown of light conducted by Newton consisted of passing a ray of solar light through a glass prism. That produced the color spectrum that can be viewed on a screen.

COMPLEMENTARY COLORS

Some mixes between primary and secondary colors produce a dirty, dark shade, specifically mixes involving magenta and green, yellow and dark blue, and cyan and red. If these were colors of light, the results of the same combinations would be white light (the equivalent of combining all the colors). This same equivalency also applies to pigment colors, with which a combination of all the colors produces black (or dark gray). These pairs of colors are known as complementary.

PRIMARY AND SECONDARY LIGHT COLORS

Newton's theory has many implications. One of the most interesting ones is that if we get white light when we mix all the colors of light, just a few of those lights (the darkest ones) are all that's needed to produce the rest of the colors. In fact, green, red, and indigo light are enough to create the other colors. These three light colors are known as the primary light colors. When green light and red light are mixed, the result is yellow light. The combination of red light and indigo light produces a very bright red, magenta (located in the spectrum between orange and red), and the combination of green and indigo produces the light blue of the spectrum, known as cyan blue. Yellow, magenta, and cyan are the secondary light colors.

In the form of light, the color white is produced by combining the three primary colors, which are seen as dark blue, red, and green.

TERTIARY COLORS

Tertiary colors are produced by mixing the primary and secondary colors with one another. This produces a circle of colors in which the passage from one color to the next is fairly gradual and that is a fairly accurate reflection of the circle of the colors of light proposed by Newton.

In pigment form, the primary colors are magenta, cyan blue, and yellow, and mixing them together produces black.

PRIMARY AND SECONDARY PIGMENT COLORS

If the primary colors of light are the darkest ones, the primary pigment colors ought to be the lightest ones. These pigments correspond in effect to the secondary colors of light: yellow, magenta, and cyan. When these colors are mixed by pairs they produce the secondary pigment colors: red, dark blue, and green.

In these images you can see the mixes of primary colors done with the airbrush. The transparency of the sprays provides a good imitation of the colors of solar light, even though these sprays are in fact pigments.

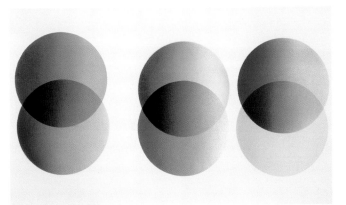

First Steps with the Airbrush

As we have already mentioned, using the airbrush is unlike any of the pictorial techniques that we are used to; as a mechanical tool, it requires a certain amount of technical knowledge. It is very helpful to have an understanding of how the airbrush and the compressor work, but the real challenge comes with doing the first sprays, since that is a hands-on exercise with the tool. There is no way to do any kind of satisfactory illustration without first doing a few basic steps to help you develop skill in operating the lever on the airbrush.

HOW TO OPERATE AN AIRBRUSH

An airbrush is a very fragile and sensitive tool, and it can be easily damaged through misuse. Proper use of the airbrush begins with holding it in the correct manner and activating it properly without forcing the lever to the point of damaging it. Most airbrushes become damaged through the operating lever, so the first rule is to use it gently, in such a way that the springs move under control.

COMFORT IN USE

Airbrushes always come with a cover on the reservoir and a sleeve that screws to the body and protects the needle and the threaded parts inside. However, when people work a lot with the airbrush, they often remove these parts for reasons of comfort. The cap for the reservoir is important, but just how important depends on the quantity of paint you are using. For example, if you are working with illustration formats, you are often using tiny quantities of paint, and in that case the cover is not so important, and it is often a nuisance to clean it with every change of color. On the other hand, it is important to keep the cover in place when you are doing a large spray, for example a background, since you'll need a large amount of paint. In addition, you'll probably be using long, sweeping strokes to fill in the background, and that could cause the paint to spill if the reservoir is not properly covered. With respect to the sleeve or hood for the needle, it is recommended that you remove it for reasons of convenience when it is time to clean the airbrush with every color change. Remember that you have to fill the reservoir with water, and then alcohol, and retract the needle until the reservoir is clean and empty. If you repeat this process using the lever, you will probably eventually damage it. It is best to retract the needle manually, and in order to do that you'll have to remove the hood or sleeve. This involves loosening the mounting nut, retracting the lever in a gentle back-and-forth movement, and when the reservoir is clean, advancing the needle to its original position and retightening the mounting nut.

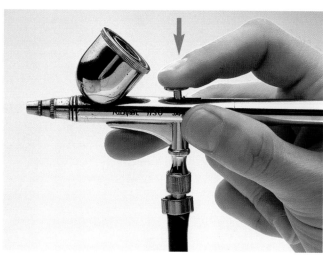

The airbrush should be held in the hand as if it were a pencil. The thumb and middle finger support the body of the airbrush, and the index finger is used to activate the lever.

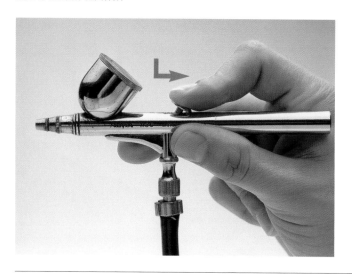

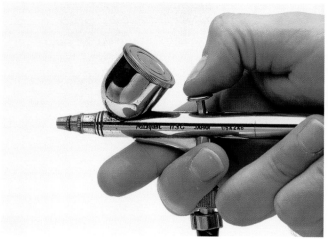

Here is how not to activate the lever, as many beginners do. This way it is very difficult to control the force used in pressing down and releasing the lever; in addition, the position is very uncomfortable.

The correct use of the lever involves simultaneously pushing downward to control the air supply and backward to adjust the flow of paint. Both movements have to be made practically at the same time and as smoothly as possible. The instrument must never be handled roughly, as that is how airbrushes become damaged.

FILLING WITH PAINT

Most paints for airbrushes come ready to use in containers that have eyedroppers that make it easier to fill the reservoir on the tool. If other paints are used, the color will have to be prepared separately and diluted to produce a liquid. The process depends on whether you work directly with the colors or have to mix them together. Sometimes it is a good idea to mix the paints separately to be sure that you have exactly the right color.

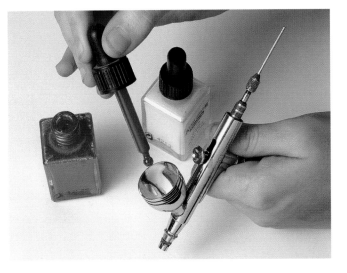

Acrylic paints for airbrushes have a cap with an eyedropper for the purpose of transferring the color directly. In this case, you will want to mix red and white, and the colors are added one after the other.

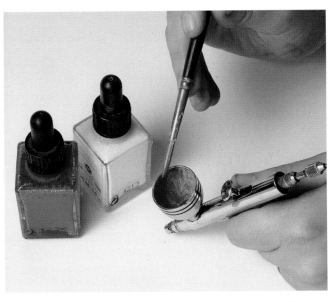

When the paint is in the reservoir, use a brush and check the resulting color. If you want a lighter color, add more white, and vice versa if you want a darker tone.

If you are using oils, gouaches, or any paint from a tube, you have to do some preparation before putting them into the reservoir. Mixes are done separately in sufficient quantity until you achieve exactly the right tone.

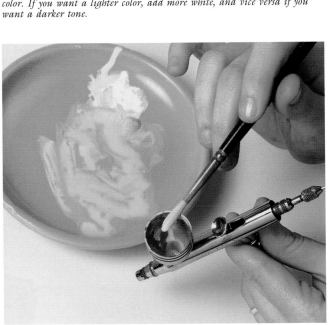

PAINT THICKNESS

The success of the spray is highly dependent on the thickness of the paint you are using. If the paint is too thick, the airbrush will surely become clogged and you won't get the right type of spray. The nozzle of an airbrush is very fine, from .2 to .3 mm. In thick paints, the pigment is so concentrated that it won't pass through such tiny dimensions, and it blocks the opening. To avoid problems, the paint has to be diluted properly. Watercolors can be used without a problem, but some opaque acrylic paints have to be diluted with water to thin them. Any paint that comes in a tube will have to be mixed with enough solvent to avoid clogging the opening; gouaches are thinned with water, oils with turpentine, and enamels with universal solvent.

Once you get the desired color, soak it up on the brush and squeeze it into the reservoir. You will already have added the right amount of solvent to liquefy the paint and keep the nozzle from becoming plugged.

DOTS AND STRAIGHT LINES

Making dots encourages control in the relationship between air pressure and paint flow, and the distance that the airbrush needs to be held from the surface. The first tendency that beginners have is to activate the lever and pull back a lot, without sufficient control. In making dots, you can retract the tool little by little and observe how the airbrush works.

The spray that you produce depends on the quantity of paint and the distance at which the tool is held.

Practicing drawing straight lines helps develop control in using the airbrush. Once you have mastered distance and pressure, you have to try to control the illustration. Drawing straight lines with the help of a straight edge helps to develop a steady hand and confidence with the airbrush.

HOLDING THE AIRBRUSH CLOSE TO THE SURFACE

Holding the airbrush close to the paper is more similar to any other technique than to real airbrush technique. You eliminate the effect of pulverization and blurring and produce lines. In these cases, the main feature is line drawing and, as a result, the ability to create features and outlines; drawing dots, straight lines, and curves is a preparatory step for controlling the pressure and the paint up close. You will see that the most important thing, in addition to the control of these proportions, is keeping a steady hand. One good learning exercise is to write words with the airbrush, as if it were a writing implement.

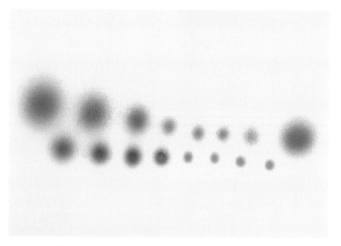

Dots basically teach us to control the size of the area sprayed. The airbrush is held with the lever pressed down, and it is pulled backward gradually. With the smallest dots, pull back only a little on the lever and keep the tool close to the paper; with the large ones, move the airbrush back and retract the lever some more.

A good exercise for using the airbrush up close consists of doodling and making random linear shapes. The rhythm of the stroke is important to the result; the quicker you are in making these shapes, the cleaner the line, since you don't give the spray any time to expand. You need to learn to use a controlled rhythm in case you need to do specific shapes in some exercise.

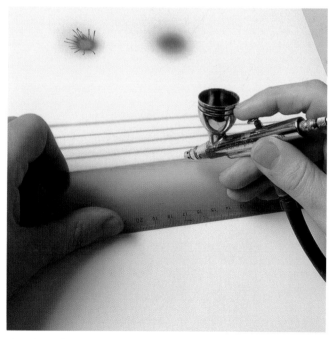

In order to draw straight lines easily, there must be no obstructions to the airbrush; it needs to slide along the straight edge without getting hung up at any point. That way, the appearance will be even and there will be no problems along the track followed by the airbrush.

No matter what project you intend to do, you have to have full confidence that the airbrush will produce the desired result, without risks or tentative efforts. For that purpose, all professionals keep a separate piece of paper on which they make all kinds of preliminary strokes to try out various factors, including the color obtained through mixing. You can also use that paper for the strokes that will tell you what kind of pressure you need, and you can check if the paint comes out in a fine spray without clogging; in addition, you can avoid creating blotches on the paper for the illustration if you first spray on the test paper.

GRADATED AND EVEN BACKGROUNDS

The airbrush can be used held far from the paper in filling in backgrounds. Contrary to what you might expect, a good deal of skill is needed for the gradation to be uniform and free of paint accumulations. In these instances the airbrush has to be held far away with the needle retracted to release a lot of paint. In holding the airbrush far away, the paint is not concentrated but is dispersed smoothly. The intensity of dark colors is not obtained by moving the airbrush closer but by using a series of passes to keep the paint from building up unevenly.

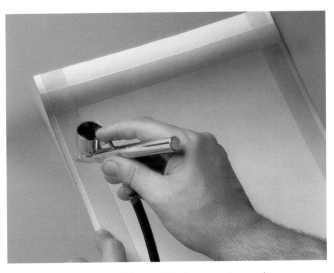

It is important to go out of the established margins in spraying; that will produce a homogenous result and keep the paint from building up at the edges.

Gradation from 100% to 0. The progression is from dark on one end to white at the other. We don't try to create a dark color at the very outset; rather, we start with a soft gray and spray in a zigzag pattern until the desired intensity is reached.

Smooth background. The surface is sprayed at a consistent distance and all areas are covered. It is intensified gradually without changing the position of the activating lever, otherwise you might produce accumulations of paint.

Central gradation. The center is sprayed with paint and the gradation is done gradually in both directions so that both sides have the same blending of shades.

SPRAYING FROM A DISTANCE

Even though backgrounds are one of the main applications for using the airbrush from a distance, this technique is also used for creating gradations that represent the shadows that impart volume to bodies. In these cases, the spray has to follow the outline of the subject in question, and the distance will have to increase in proportion to the size of the object. If you spray at too great a distance, the result will be a flat area of color without volume; if the airbrush is held too close, the spray will be too minute and it won't convey the volume of the body clearly.

CURVES

Curves develop freehand control in drawing lines without any type of support. This exercise is ideal for doing the shading on any type of three-dimensional object that has curved, convex, and con- cave shapes. For flat objects, simple gradations are used. It is a good idea to work with these types of shapes in prep- aration for including them in some future, more complex project, in order to gain experience with all kinds of silhouettes to work on, shade, and so on.

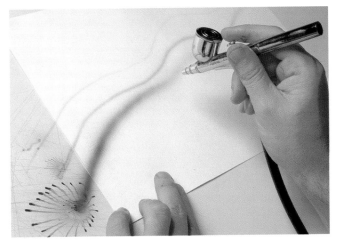

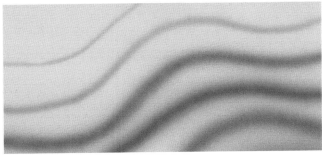

Drawing curves of different breadths helps in two ways: first, in controlling lines, always following the same curvature on each of the stripes, and second, in controlling the pressure, which will increase along with the desired breadth of line.

PROBLEMS

It is no simple matter to use an airbrush, no matter how much you practice. Errors are inevitable, as are problems that arise from unfamiliarity with or improper adjustment of the tool. Here are the main problems that may crop up, with solutions that will help the operator repair the airbrush without recourse to a professional repair person. In any case, there are always problems that we can't solve ourselves and that will require professional repair. If that cost becomes prohibitive, it is a good idea to get a new airbrush.

CONSTANT CLEANING

Many times an airbrush that hasn't been cleaned properly can cause problems. If you are careful to clean the airbrush every time the color is changed, plus before and after using it, there probably won't be any problems. It is also a good idea to keep at hand a natural bristle brush soaked in alcohol to rub regularly on the nozzle of the airbrush; that will remove impurities and residues from the opening through which the paint passes.

CHART OF COMMON PROBLEMS

PROBLEMS WITH LINES

Problem: *Blotting*

Cause: *Paint is too runny. The airbrush is too close to the paper. The needle is retracted too far.*

Solution: *Thicken the paint. Hold the airbrush further away to reduce the force of the impact. Correct the position of the needle.*

Problem: *Spotting*

Cause: *Lack of air pressure. Excessively thick or improperly mixed paint. Particles of pigment in the nozzle or the inside of the airbrush.*

Solution: *Adjust air pressure. Empty and clean the airbrush, and mix the paint again. Thoroughly dismantle and clean the airbrush.*

Problem: *Spotting at the start and end of lines*

Cause: *The lever has been activated too quickly.*

Solution: *Release and press the lever more gently.*

Problem: *Irregularities in lines*

Cause: *Lack of confidence in using the airbrush. Obstruction in the nozzle.*

Solution: *Practice and develop greater confidence. Clean the nozzle.*

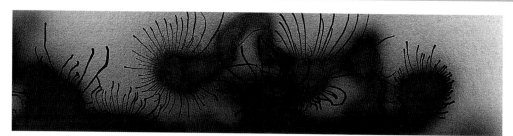

Problem: *Excessively broad lines*

Cause: *The needle is damaged. Improper installation of nozzle or housing.*

Solution: *Replace the needle. Install housing or nozzle properly.*

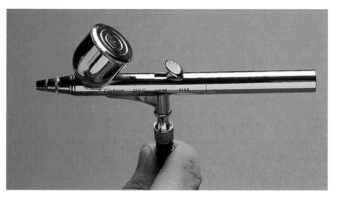

Problem: *The lever doesn't return to its original position after use.*
Cause: *There is insufficient tension on the valve spring. The lever is broken.*
Solution: *Increase spring tension, or replace spring. Professional repair.*

Problem: *Paint flow is interrupted.*
Cause: *Excessively thick paint. Needle too tight in nozzle. Lack of paint in reservoir. Broken control lever. Dried paint obstructing nozzle.*
Solution: *Dilute the paint. Take apart the needle and check the mounting nut. Clean the reservoir. Professional repair. Dismantle and clean nozzle and needle.*

Problem: *Air leaks when brush is not in use.*
Cause: *The stem of the air valve is not adjusted properly, or the diaphragm is broken.*
Solution: *Professional repair.*

Problem: *The needle gets stuck inside the airbrush.*
Cause: *Dried paint inside. Damage due to improper maintenance.*
Solution: *Submerge the airbrush in water and carefully free up the needle. Professional repair.*

Problem: *Air leaks out the nozzle and produces bubbles.*
Cause: *Nozzle is not screwed in properly or tight. Air is under insufficient pressure.*
Solution: *Adjust nozzle properly. Increase air pressure.*

AIRBRUSH MAINTENANCE

An airbrush is a delicate instrument, and obviously continuous use can cause damage; however, you can insure good maintenance with a little practice in use and cleaning. The tool needs to be cleaned with every color change, plus at the end of every session it needs to be cleaned thoroughly. Once a month or every two months it is a good idea to soak the airbrush in hot water and liquid soap. With respect to use, the most important thing is to never force the activating lever; it has to be used gently and lightly.

Imitating Textures

As we have already noted, the airbrush can be used for creating images, shapes, and textures. This is because the tool is so versatile—a "magic brush" that's capable of creating a line as fine as .118 inches (0.3 mm) or a broad sfumato. In the following exercises you will see how to create some of the most common textures found in nature.

AN INFINITE NUMBER OF POSSIBILITIES

If you observe nature, you see how every animal, mineral, or vegetable surface has individual characteristics that you recognize as texture: hair, skin, tree bark, water, air, stones, earth. There are an infinite number of possibilities and combinations for representing any specific scene. Direct observation and a few tricks can help you find the right way to incorporate most of them.

WOOD

This texture is based on polished wood. Since it is found on all types of furniture, this technique will be useful in depicting interiors. Of course, all the shapes that are traced will be rooted in direct observation of a piece of wood; just the same, once you have learned the technique, you won't need to refer to models.

1. Use a craft knife to scratch the surface of the paper; try to make fine, parallel lines in the desired direction (diagonal in this case).

2 and 3. Spray on some ochre paint with the airbrush to create broad stripes of differing intensity. You can see how the paint gets into the fine lines created with the knife. If you don't want to damage the paper, the fine lines can be traced with a pencil of the same color.

4. Use sienna to draw the actual grain of the wood. In so doing, bring the airbrush up fairly close and draw the figure of the grain freehand, not using a template.

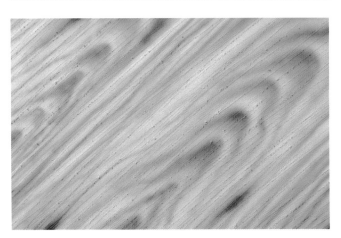

5. Repeat the operation at both ends of the page so that three sets of grain are visible; the one in the center is the largest and most important one. Fill in some straight lines between the figured grain; do these freehand with the airbrush held close to the paper.

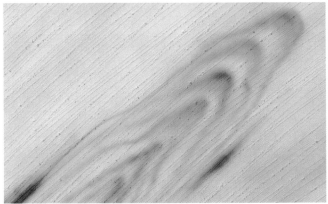

VARIOUS COLORS

Wood displays many colors and tones, depending on the type of tree it comes from. For reddish woods, work directly with siennas; for darker woods, use sepias and browns.

GRANITE

Granite is composed of a conglomerate of minuscule particles, which means you have to use numerous hues and colors in the shape of dots. These characteristics are also observable in sand and mud. Granite rock is solid and rigid, though, and it is easy to use the airbrush to produce cracks and grooves.

1. Start with a white base and go over it a couple of times with blue. Keep the airbrush at a moderate distance and apply a diaphanous and uneven spray.

2. Apply the characteristic splatter of granite with an old toothbrush. Dip it into liquid black paint and run your finger along the bristles close to the paper to speckle the entire surface.

3. Mix blue with a little black to create a very cold shade of gray. Then use the airbrush to spray very close to the paper and create the cracks and grooves in the rock.

4. To finish off, add some new dots and splatters with a brush and a light color to create contrast and variety in the texture. These colors can be obtained by applying lye directly, since it eats through the color. This can also be done with white or other colors.

RELIEF

Although the rock was presented in flat form in this exercise, it is most common to encounter it in rough and irregular shapes. To create this effect, you merely need to add shadows in the same color as the cracks to represent the recesses in the rock.

MARBLE

Marble is a very attractive texture because of the grain and the tonal variety that it possesses. In contrast to granite, it does not have cracks, and its texture is smooth and brilliant. As always, before painting this material you have to observe its characteristics very carefully.

1. Use a cloth dipped in English red to make a pink base on the paper to create the effect of a subtle pattern.

2. Fill the airbrush with burnt umber and spray densely to represent the initial grain of the marble.

TYPES OF MARBLE

Here we have presented pink marble with white graining, but there are other types that are mottled. In this case it is necessary to add dots, as with granite.

3. Use straight white to soften certain areas and give them more of a pink appearance. Also create the most obvious grain.

4. Finally, use white to texture the entire surface. The lines follow a diagonal direction, and they cross and join as if they were roads on a map.

SILK

Silk, satin, and any other type of shiny cloth have a good texture for reproducing with the airbrush, and it is easy to do freehand. It is especially noteworthy when the fabric has folds.

1. Observe a wrinkled piece of fabric and establish the folds. Hold the airbrush at a moderate distance from the paper, and use black paint to create the curved shapes that represent the volume of the cloth, its reflections, and its shadows.

3. To highlight the sheen of the cloth, lighten the color with an eraser. This treatment is applied to the areas of highest relief.

2. Cover the whole page with carmine. The same color is used to intensify the shadows and integrate them into the general color scheme.

OTHER FABRICS

The characteristics of a fabric depend on how soft or stiff it is. Flexible cloths are handled in the same way as silk, with rounded folds, but with less sheen. Stiff cloths form folds more along straight lines.

4. Finally, you can see the sheen created in concrete and linear form. The best way to do this is to use a refillable eraser or a hard eraser.

This is another texture that is characterized by folds and different planes similar to what is seen in articles of clothing. However, in this case the shapes are not curved and rounded, but straight, and the subject can be treated using movable, straight templates such as rulers or a simple piece of paper.

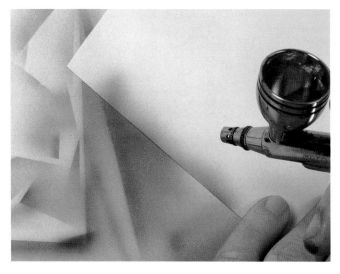

1. Hold the airbrush at a moderate distance and cover the white of the paper using smooth sprays of black, which will produce a gray shade because of their transparency.

2. Make some straight lines using a piece of paper as an aerial template, and define the wrinkles with straight lines like the edges of the paper being used.

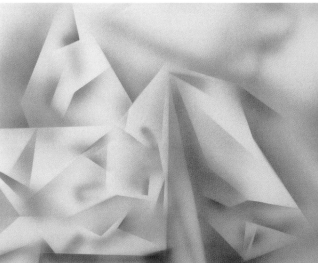

3. Next, define the main wrinkles by indicating the stiff folds in the paper.

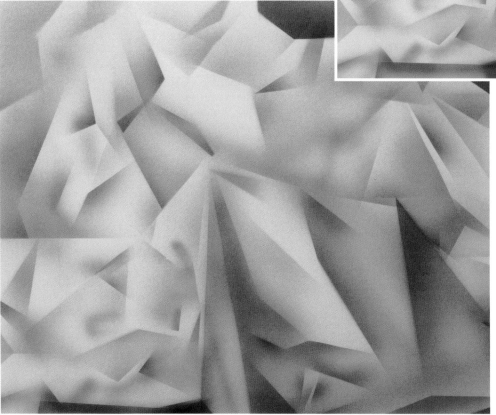

SOFT FOLDS

This exercise involves a very wrinkled piece of paper with abrupt changes of plane. However, you can create much softer folds by spraying at a greater distance or by using less paint. In any case, the best aid to success is direct observation.

4. The work is completed once all the folds of the paper are established. In doing this exercise it is very useful to study a crumpled piece of paper to duplicate its creases, reflections, and shadows.

WATER DROPLETS

Many times we have to illustrate specific, shiny objects such as droplets of water or soap bubbles. These are easy to do with self-adhesive masking film and gouache.

SOAP BUBBLES

Use the same process with a few variations for creating soap bubbles. The outlines have to be perfect circles instead of irregular shapes, and the shine is created in the usual way.

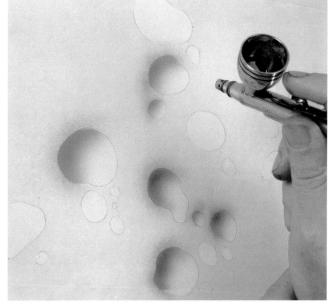

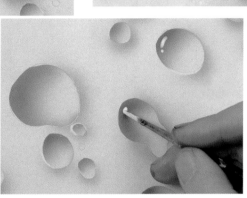

1. Cover the paper with masking and cut out the forms that correspond to the droplets, some smaller and others larger, rounding them but keeping them irregular. Next, spray the inside and darken the left side.

3. Create a shine on the surface of the droplets on the left-hand side where the airbrush was used to darken the color.

2. Remove the masking to check the shapes created with the foregoing spray and cover up the droplets. Spray the areas around the droplets from the right to imitate the shadow that they cast onto the surface.

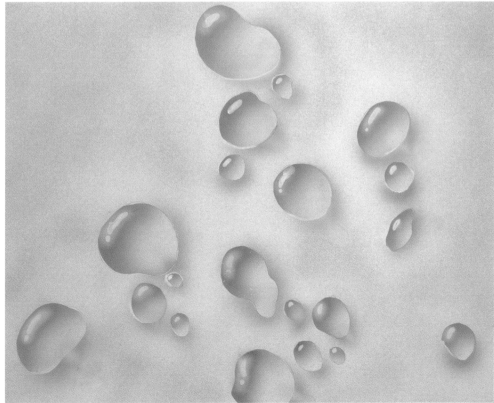

4. Finally, spray some white onto the shiny spots to blend them in a little. An extraordinary sense of volume is created by the contrast between the pure white and the shading in all the droplets.

CLOUDS

Clouds tend to have an airy and wispy appearance. This makes them one of the best types of illustration to do with the airbrush, since the color comes out in the same vaporous way as the air. Most skies can be done freehand.

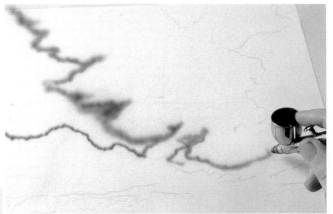

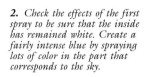

1. Use blue to spray the outlines of the clouds so that the blue is on the outside and the white is on the inside of the clouds.

2. Check the effects of the first spray to be sure that the inside has remained white. Create a fairly intense blue by spraying lots of color in the part that corresponds to the sky.

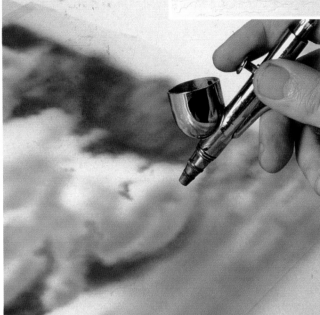

3. Spray some gray directly onto the clouds to create a sense of volume. Try to create volume and different color intensities.

VERY WISPY CLOUDS

This exercise has involved creating fairly thick and compact clouds freehand. In dealing with more wispy clouds, you can make aerial templates out of cotton to create much softer tonal transitions.

4. Here is the final result of applying the grays. The light clouds convey their volume perfectly. If the gray has darkened the clouds too much, open up some white area with an eraser.

FIRE

Images of fire can be done freehand in the same way as clouds. The colors will be warm ones selected from among the oranges, reds, and yellows. The shape depends on the context in which the fire is found and its nature, whether a simple flame or a violent explosion.

1. We have chosen to represent a catastrophic fire like a huge cloud of flames. Certain parts are covered with black and the interior is sprayed with yellow.

2. Incorporate some new shades of orange, but keep the pure yellow visible in certain areas. Hold the airbrush at a moderate distance from the paper.

3. Enrich the color of the fire by adding red, but keep the lighter orange and yellow visible.

A SINGLE FLAME

In order to represent a single flame, the same colors are used but in different shapes. Spray from bottom to top to create a broader base and a point at the top, like the shape of a flame.

4. Finally, bring the airbrush up closer to accentuate the accumulations of color over the entire area. A little purple and blue are added to the dark area to reinforce it.

GETTING STARTED

GLASS AND CRYSTAL

Images that include shiny surfaces and reflections require lots of observation and synthesis on the part of the artist. The shapes and colors of glass and crystal are conveyed by contrasts between light and darkness. It is very helpful to have a photo that shows a clear image so you can work with confidence.

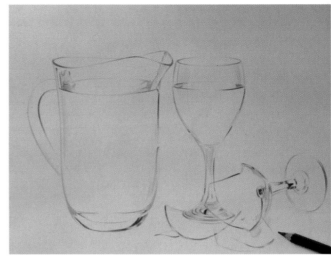

1. Use the airbrush held far away from the paper to spray a grayish background as a base color. Afterward, use a black pencil to go over the glass forms to make them stand out clearly.

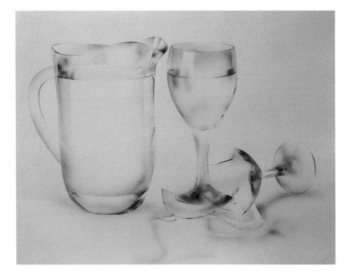

2. Fill the airbrush with black paint and darken the grays inside the objects. Different areas are separated by using straight and curved movable templates; the areas can be blocked off without using self-adhesive masking film.

BACKGROUND COLOR

The color and contrast of a transparent object are a function of the background. A dark background will produce very pronounced contrasts, while a light one will effectively neutralize the shape. In any case, the first thing to do is to establish the background color and work with dark and light colors applied on top of the base.

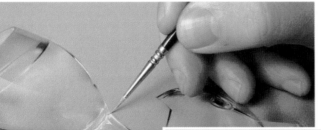

3. Broader sheens are sprayed with the airbrush; finer, linear ones are done by direct application of white gouache.

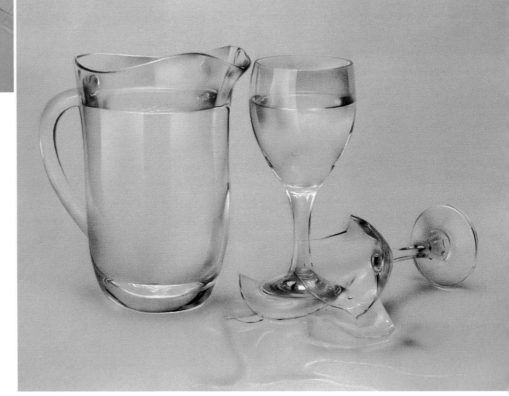

4. The final result is very realistic even though a very limited color spectrum was used.

METAL

The shine on metal is even more intense than the shine on glass. The main characteristic of this type of texture is the absolute contrast between light and shadow, and this is reproduced perfectly with the aid of self-adhesive masking film.

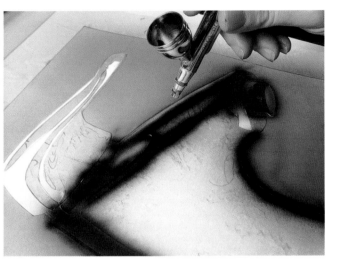

1. Color the background of the object with a shade of gray; cover the entire paper with self-adhesive masking film and cut out the precise shape of the areas to be sprayed.

2. Spray the exposed areas with straight black to establish the darkest reflections of the object.

3. Remove the masking from the object and check the shape and the intensity of the black areas. Then spray again freehand to create softer reflections.

REFLECTIONS

Reflections on metal and glass always follow the shape of the object. To be sure that they are arranged correctly, maintain a stable position in front of the object. The surest way to get this right is to work with a photograph.

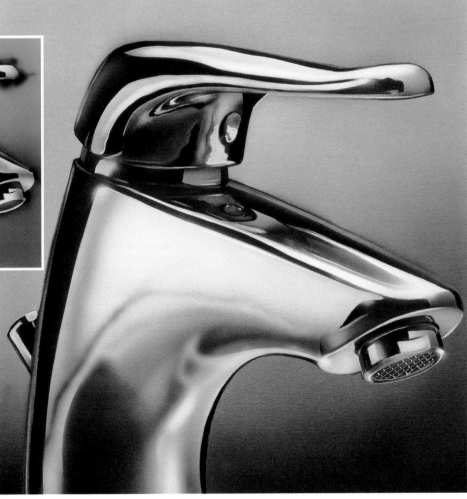

4. Finally, add some shades of gray and white to the rest of the object to create a pronounced chiaroscuro appropriate to the texture of the metal.

Basic Shapes

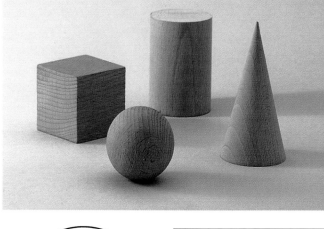

Once you have gotten used to how the airbrush behaves and the effects of distance on the spray, it is time to apply the technique to the basic shapes of objects: the cylinder, the cube, and the sphere. Each of these forms is unique, and a few simple exercises will help you produce a realistic appearance of relief and three dimensions.

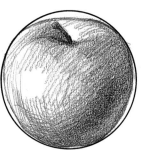

ALL OBJECTS CAN BE REDUCED TO BASIC SHAPES

The painter Paul Cézanne was the first to observe that the features of all objects can be reduced to simple geometrical shapes such as the cylinder, the cube, and the sphere, represented in the correct perspective. Interpreting them as simple objects simplifies the job of conveying distance and all the technical considerations that perspective involves. The cubist movement grew out of Cézanne's observations; it exploited to the maximum the similarity between all features and their simplifications. Objects can also be structured according to shapes such as prisms, cones, triangles, and ovals. In the first place we have to see and draw the basic shape that best represents and summarizes the model; then we have to calculate the actual measurements, shapes, and proportions.

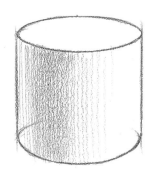

LEARNING TO SYNTHESIZE

Synthesizing the shape of an object makes it easy to develop a representation of it. In representing an apple, for example, the first step is to draw a circle to act as a framework for the rounded shape of the fruit. The same process applies to objects that have flat planes and are more clearly subject to the laws of perspective than spherical objects are. In any case, synthesizing is an indispensable first step in creating accurate representations.

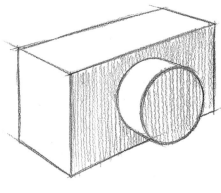

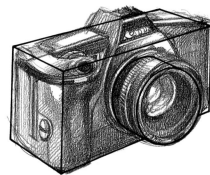

You can see that the framework for an apple is a sphere; for a cup it is a cylinder; and the cube and the rectangular prism are part of many objects ranging from a box to a large building. If all these shapes are combined, you can construct and draw outlines of complex objects such as cars and cameras.

A CUBE

Depicting a cube involves establishing the planes that constitute it. These are straight shapes that are created with simple gradations, since each face of the cube has to be darker than the next one to interpret correctly how the light falls on it.

Unmask all the faces one by one and spray from a distance to produce a uniform color.

The end result shows high relief. The gradations make up the planes; the darkest ones receive less light than the ones that are lighter in color.

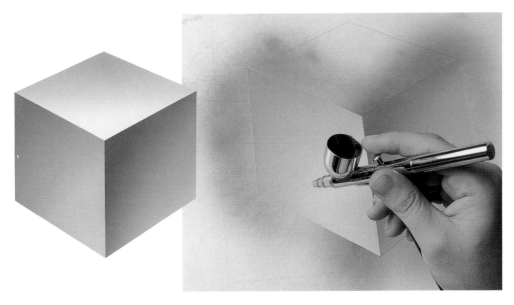

A SPHERE

A sphere is a geometrical shape that has no edges; it is totally round and made up of a single plane. Simple gradations are of no use in creating a spherical shape. The spray has to be applied freehand and in a circular motion.

Do a progressive spray by first deciding where the light source is. If it is to the top left, the color should be left light in that area of the sphere. The action of spraying follows the direction of the sphere and accentuates the edges. The end result has remarkable volume.

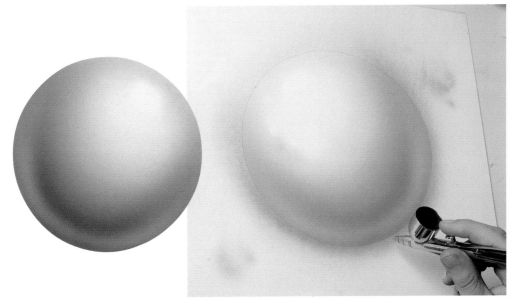

A CYLINDER

As with the preceding shapes, this form stands out in the light. In the case of a cylinder, the shine appears as a stripe that runs along the body of the shape.

Begin by defining the hollow part of the cylinder and leaving the rest of the shape covered by masking. The opening will appear darker than the rest of the shape.

Locate a central illuminated area on the outside and apply shading along straight lines to help define it. Sprays applied in a transverse motion create blended but continuous stripes.

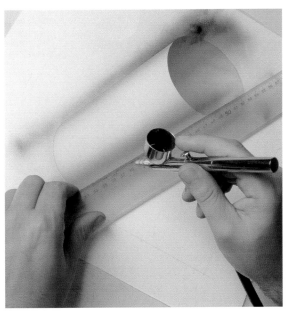

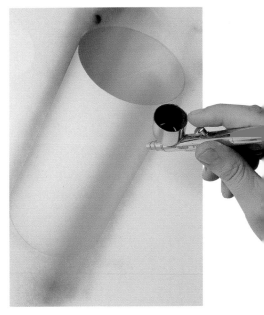

A SAMPLE STILL LIFE

To demonstrate what you have learned about spraying perfect shapes, put your knowledge into practice with a simple still life composed of features that are comparable to the basic shapes. In the foreground there are a couple of cherries that are clearly spherical. The chocolate bar is prism-shaped, but certain areas of that complicate the job somewhat, and the fingers are clearly cylindrical. You are not working on only the shapes of the foods. The textures are very appealing, and they too demand a specific treatment in each case.

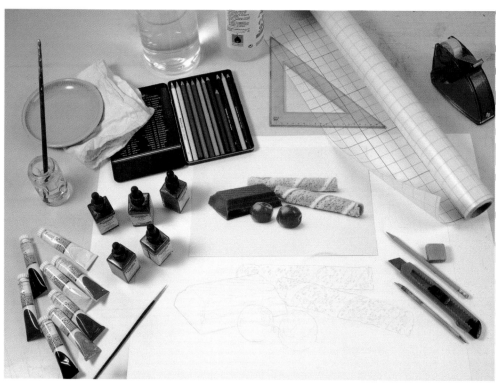

Materials needed: acrylic paints, masking, and alcohol. Gouaches and colored pencils will be used for the final finish.

1. Draw all the shapes on the paper using line drawings, with no values representing light and shadow. Next, cover with self-adhesive masking film and cut out the outlines using a craft knife.

2. Remove the masking that corresponds to the bar of chocolate and spray longitudinally at a moderate distance. Use straight burnt umber paint.

VOLUME

The volume of each body is determined by its shape and color; you establish the appropriate shape and three-dimensional effect using lines. In adding the shadows, you have to know how to control the intensity of the hue, which is different when dealing with light-colored objects such as the fingers and dark ones such as the chocolate bar.

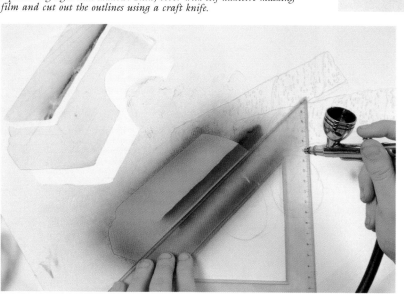

3. When all the color has been applied, emphasize the color differential in the different planes. The upper part is lighter and the various steps are set up on the edge of the bar by using a straight edge.

4. Once the desired contrast is achieved, the task of coloring the chocolate is done. Cover up the chocolate bar once again and begin to work on the fingers.

5. Uncover the furthest finger and spray the outline of the closest one to show the separation between them.

6. Remove the masking from the fingers in the middle and hold the airbrush very close as you paint on the creases and the overlaps with umber paint.

7. Spray the two cylinders with ochre and follow the direction established by each one. Leave the part along the middle light in color and darken the fingers nearer the edges to create an impression of volume.

8. Cover up the remaining features and uncover the first cherry. Use red to create the shape. In the areas where the cherry shines, bring the airbrush up close to work on the details.

9. Then uncover the second cherry and repeat the process. Spray the two cherries carefully to show their shine. Use very dark color for the rest of them.

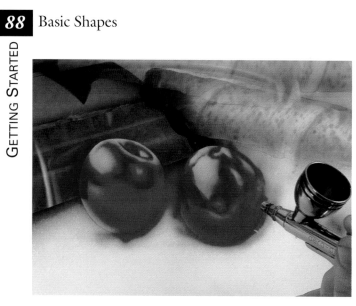

10. *Add a little sepia to the red and apply it to the areas that contrast most with the gloss.*

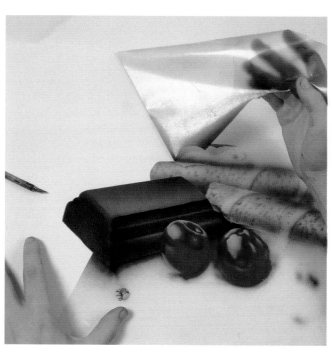

11. *Then remove the mask that covers the background to check the color and the contrast that have been created.*

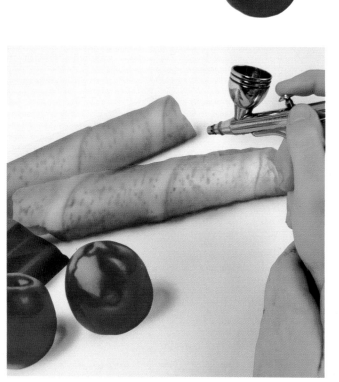

12. *The foods are the right colors, but they still need outlines so they don't appear to be floating in space.*

13. *Cover up the fingers to shade the lower part without contaminating the color, and use very diluted carmine to represent the shadows of the cherries.*

14. Start working on the details of the chocolate bar and highlight the relief on the upper surface by adding diagonal lines with a brown marker and a cream-colored pencil to make them stand out.

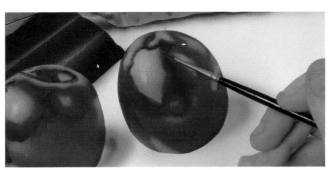

15. Use a fine artist's brush and dark carmine gouache to detail the dark reflections that can be seen in the cherries.

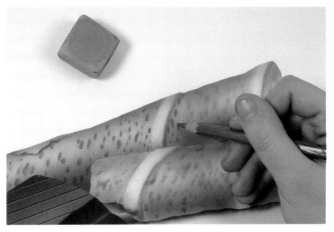

16. Use a brown pencil to accurately represent the folds in the texture of the fingers.

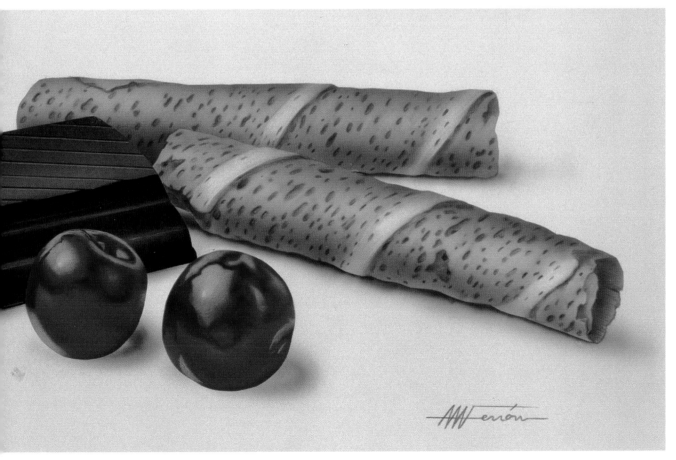

17. Finish the work with a combination of spray from the airbrush and an application of gouache, marker, and colored pencils to represent the details and the textures. The result is very realistic.

Controlling the Airbrush Freehand

Freehand work is the most artistic part of using an airbrush. The fact that you don't need to use masking means that you can use the airbrush with the same freedom and deftness as a conventional brush. Obviously, not all images are good candidates for freehand work. Outlines are less precise than when using masking, and the colors can mix on the paper since shapes are not blocked off.

When working freehand you don't have to block off specific areas. Merely use self-adhesive masking film to block off the margins and keep the illustration centered properly.

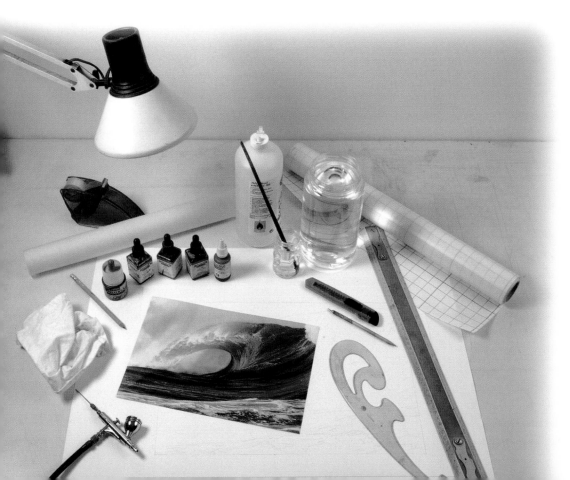

SEASCAPE WITH A SPECTACULAR WAVE

Ideal subjects for freehand work are those in which there are no specific and detailed shapes. Landscapes in general satisfy this requirement, and they allow the artist to work with great freedom. Another important factor in working comfortably without masks is the color. If the image uses similar shades of the same color range, it won't be necessary to separate one color from the others.

It is important to prepare all the materials in advance. Using movable templates is one innovation; they help in completing certain specific shapes. Both curved templates and those made from tracing paper are used.

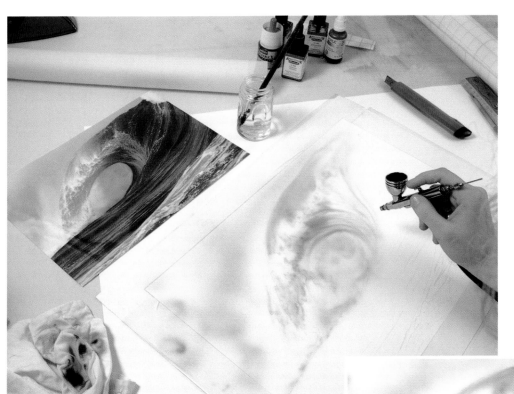

1. Begin by spraying the illustration with turquoise. Before applying the color, use a very fine pencil with light pressure to draw the shapes of the wave and the foam to help you spray with confidence.

2. Continue working on the illustration with the turquoise. The airbrush is used as if it were a pencil or a brush, moving it further away to create backgrounds, and bringing it closer to define the main curves that make up the wave.

DEFTNESS OF LINE

In all freehand work, agility and mastery of the spray are the crucial factors. You have to work with confidence, always in control of both the pressure of the paint spray and the distance between the airbrush and the paper. Before starting a work of this type, you have to have acquired the necessary deftness in this kind of work.

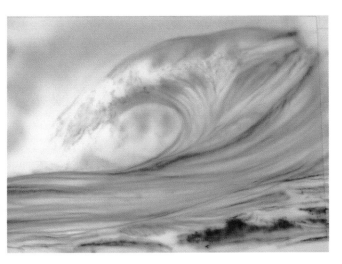

3. Once the first plane has been defined, complete the spraying of the entire paper. It has to be darkened just right in order to create a general tonal progression in the work.

4. Use a movable template made from tracing paper to separate the first plane from the rest of the illustration. Superimpose a piece of tracing paper and draw the precise curve you wish to block off; cut it out separately with a razor blade.

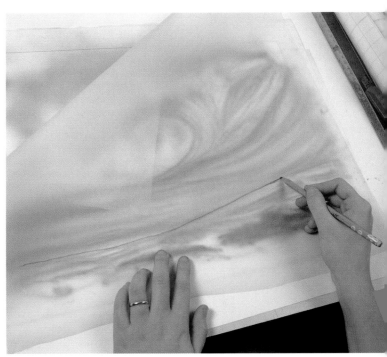

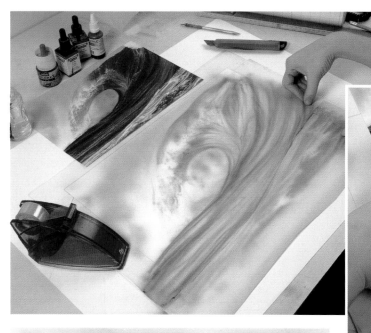

5. *Secure the movable template to the paper by placing a little clear cellophane tape in the margins, without touching the painting.*

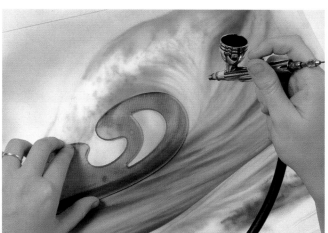

6. *Now use some sapphire blue, which is a colder color than turquoise, to introduce some new shades. The foreground is blocked off, and using the leftover tracing paper, trace the undulating forms onto the ocean using it as a loose template.*

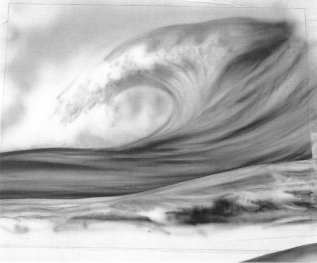

7. *Here is the result of applying the sapphire blue to the middle area and turquoise to the remaining areas.*

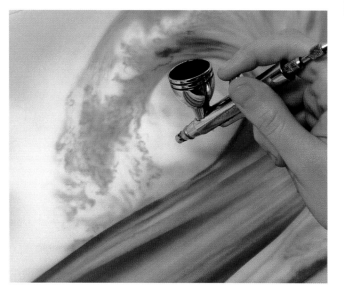

8. *Work on the crest of the wave with the help of the curved template. The idea is to highlight the ellipses that form inside the wave by using the airbrush in the right motion.*

USING GOUACHE

When you open up areas of white with an eraser, they may not appear totally white. If the color has penetrated into the paper, it will be difficult to clean up the traces even if you use a hard eraser. In this case, as long as you're dealing with whites in linear or dot form, you can use white gouache to get the greatest shine.

9. *The foam of the wave is represented by using the same turquoise and holding the airbrush very close to the paper.*

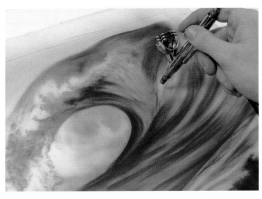

10. *The mixture of sapphire blue and emerald green produces an intermediate color that is very dark and that is used to define the strongest contrasts inside the wave.*

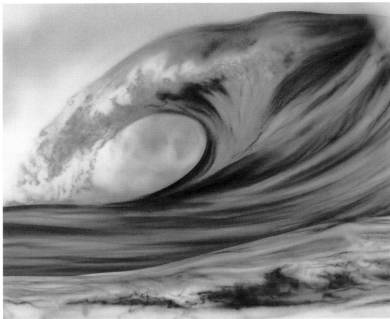

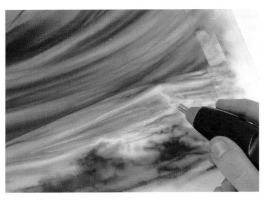

11. *In this stage of development, you see the middle of the wave, where the colors are colder and bluer, and the water in the foreground, which appears greener.*

12. *The electric eraser can be used to create details and open up some pure white areas in the foam.*

13. *Complete the contrast in some areas with a little ultramarine mixed with green; this is incorporated with some of the most intense whites to create contrast.*

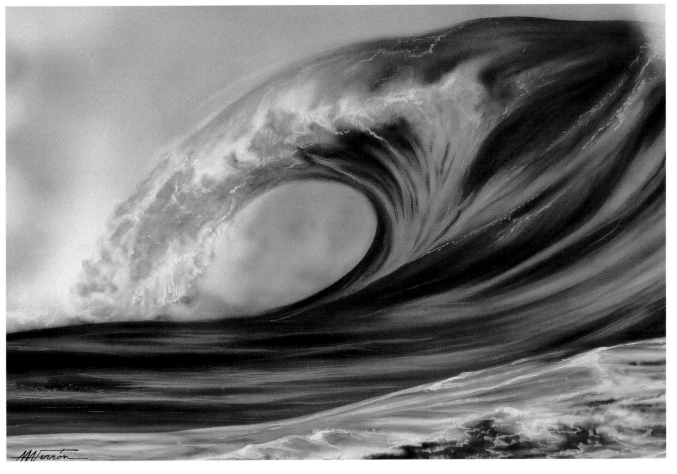

Flesh Tones

Nudes are a classic theme in oil painting, but there's no need to isolate a modern technique such as airbrush from more traditional ones. We have already noted that spraying can be done with any type of paint, including oil. We will now see a new way of creating effects of volume and fusion with a tool other than the artist's brush.

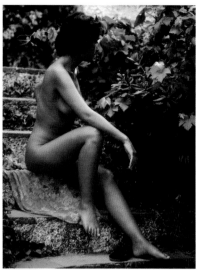

Begin with a nude outdoors, with plants and architectural elements such as the stairs. A photograph allows you to work from an enlargement in the studio.

FEMALE NUDE IN OIL

We have selected a nude in nature, so we have to deal with not only anatomical issues but also certain questions related to representing the vegetation.

REPRESENTATIONS TO SCALE

We are working in a very large format with the intention of completing an oil painting. For that purpose we have placed a grid over the photograph and magnified it by a factor of two or three on the canvas.

FLESH COLORS

Depicting faces and figures is complex work with respect to both the initial sketch and the coloring; don't devote much attention to the drawing here, since you can assume that it is a skill that you have already mastered; rather, focus on the coloring and its importance in conveying the texture of the skin. It is a good idea to use light passes with the paint just in case it is not exactly the right shade, and to create the small nuances that enrich the work. This is a simple job when working in transparent layers.

The coloring of skin never has to be restricted to a single color. Even though you have a good photograph to work

from, you still have to be an astute observer and analyze the variety of shades in the skin. You can study your own hands and see the number of shades that you find, from pinks and ochres to greens and blues, all united to form a whole that gives the overall impression of flesh tones. Naturally, this chromatic variety is very subtle, but if it is applied properly it will produce a very important visual realism. The color of flesh tones, like that of any other object, depends entirely on the colors that surround them. The contrast and the base color are influenced by the reflections that they pick up from the surroundings, which is a very important consideration in depicting a nude.

Although specialty art shops sell prefabricated flesh colors, they are not suited to serious works as they look very artificial and overly pink. You may use them for certain shades, but in general they have little in common with reality. We advise you to create the flesh tones yourself by combining browns with reds and ochres. The end result is a good deal more in line with the true appearance.

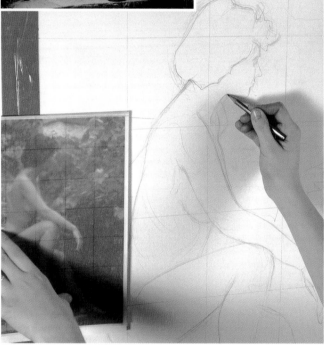

1. In order to enlarge the photo that you have, you first draw a grid onto a piece of tracing paper superimposed onto the photo, and trace the basic features of the figure and some elements in the background. Next, using very fine lines, reproduce the grid on the actual work paper using a graphite pencil. That will help in reproducing the sketch made on the tracing paper onto the work paper.

2. Draw the figure in the new format and preserve the proportions of the image. Don't focus on the background, since it involves shapes that are much less precise.

3. Here is a tentative representation of the figure done in a single color. The volume of the body has been created using color saturation and transparency. At this point white is not used at all.

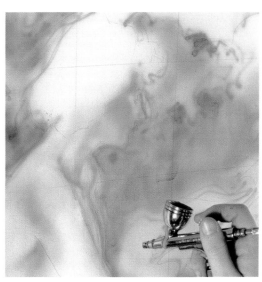

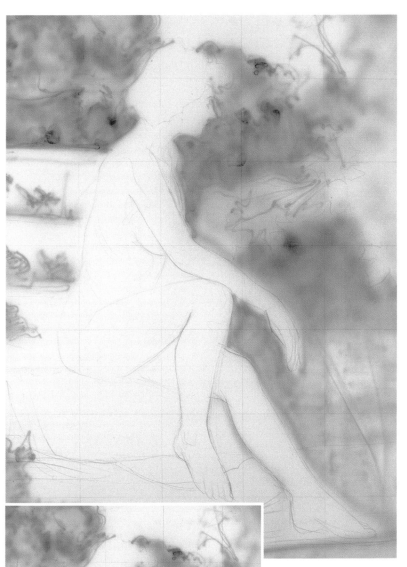

4. Next, start to spray the background with straight emerald green. The colors representing the greenery are kept from intruding on the color of the woman's body. Increase the pressure in the compressor to about 60 pounds (4 atmospheres) to increase the spraying power.

THE AIRBRUSH AS A BASE

In an illustration as large as this one and in a medium as dense as oils, not all ideas can be addressed using the airbrush. Many things require linear strokes and very precise details that are later added by brush. The airbrush is ideal for covering flat surfaces quickly, and the desired details can be filled in later.

5. Begin coloring in the body with a flesh color produced by mixing ochre and English red. Use the same color to set up the shadows and lights on the body, and to define the shape of the shoulder, the neck, and the collarbone.

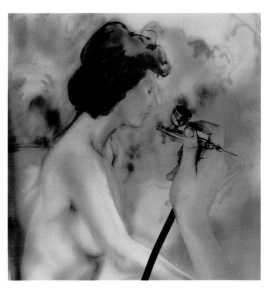

6. Use brown to add new shades of color to the figure. It is applied densely to the hair to create total darkness. The color intensifies the shadows and defines the shapes in the face and neck.

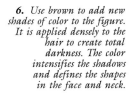

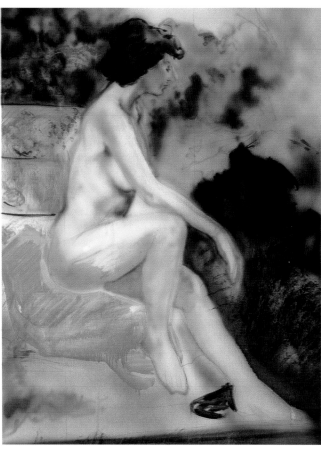

8. *You are going to create the figure by solidifying the shapes and contours. For that purpose cover it with tracing paper and very carefully cut out the silhouettes that you want to block off.*

7. *Intensify the color and the contrast in the work. Convey the most salient contrasts in the work, in the face and below the breasts. Mix some brown with emerald green and put in the first contrasts among the leaves.*

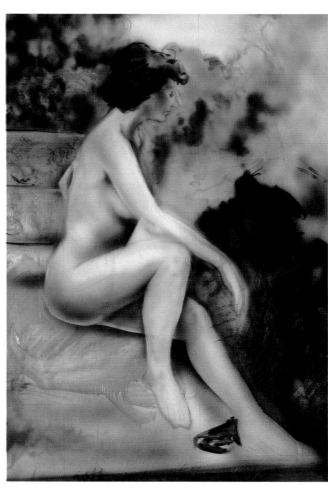

9. *Darken the background to make the figure show up better. The spray used for the background is a mix of green and brown; applied from a moderate distance, it gives a hazy appearance to the background.*

10. *Sepia paint and movable templates made from tracing paper are used in intensifying the contrasts in the figure. You have a general view of the shape and the chiaroscuro, but some details are still missing.*

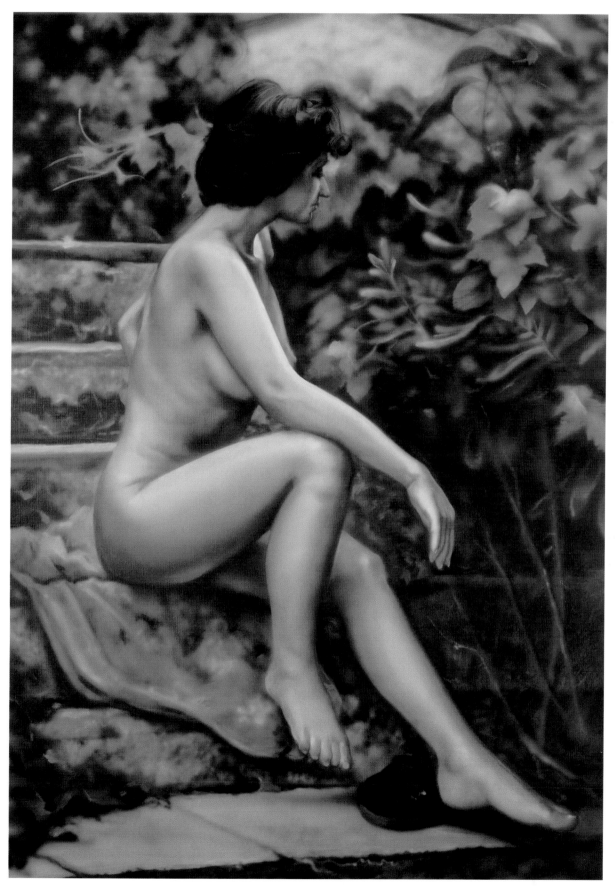

11. *Using a paintbrush, all the details have at last been added to the nude. Some final spray has been added with the airbrush to highlight the shapes and volume. The result is a nearly photographic work with lots of atmosphere.*

Working in Planes

Now we propose a different way of doing an illustration; it is far removed from the concept of photographic realism that is commonly associated with the airbrush. This is a way of developing shapes based on simplification and synthesis, and the result is as attractive as more detailed works.

2. By using a photocopy machine to enlarge the drawing and then by tracing on a light table, transfer the sketch to a paper suited to airbrushing; all the details are depicted so that the shapes can later be cut out conveniently, avoiding the need to invent anything. Then the entire paper is covered with self-adhesive masking film.

THE INITIAL IMAGE

We have selected the human body as a model, but this time we'll focus on just a fragment. The initial photo shows the muscles of a bodybuilder lifting weights that bring his entire musculature into play. This highlights his anatomy, so the illustration will have many more possibilities than if you were dealing with a position of repose. The presence of additional features such as the weights and the clothing enriches the color by introducing tones other than the human skin.

THE INITIAL SKETCH

Whenever you wish to change a photograph to create your own illustration, you have to do an initial sketch or drawing in which you note all the changes that you want to add. In this sketch we have structured the body as a series of planes; in other words, the bodybuilder's musculature has been conveyed through concrete shapes in different color intensities, instead of using the typical color gradations that are used to represent volume. We have separated the body into planes that convey the anatomy and musculature, and we have assigned color values to each part. Obviously, the shine on the skin and the shadows that the weight casts on the body are also part of working in planes.

Chosen photo of the model

1. Sketch made with colored pencils where each color indicates the planes that will subsequently be created.

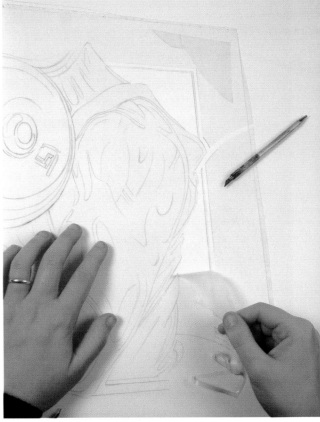

3. Cut out the part of the masking that corresponds to the background; then cover and block off the rest.

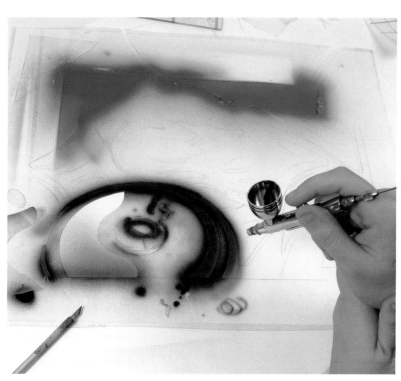

4. *The part of the background behind the back has been sprayed with sapphire blue; several passes were used to create a dark color.*

5. *Now work on the color and the shape of the weight. Mix purple with a little sepia to create a very dark lilac color, which is used to color the barbell plates that are lighted obliquely and that show some dark reflections. The remaining areas are still blocked off.*

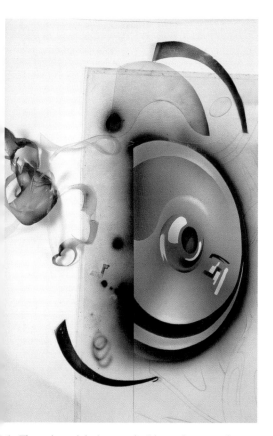

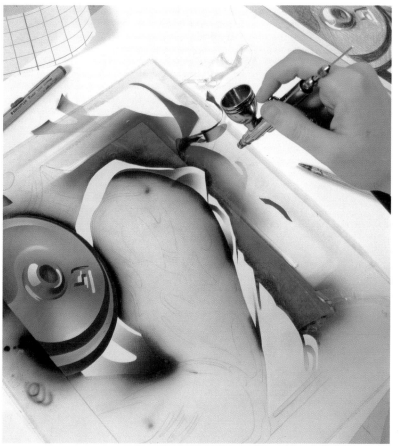

6. *The entire weight is sprayed with purple, except the points that show very noticeable reflections. These areas are kept blocked off, and after the background is sprayed, remove the masking. Next, apply another gentle pass of purple so that the reflections are not totally white and blend in with the overall color of the piece.*

7. *Use masking to block off the background and the weights, and the part that corresponds to the T-shirt is uncovered. With the rest of the illustration covered, apply a medium yellow spray.*

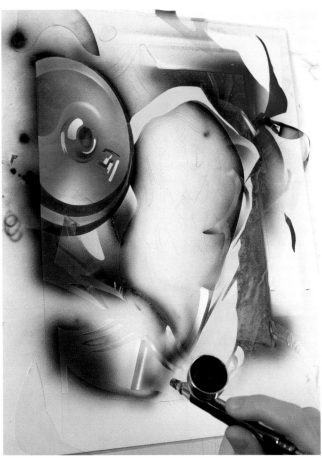

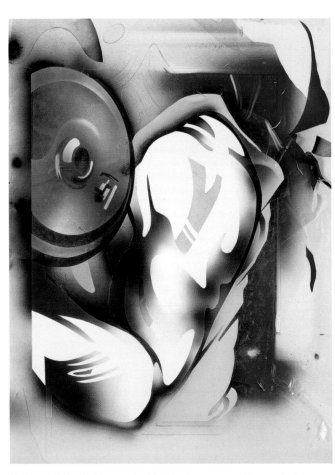

8. Spray the dark parts on both the person's skin and T-shirt with straight umber. The shaded areas of the flesh remain very light because you are working in planes; as a result, you merely need to unmask the shadows and keep the rest blocked off.

9. Now all the shadows on the skin have been sprayed; the rest is then uncovered, leaving blocked off only those points that correspond to the shine on the skin.

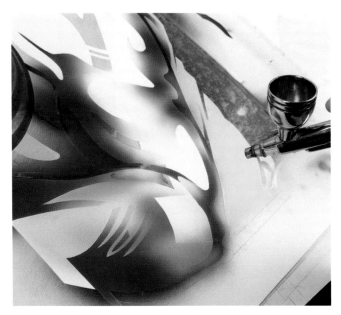

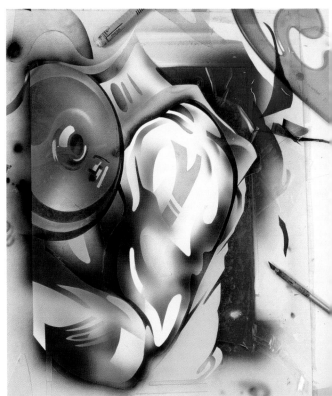

10. The whole illustration is blocked off except the arm; spray on some English red to create effects of volume with a more or less saturated color.

11. Then incorporate the red into the skin where it is intended to look more pink, and shade off the rest until it returns to white. The red blends with the umber without affecting it, and it does not need to be blocked off because you are working with transparencies.

12. *Airbrush the entire arm with yellow, except for the shiny areas that are blocked off. Again, since you are working in transparency with a color lighter than red, it is not necessary to apply new masking.*

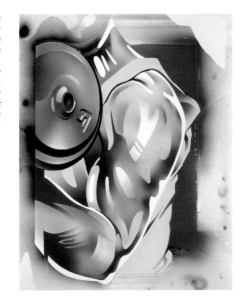

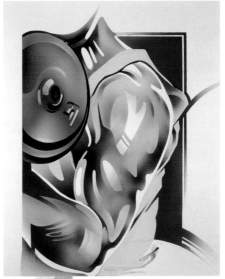

13. *Remove the masking from the outlines and check the results of the sprays.*

A DESIGN IMAGE

Working in color planes does not have much in common with extremely realistic works, but it does with conceptual design. The advertising world and design are always looking for minimalist conceptions of things. They tend to simplify shapes rather than complicate them, and for one reason: The goal is direct, clear information combined with visually pleasing graphics. This was the intent of the present illustration; the outline of the weight lifter has been transformed into a series of planes and colors that have a very visual rhythm and composition. The results could be intended for a poster or an advertising logo for a gym, or for some other sport.

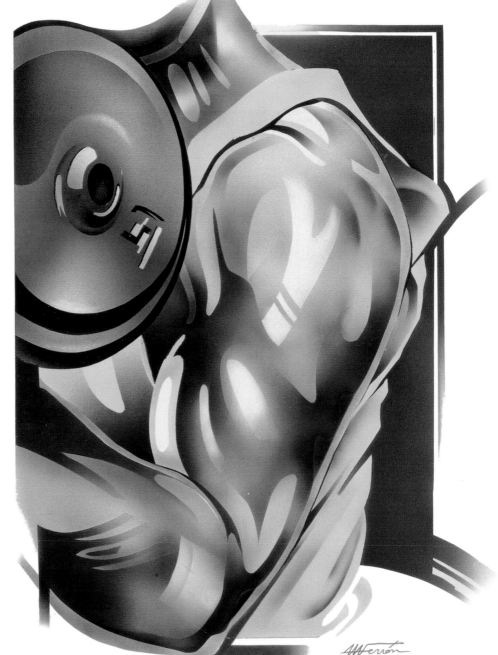

14. *Finally, spray the illuminated areas with blue, but first block off the contours to protect them. In this illustration done in planes, no supplementary material, such as colored pencils or gouaches, is needed. Everything is done with the airbrush, since no fine detail is involved.*

A Conceptual Illustration

For a long time the airbrush has been used as a tool to depict imaginary and fantastic worlds. In this way images born in the mind of the artist have been depicted as a creative method for producing illusion.

After selecting the two models, the woman and the doll, make a sketch with a marker that allows you to check how close you are to what you want to accomplish.

THE CONCEPT

We have come up with an idea, and our intention is to create it using the resources that the airbrush has to offer in making it appear as real as possible. We will invent a porcelain figure holding a mask that is a real face. The idea is to create a phantom, mysterious, and romantic world that is a little grotesque, and where roles are reversed. The mask is transformed into flesh, and the body becomes artificial, made of porcelain; in other words, the real becomes false, and vice versa.

REFERENCES

Before doing an imagined illustration, you have to get some photos together. On the one hand, you need a female face in order to depict a mask with real and credible features that don't look like those of a doll. For the figure that is holding the mask, you need an image of porcelain. The doll can help in observing what porcelain is like and how it shines when it is in the shape of a face. The dark background will also serve as a reference in contrasting the images in the drawing.

1. Draw the image as you want it to appear onto a piece of tracing paper. You have to use the sketch as a guide and determine the final shapes that you will trace onto the paper.

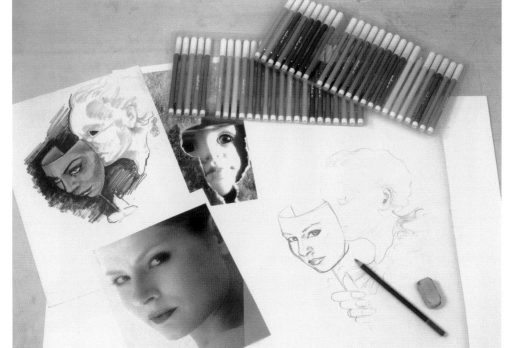

2. Trace the drawing, placing special emphasis on the representation of the face. Draw it with a flesh-colored pencil, and concentrate on the shapes; the lines will blend in when the airbrush is used.

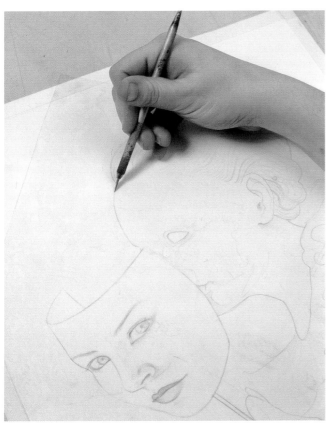

3. *Cover the entire paper with masking film and carefully use a scalpel to cut along the outlines of the figures.*

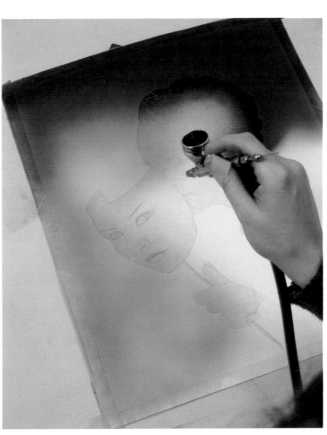

4. *Remove the masking from the background and begin spraying with umber, holding the airbrush very far away. Saturate the color in the upper part to darken it, and create a gradation toward the bottom.*

5. *Add some sienna in the center of the background, and a little purple toward the bottom in order to produce a varied and continuous shading. A few shapes are added beneath the figure to suggest carnival clothing.*

6. *Darken the clothing with umber, and uncover a few areas to check the degree of darkness created.*

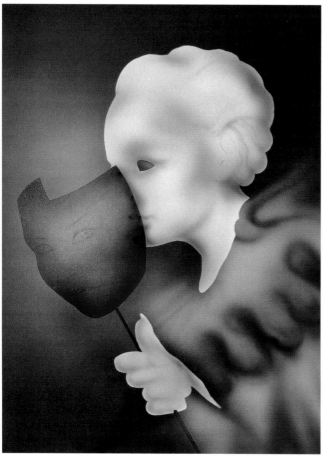

7. Shade the eye of the figure with gray and uncover the remaining shapes that will be made to look like porcelain.

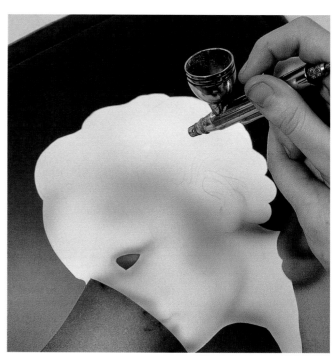

8. Begin to define the shapes of the porcelain face using a gray made by combining sepia and a little blue. Work in transparencies so you can open up some white areas later on.

10. Using a piece of paper cut out in the right shape to form a suspended template, define the most concrete shapes, such as the waves of the hair.

9. Here is a preliminary version of the figure in which the major shapes are evident. You have to avoid darkening it too much, since you are dealing with a white figure.

11. Use an eraser to open up white areas in the face and the hands, in imitation of the reflections from porcelain.

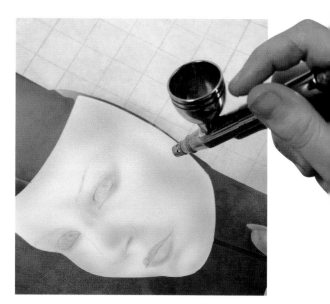

12. Once you have finished opening up the white areas, you will see a brilliant texture appropriate to porcelain. For brighter reflections you can use the electric eraser.

13. Cover the image of the porcelain face with a piece of paper trimmed to size and shape so that the paint does not come off and spoil the work when you put on a new mask. Now cut out and uncover the part of the new mask that you are about to work on.

14. Using English red, go over the pencil lines and start to define the shapes of the face. The eyes are still blocked off.

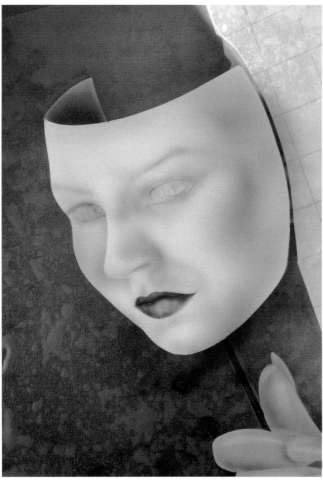

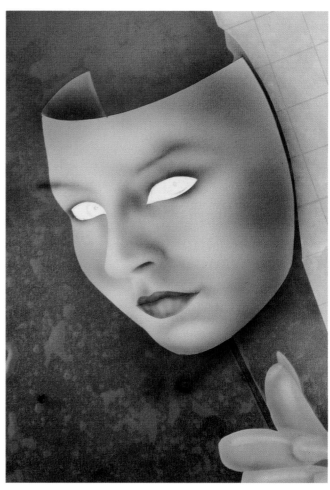

15. *After making a movable mask in the shape of the mouth, spray it with the same English red, but much more intensely, to create the lip shade that is visible in the picture.*

16. *Spray the whole face with a light coat of ochre to create a flesh color. Then, using umber, create the shadows that will give the face volume and contrast. Now you can unmask the eyes.*

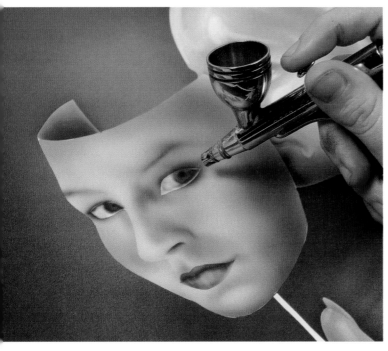

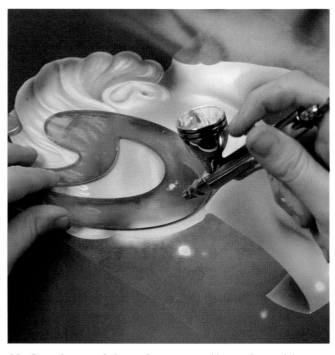

17. *A mixture of blue and a little sepia produces a neutral, grayish blue that will serve to define the color of the eyes. Hold the airbrush very close to create the shape of the iris and the eyelids.*

18. *Cover the woman's face and return to working on the porcelain. To make it shine more and appear lighter, spray certain areas with white acrylic.*

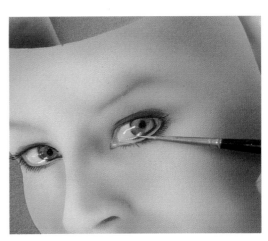

20. Now begin working with some different materials. The girl's eyes are done using gouache and colored pencils to create the most convincing realism. A couple of reflections rendered in gouache will make them stand out.

19. Add the luminous white to some reflections on the face and the waves of the hair. Apply the white to the clothing so it appears very filmy and imprecise.

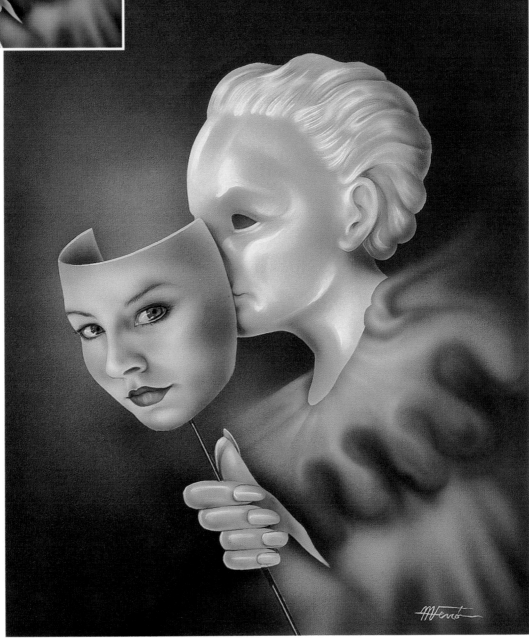

21. Finally, the entire face of the girl has been worked to produce the jaw line and the nose, the eyelashes, and the lips. The thickness of the mask is indicated by using a fine brush and a gouache flesh color. In the result you see how the porcelain and skin textures contrast.

Naturalistic Illustrations

Illustrating with the airbrush has long been the most efficient way to do scientific illustrations. This involves illustrations that cannot be created with photography, but that look fine when they are rendered with the realism of the airbrush.

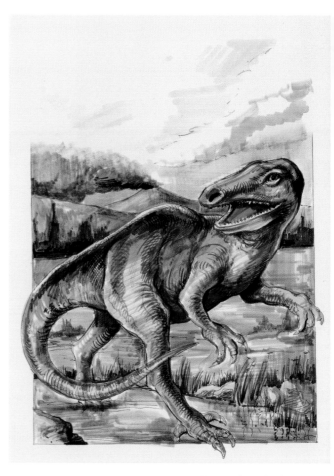

DEPICTING ANIMALS

The airbrush is often used to depict animals, especially in illustrations that provide information on nature and fauna. In many books devoted to nature themes, especially those for children, photographic images are combined with drawings and engravings. Although animals can be drawn using any technique, scientific illustrations tend to seek a high degree of realism and detail, and in such cases the airbrush has been employed with great success. Every animal, with its special morphological characteristics, requires a different technical execution. The procedure varies depending on whether you have to depict feathers, fur, or scales.

1. After studying the drawing you intend to make and compiling the various documentation, you need to make a sketch, in this case with a marker, of the image you are going to create.

You can find information on the outward characteristics of animals and their habitat in other books, or you can develop them from documents from an expert in the field. In addition to being attractive, the illustration also has to be credible, so proper documentation is essential.

THE SKETCH

The shape of the dinosaur cannot be done too quickly; rather, you have to do a sketch to work out the position of the animal and the natural environment in which it is found. The contrasts have to be established in the sketch, the colors and the shapes of the objects, in addition to the composition of the scene in which the objects on the paper are distributed. We suggest a central image of the dinosaur so that it appears as the focus of the drawing. In the foreground there will be a stream with rocks and vegetation; behind the animal,

a plain; and in the background, a leafy forest behind which rises an active volcano topped by beautiful clouds. Obviously, this is a complex illustration in which you have to deal with portraying the natural landscape as well as the animal.

DOCUMENTATION

All illustrators should have plenty of visual data to help in completing their work. Invention may be fine for arriving at an idea, but expressing it with precision requires use of documentation, preferably photographs. In the present instance, the subject is complicated; there are no photos of real dinosaurs, and all representations of them are based on theories and scientific knowledge on the part of experts. Their characteristics, though, are common to reptiles, with their rough bodies covered with scales, so photographs of lizards and crocodiles can serve as references as you create the texture of the skin. In regard to the background, you can use any photograph to observe the nature of rivers, mountains, and trees.

2. Start by drawing the dinosaur on the paper and covering it with self-adhesive masking film. Then use a scalpel to cut out the area that corresponds to the head and remove it for spraying.

3. Begin by spraying the face of the creature with umber, controlling the pressure and the distance to produce the desired width of lines. As you draw the shapes, you have to work with the airbrush as if it were a pencil.

4. Now you have created the animal's face, and you can see the first scales done with the airbrush held very close, plus the volume created by spraying from a greater distance.

TEXTURES

Dinosaur skin has a particular texture, very similar to that of some lizards. The effects of texture can be created by adding fine cross-hatching on top of a base color. In order to guarantee the quality and realism of this appearance, you have to try it with different colors on a separate paper before painting on the actual work.

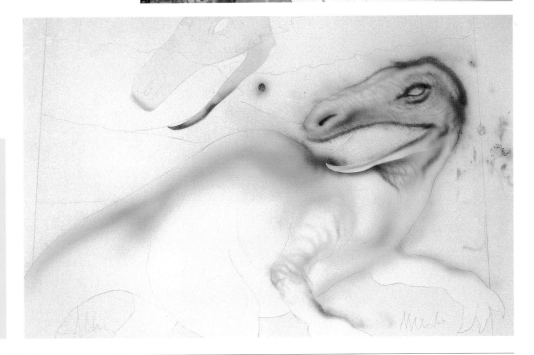

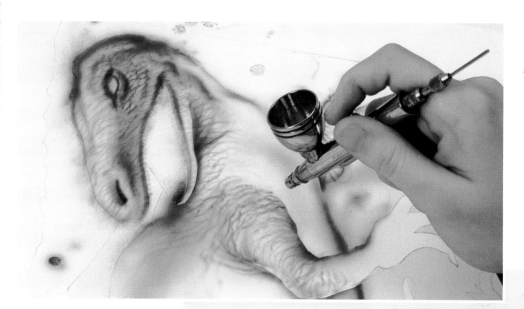

5. *Here you observe in detail how the texture of the skin is created by working with the airbrush held very close to the paper, in this case, for the leg.*

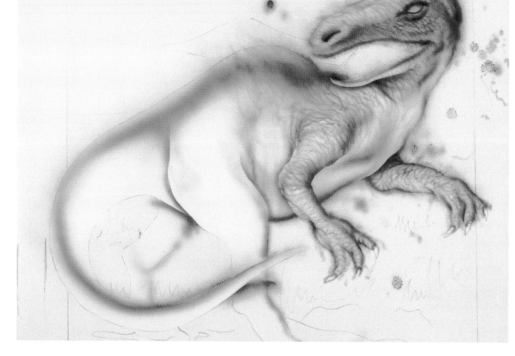

6. *Continue working on the body by using the airbrush to shade the animal's back and tail from a moderate distance to create an appearance of relief.*

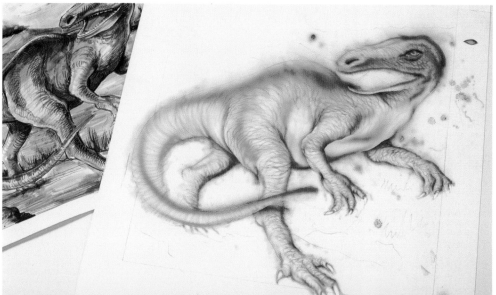

7. *Complete the texture by adding some umber. The cracks in the skin are in proportion to the size of the respective areas, so that they are small in the face and larger in the extremities and the body.*

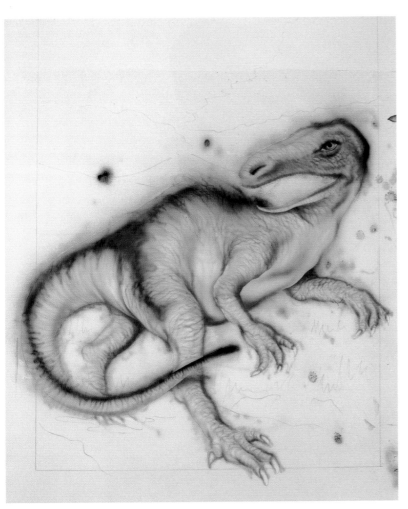

8. *Next use some sepia to shade in the upper part of the animal, imitating the dark areas on the back and the tail.*

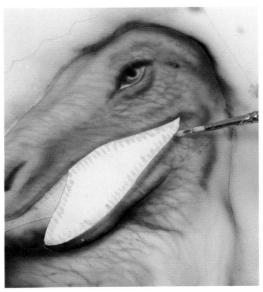

9. *Then unmask the interior of the mouth and cover up the rest of the head. Apply some liquid masking glue in small brushstrokes to simulate the teeth.*

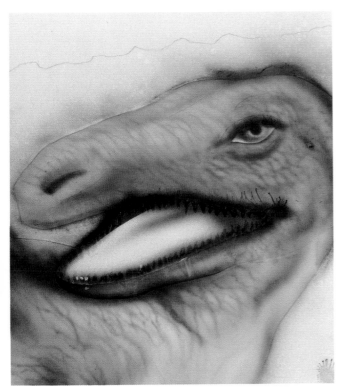

10. *Once the glue is dry, you can spray the interior of the mouth in black to shade the area behind the teeth.*

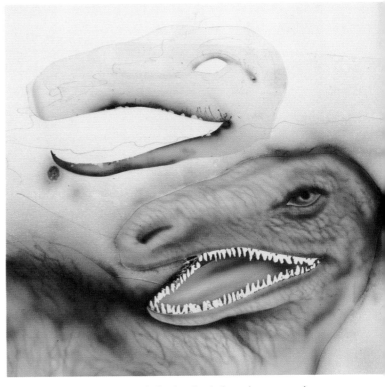

11. *Remove the masking from the head and rub the teeth to remove the masking glue.*

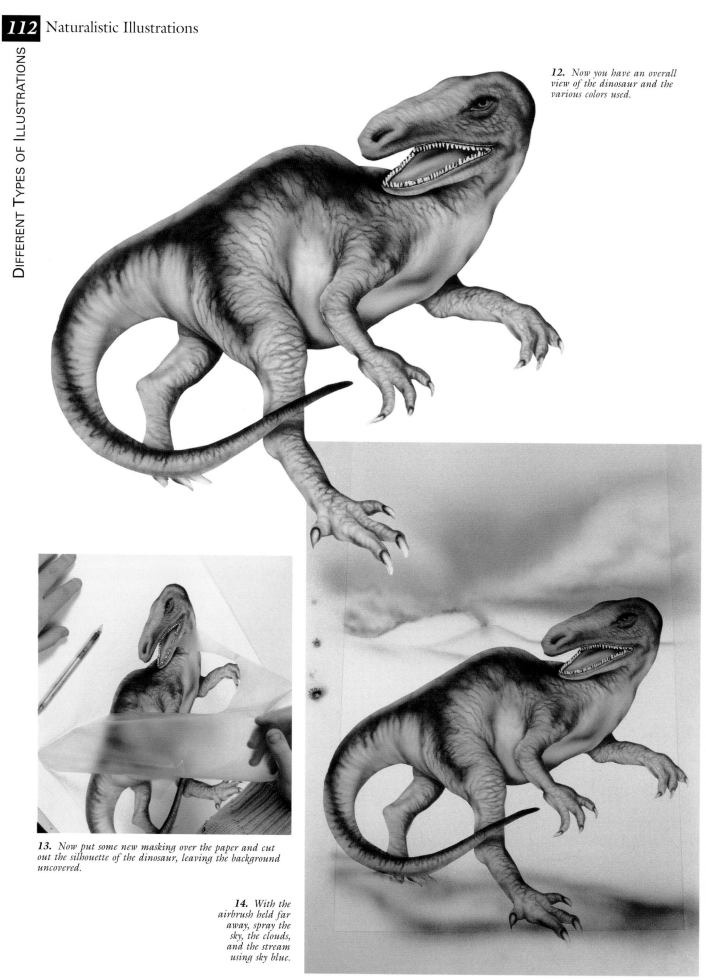

12. *Now you have an overall view of the dinosaur and the various colors used.*

13. *Now put some new masking over the paper and cut out the silhouette of the dinosaur, leaving the background uncovered.*

14. *With the airbrush held far away, spray the sky, the clouds, and the stream using sky blue.*

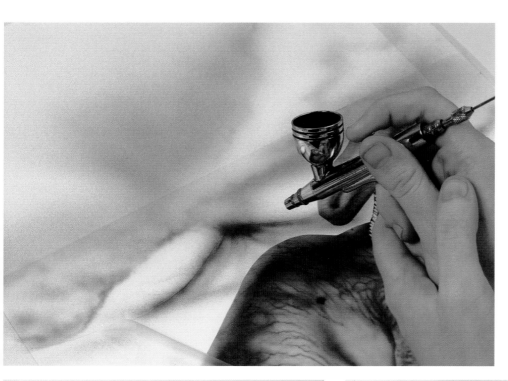

15. *After that, cover the sky with masking, cut out the silhouette of the volcano, and spray with Prussian blue to simulate the cracks in the mountain.*

16. *Add some colors to the sky to create a stormy appearance. Spray some lilac on one side of the clouds to create a sense of volume. Add some yellow and red to the horizon, and use these same colors to create the smoke that issues from the volcano.*

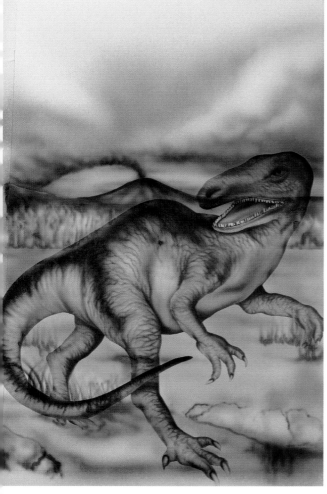

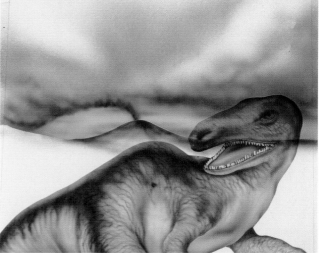

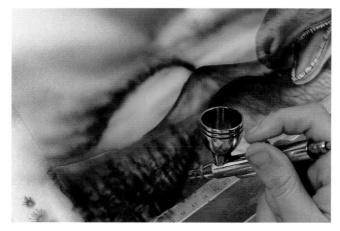

17. *Use olive green to form the trees in the background and the bushes. Hold the airbrush very close to imitate the leaves on the trees; simple strokes will suffice for the bushes. Use the same green on the plain to create a variety of levels, and then go over it once with ochre to create the color of the earth.*

18. *Mix some green with a little sepia to create a very dark color to use in creating the shapes and contrasts among the trees. Place a straight edge at the bottom to keep the border with the earth straight.*

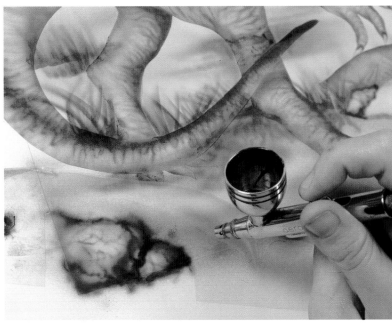

19. *Check the contrast between the dark trees and the animal's back.*

20. *Work on the rocks in the foreground by using straight sepia to depict their furrows and cracks.*

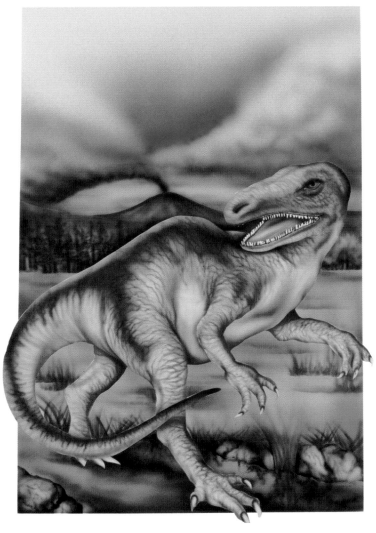

22. *Use colored pencils and gouache to texture the animal's skin; use an eraser to bring out some reflections in the areas of highest relief.*

21. *Here you have a new overall view of the dinosaur's color and the surroundings. All that is left to do is add some small details.*

23. *Add the details to the foreground, creating reflections in the water and the bushes.*

24. *At last you have completed a detailed rendering of all the textures that are part of the image, both in the background and in the animal that has a wrinkled and textured appearance. You have imparted a tremendous amount of information on the background (where the leafy landscape of that era is visible) as well as the morphology and the characteristics of the great reptiles.*

Illustrating in the Style of Comics

Now we turn to illustrating a cover for a comic book. Normally the pictures inside are done with less detail, since a lot of information is provided in a small space, and it would be a tremendous amount of work to do the whole comic book with the same degree of precision and shading.

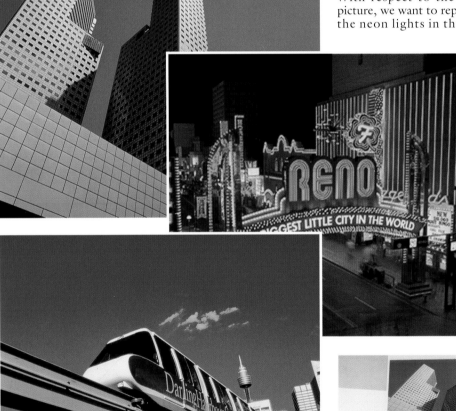

In doing this illustration, we have chosen three different images as a point of departure; each one offers important information for our illustration. The skyscrapers and the elevated train will form the composite that you need. They provide the perspective, the diagonal, and other elements. The photo of the illuminated signs help you understand how neon lights look and how to set up contrasts in the picture so that they stand out against the other features.

PHOTOMONTAGE

We have selected an urban theme with very modern and futuristic traits (many comic books feature large cities and high-rise buildings). To create the desired image, we have selected three photographs that we find interesting for different reasons. Those involving the buildings and the train will be used to create a photomontage where two images will be blended into one. We will use no computer resources, nor cut out the silhouettes to mount them. Both images have enough similarities of color and perspective to join them mentally and create a new image simply by drawing. With respect to the third picture, we want to represent the neon lights in the new design. The presence of the illuminated signs will introduce more color and contrast, and will create a lighter and more eye-catching vision.

WORKING IN INK

In illustrations for comic books, ink is indispensable, whether the comic is in color or black and white. In black-and-white illustrations, the ink defines the darkest shadows such as the halftones, which are created through crosshatching; the more lines, the darker the grays, and vice versa. In color illustrations, the ink takes on a different function. The grays and intermediate colors are done with inks of the appropriate colors through glazes, whether with the airbrush or with an artist's brush and watercolors. Properly speaking, working with ink involves applying black onto the image. Even though this is not a factor in the halftones, it is used for the darkest and most clearly defined shadows, and for profiling the features, clarifying their shape and outline.

1. Draw the final outline of the desired illustration on tracing paper, introducing a few variations into the image to adapt it to the new vertical format. Perspective is to be observed scrupulously, and that constitutes one of the main attractions of the illustration.

2. Once the drawing is done correctly, cover the paper with self-adhesive masking film and cut it with a scalpel. Use a ruler for the straight lines and press down with the cutter as if you were using a pencil.

3. Trace the sketch onto the paper using a fine pencil and a light table. The sketch contains the shapes and the details from the pictures that you want to incorporate.

4. Holding the airbrush far away, and using a sapphire blue, spray the sky with several passes to create the right shade. The blue needs to be more intense in the upper part of the sky.

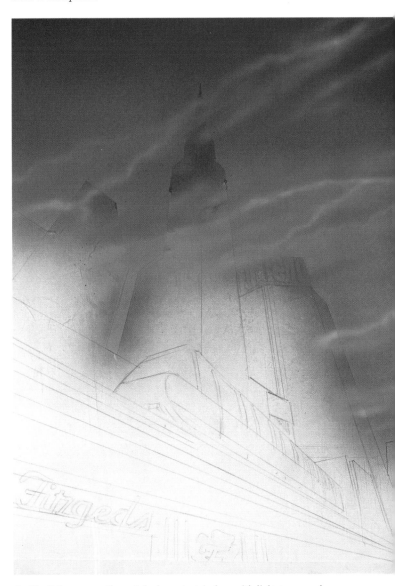

5. Mix some white into the blue to produce a lighter shade for creating the clouds. Use a piece of paper torn in an irregular shape as a suspended template to create the cloud shapes.

6. The lightest atmosphere of the lower part is done with light passes and movable templates. The buildings are blocked off with masking to shield them from the spray.

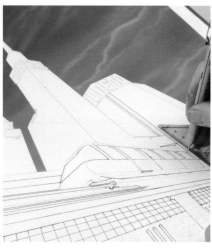

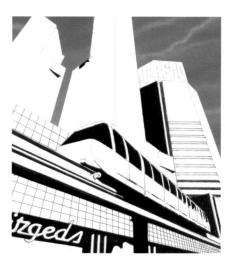

7. *Uncover the buildings and check to be sure that they are still entirely white. Go over the shapes using a fine-point marker to make them clear and visible. Use the ruler throughout.*

8. *Work in negative in the lower part of the drawing. Establish the shadows with black and leave white the parts that will be colored in. The largest areas can be filled in with a brush dipped in black ink.*

9. *You have established the major black areas of the scene, and you have an initial view of the shape that the vehicle takes on through the application of the ink.*

10. *Work on the tall buildings to create the shapes of their windows. In the lightest planes a blue marker is used to define the straight lines.*

11. *More straight lines are drawn in blue to integrate the shadows with the sky.*

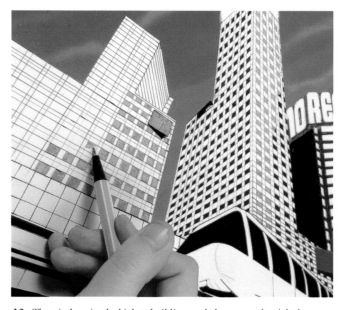

12. *Now go over the shapes of the first sign with a blue fine-tipped marker so it can be read with ease.*

13. *The windows in the highest building and the one on the right have to be defined. It will take a lot of patience to color them in.*

14. Finish the work with ink and marker. The lower part is ready for adding colors, using the airbrush on a well-defined base with plenty of contrast.

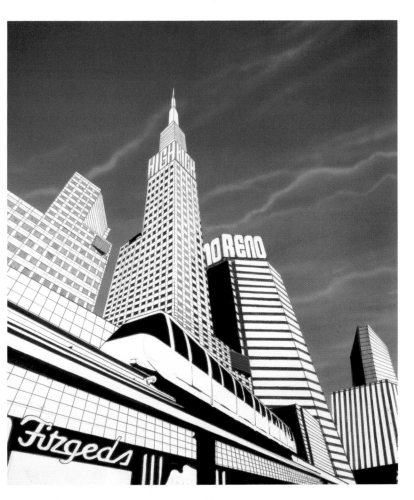

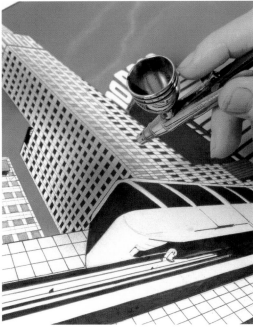

15. Mix Prussian blue with a little sepia to produce a cold umber tone. Block off the light areas and the lower part and begin to spray the darkest walls.

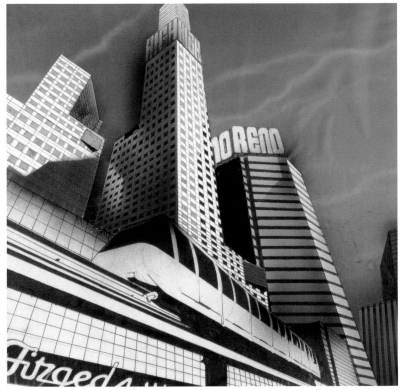

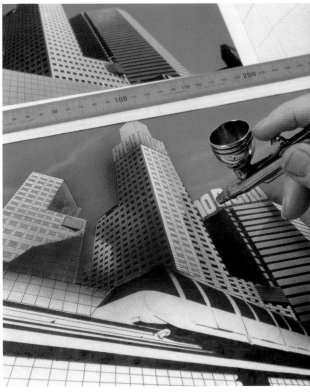

16. Use straight movable masks to keep some areas separate from others; it is not necessary to use self-adhesive masking. Spray with straight blue on other planes to create a variety of cool shades.

17. The lower part is still blocked off; now spray it with very light orange. This new color breaks with the cold feeling of the buildings and lends warmth to the whole work.

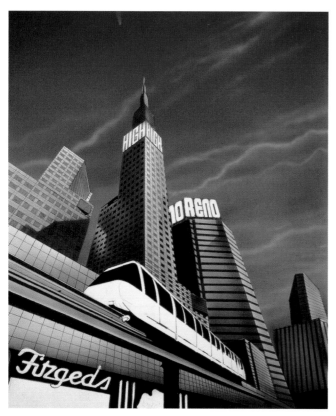

18. Keeping the train blocked off, spray the middle front wall. It becomes clear that all the buildings are based on the contrast between light and shadow, and between blue and orange.

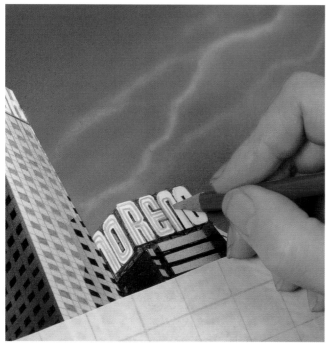

21. Highlight the signs on top of the buildings with colored pencils or markers. This involves lines applied by hand, and the airbrush is not needed. It is a good idea to rest your hand on a piece of paper to avoid smudging the area already sprayed.

22. Use the airbrush directly on the lower signs. The colors need to be bright and varied for you to perceive them as real lights among the dark areas.

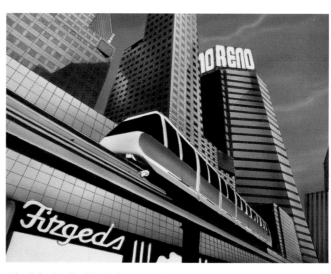

19. Color in the side of the train, the upper part with ultramarine, and the lower part with sapphire, to create a mild gradation. To spray with confidence, first mask the train and uncover the strip to be colored in.

20. Spray the neon lights in the chosen color—orange in this case. Now we see the importance of having done the whole illustration as a negative in black and white; the lightest and most transparent colors do not interfere with the black, so there is no need to mask them again.

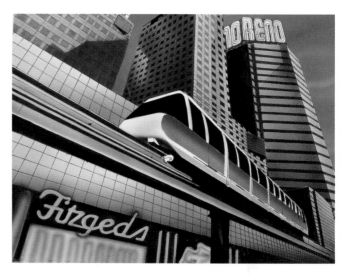

24. Spray a little white to create a wake and represent the movement of the train. This creates an impression of speed.

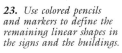

23. Use colored pencils and markers to define the remaining linear shapes in the signs and the buildings.

25. You have created a scene worthy of any urban comic book cover, with great contrasts and details in ink that are part of an airbrush illustration that is graphic and pictorial.

Science Fiction Illustrations

N ow we will tackle one of the favorite themes of airbrush artists. Space, spaceships, stars, and galaxies are wonderful subjects for the airbrush. On the one hand, the realism you can achieve with the airbrush is just right for shiny, metallic spaceships. On the other, the background, with its lights and color fusions, comes out better with spraying than with conventional methods, which inevitably show pencil and brushstrokes.

LETTER DESIGN

Don't base your image merely on outer space and a flying spaceship, but rather give it a more modern and conceptual sense by adding some lettering to it. The spaceship will be in the shape of letters that contain a message, which may be the name of some modern shop, a discotheque, or just a pro-

motion for some new fad item. The design for the lettering is done on a separate paper, playing with combinations of the word *zone* and the number *2010*. Selecting the type style is a lot more laborious than it appears, and you have to try out several possibilities before hitting on the right design. The ability to do this graphic design depends on the artist's inventiveness and creative talent.

Here you have a sketch where the letters form the spaceship. The top plane contains the word ZONE, and in the frontal plane the number 2010. The letters and numbers are interpreted as lighted, contrasting metallic blocks that form a spaceship, with its indentations and projections, its curves and straight lines appropriate to each letter and number. The exhaust flames are drawn behind the spaceship's jet engines, which provide mobility to the object in space. As a preliminary step to the drawing, make an outline on tracing paper. Before completing the real work, you always need to make a sketch in which you set up the relationships among shapes, light and shadow, and colors.

1. Trace the shapes from the sketch onto the paper for use with the airbrush. You can do the tracing on a window or on a light table. It is important to use rulers and curved templates to keep the lines sharp and clear.

2. *The letters should be traced in blue in such a way that there is no doubt about the planes and the shapes. If you used a black graphite pencil, the lines would be too dark to cover up with the subsequent spraying.*

3. *Next cover the whole image, including the margins, with self-adhesive masking film. You have to avoid formation of any air pockets.*

4. *Use a craft knife, rulers, and templates to cut out the silhouette of the spaceship.*

5. *Then very carefully uncover the part that corresponds to the background. The spaceship, the jet exhaust, and the planet have to remain blocked off.*

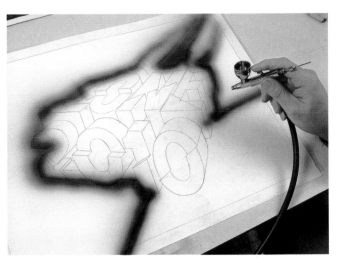

6. *First spray the outlines of the blocked-off silhouettes in black. Try to establish the color of outer space, focusing first on the edges of the central masking and the planet.*

7. *Then hold the airbrush far away to spray the background. Make numerous passes, filling the reservoir as many times as necessary to create a very dark color.*

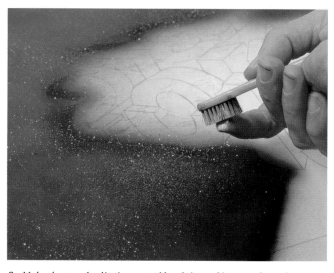

8. Make the stars by dipping a toothbrush into white gouache and spattering it onto the surface of the paper.

9. You can clearly see the mottled effect of white on black. It is good to make the spots of different sizes.

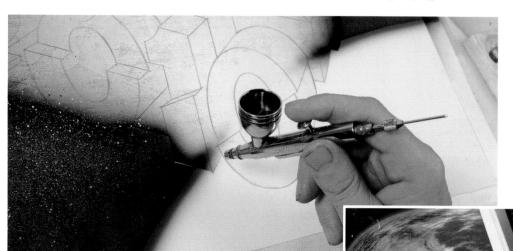

10. Uncover the silhouette of the planet in the lower part of the picture and spray it with cerulean blue at the edges where it meets outer space.

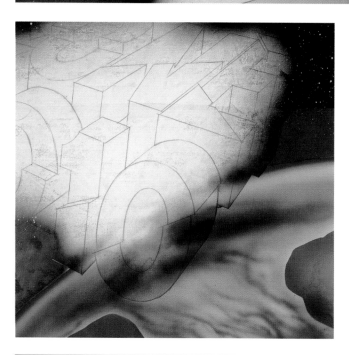

11. Use the same shade of blue to establish the areas of water on planet Earth; keep the parts corresponding to the continents blocked off. In order to make this composition, you have to have a good picture of Earth from an atlas or some book about the solar system.

12. Block off the oceans and spray the land forms. Alternate passes with green, ochre, and umber to create mountainous relief.

13. *Begin defining the clouds that envelop Earth's atmosphere, alternating between the electric eraser and spraying with white. Preserve the contrast with the background of the planet.*

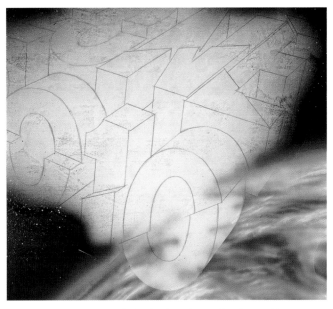

14. *You have finished with the clouds and created a dense, white atmosphere that envelops the planet. You haven't had to do much to create relief in the continents because they are covered in clouds.*

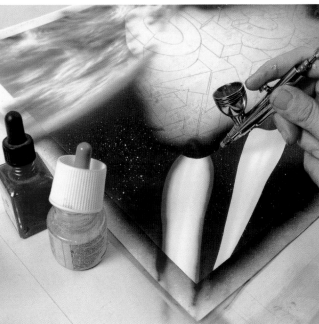

15. *Once the background is done, uncover the area that corresponds to the fire from the jet propulsion. Spray with red and yellow without masking the background; since it is black, it won't be affected by the application of lighter colors.*

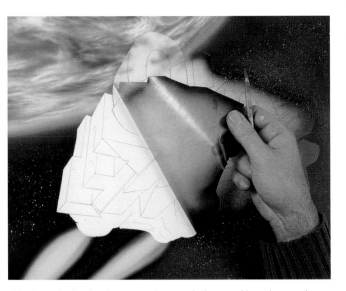

16. *Once the fire has been sprayed, unmask the spaceship to be sure that no color has gotten under the masking.*

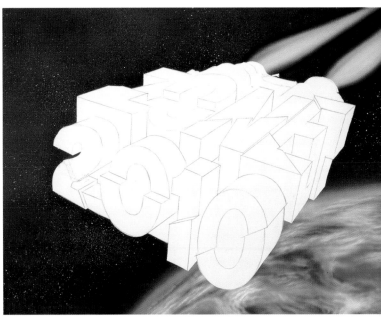

17. *You have a first view in which the background, the fire, and the planet are done. Now all you have to do is define the spaceship.*

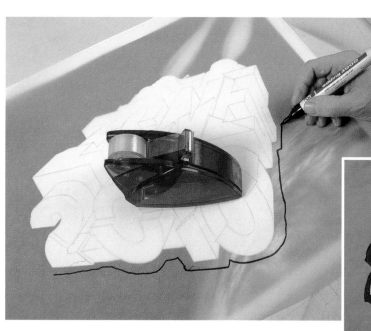

18. Now, to work exclusively on the ship, block off the background with tracing paper in order to not damage the painting. Put the piece of paper onto the drawing and place a weight in the center to keep it from moving. Then use a pencil or marker to trace the approximate outline of the spaceship.

19. Cut the silhouette out of the tracing paper and place it over the picture. Then put self-adhesive masking film over it and carefully cut around the exact outline of the spaceship.

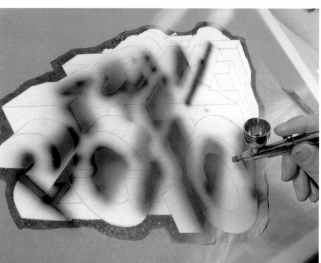

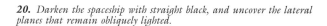

20. Darken the spaceship with straight black, and uncover the lateral planes that remain obliquely lighted.

21. Add a little violet to the shading to create a more metallic appearance. Uncover the frontal planes to see the contrast that has been created.

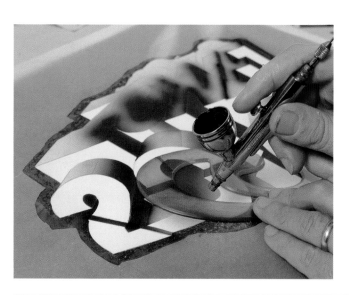

22. Color in the frontal planes with smooth passes in cerulean blue. Use a curved template to create the separations of the round letters against the others. Use a ruler for the straight lines.

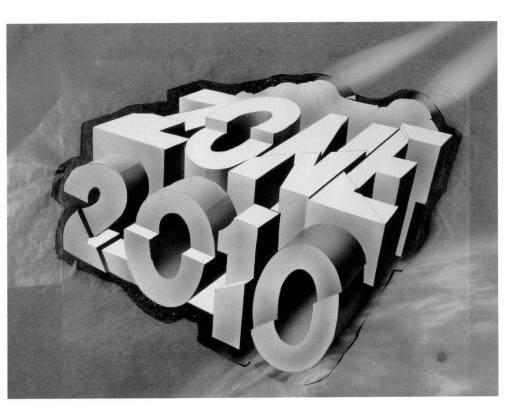

23. *Remove the masking from the upper planes and check the three-dimensional effect of the letters that make up the spaceship.*

24. *Make a light pass with ochre across the top planes so they appear to reflect the heat from the propulsion.*

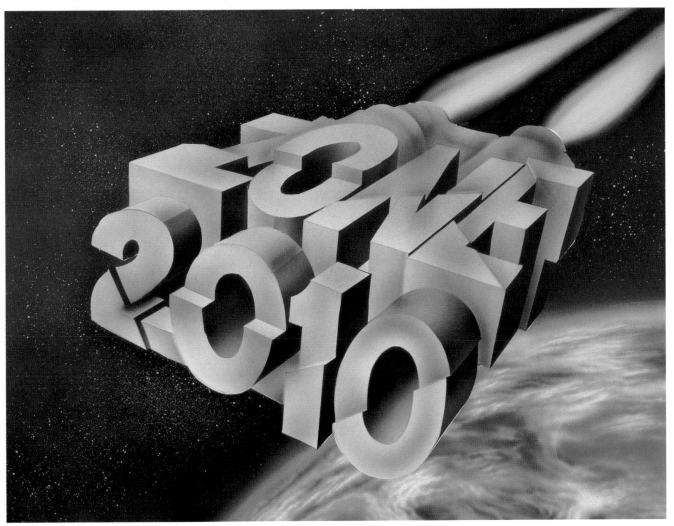

25. *Once the spraying has been done with the airbrush, use supplementary materials to fill in the details. Use white gouache to trace the relief in the compartments of the spaceship.*

26. *Next, use white gouache mixed with yellow to very carefully paint the windows and all the illuminated details of the areas that appear in glancing light.*

27. *With a fine-tipped marker, go over the details of the compartments, especially where the white was applied, to create the proper relief.*

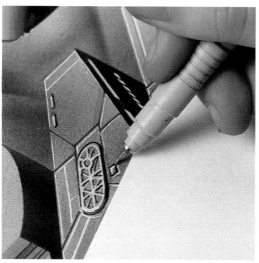

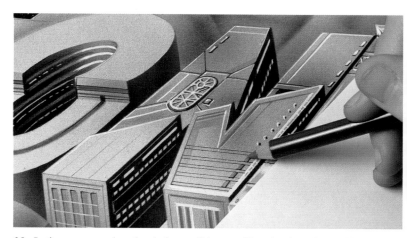

28. *In the upper part where there is the most light, use a lilac-colored pencil to establish the equidistant divisions in the spaceship; this color will stand out adequately, but not as forcefully as black.*

29. *Enlargement in which you can see the minute detail done with colored pencils, black marker, and gouache. You have to begin in the upper part and check the resulting appearance.*

30. *One part of the spaceship has been thoroughly worked on, and you can see how the overall effect changes as you add the details. Now finish the rest of the illustration with the same precision.*

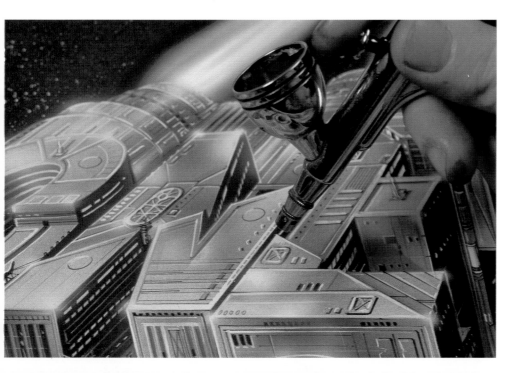

31. Finally, put some white into the airbrush reservoir and create the main reflections on the metallic surface of the spaceship.

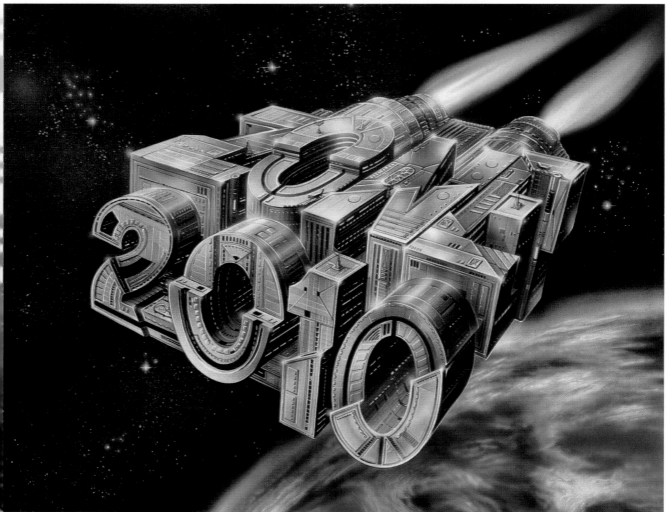

32. You have done a magnificent illustration in which several factors have been incorporated: the metallic shine of the spaceship, a spatial background with a planet, and especially a series of letters adapted to an imaginary and original spaceship that constitutes a very fine piece of graphic design.

Decorating a T-shirt

One of the current applications of the airbrush is focused on decorating T-shirts. Many painters have specialized in this area, which allows the purchaser to own a unique, handmade article of clothing. Special acrylic colors are used for this technique; once they are ironed, they adhere permanently and become capable of withstanding the many washings to which we later subject them.

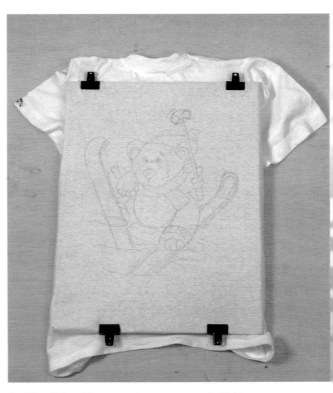

1. *Use a light table to trace the pattern onto the T-shirt. Then use binder clips to secure the cloth to be painted to a piece of stiff cardboard. The cloth has to be stretched taut with no wrinkles.*

AN ILLUSTRATION FOR CHILDREN

One of the most viable routes for illustrators involves the world of children. Illustrations for children are part of many storybooks and entertaining stories for small children, and there are many T-shirts, hats, and all kinds of items that target this clientele. What are the distinguishing traits of an illustration for children? The answer is obvious: The simpler the shapes, the easier they are for children to recognize. Illustrations that are filled with an abundance of details are not as readily accepted as direct, simplified ones

are. Before doing a model for this type of illustration, you have to create simple, clear, and amusing shapes that are attractive to look at and especially colorful. There is a wide variety of subjects, and practically any idea will work. Here we have drawn the caricature of an animal—a skiing bear with human characteristics—with easily identifiable features and some type of clothing such as a scarf and a cap, which are designed to appeal to the youngest children.

To begin with, you have to locate or create the desired theme, and make a sketch based on it. You need to choose something in a vertical format so it will fit onto a T-shirt. This drawing can be made actual size, otherwise you'll have to use a photocopier to enlarge or reduce the drawing.

2. *Trace the same picture in the same size onto a separate piece of posterboard; cover it with self-adhesive masking film, and cut out the templates that will subsequently be applied to the T-shirt. These shapes can't be cut out directly on the T-shirt, which surely would be damaged in the process.*

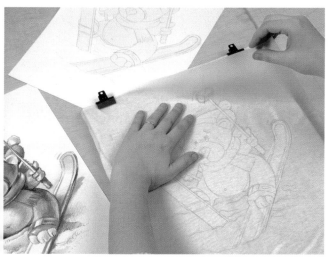

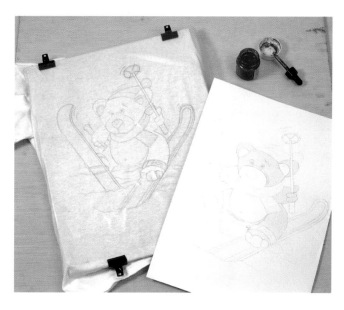

3. *After cutting out the silhouette of the bear and the skis, cover the background of the T-shirt, leaving the bear exposed.*

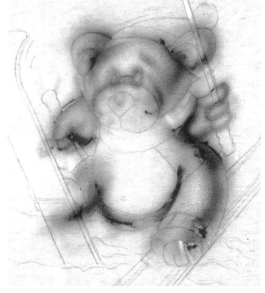

4. *Block off all the parts of the bear except the fur. On the posterboard you can see the masks that are uncovered in the clothing.*

5. *Spray the surface of the bear with sienna; round out the shapes by saturating the color in the right places. You can define some shapes by using a curved template.*

6. *When you spray the bear's fur you can see the spectacular sense of volume that can be created with just one color.*

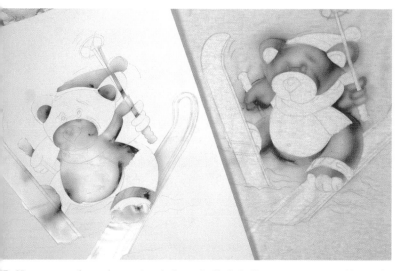

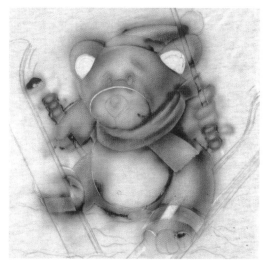

7. *Next, remove the masks covering the bear; the blocked-off areas now appear white on the T-shirt. Put the masks back onto the posterboard to avoid confusion. It is always a good idea to put the templates that are not being used back onto the posterboard.*

8. *Cover the white and brown areas with the templates and spray the bear's clothing with red. Color saturation will create the appearance of volume and of fur. Keep working to create rounded shapes.*

ADVANCED AIRBRUSH APPLICATIONS

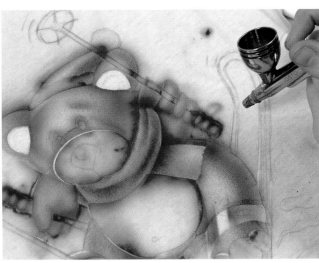

9. Block off the red areas and color in the white areas with a small amount of very transparent cerulean blue.

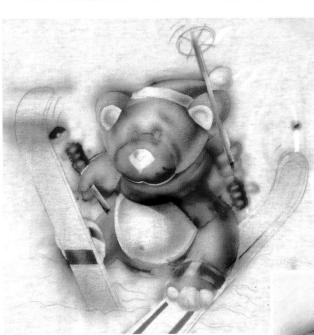

10. Apply very light blue to the bear's muzzle and belly and to the skis. The remaining areas are kept blocked off.

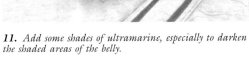

11. Add some shades of ultramarine, especially to darken the shaded areas of the belly.

12. Apply some black to define the bear's muzzle and eyes.

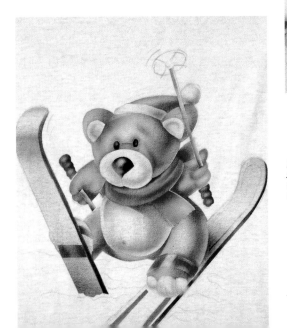

13. Darken the skis and the bear's shadow using the same black; then remove all the masking to check the results.

14. Once you are finished with the airbrush, work some shapes with a conventional brush; these include the eyes and the eyebrows, as well as some of the most precise outlines.

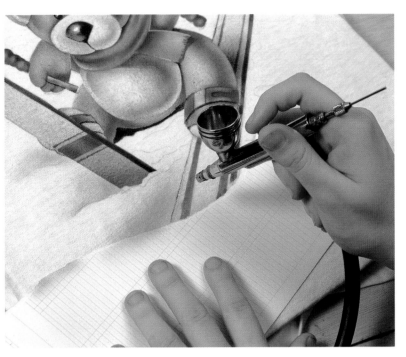

16. *Iron the back of the T-shirt with a very hot iron. The paint will adhere perfectly to the cloth, and the shirt can be washed in detergent with no problem as often as needed.*

15. *Using a piece of irregularly shaped paper, create an impression of snow. You can use very light ultramarine blue and let the white show through.*

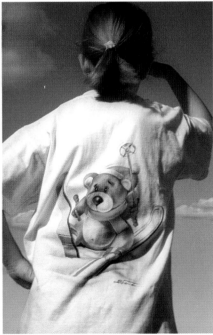

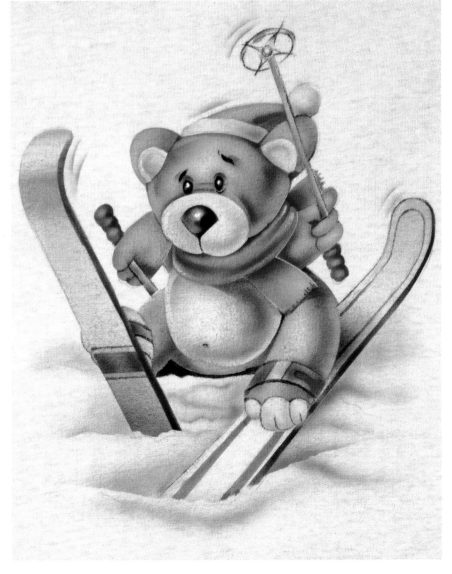

Here we see the final appearance of the bear T-shirt worn by a young girl.

17. *The illustration is finished. The picture of the bear is a highly stylized caricature for children. With respect to the procedure, the posterboard that was used to cut out the self-adhesive masks and establish an order in applying the colors is very important. The final details are applied with a brush.*

A Picture of a Mechanical Device

Technical illustrations may be the most complex ones that can be done with an airbrush. They are often chosen, and the images are filled with details and important elements for the functioning of the mechanism. The artist has to strive for absolute accuracy so that all the parts appear realistic and any specialist will recognize them instantly and confirm that the shape and position are accurate.

THE INITIAL IDEA: A BICYCLE

You have to start with an existing image that is detailed enough for you to work with the necessary precision and include all the small details, including the tiniest bolts. The principal mechanism has to be very clear, including all the details of the cranks and the chain. The documentation used was a series of photos taken in a bicycle shop; one of these photos includes the entire bicycle that shows its proportions and outline. A second photo captures a fragment of the bike where the mechanical details are more visible; the closeup was not chosen at random, as it is the most important area that includes the wheel, the frame, the chain, and the chainring. The main task involves choosing the best composition and isolating a section that is visually attractive as well as illustrative of how the bicycle works. To conclude, a third section of the bicycle was photographed in which the rim and tire are featured; their complex patterns require detailed study and could not be done from an overview of the bicycle.

GATHERING DOCUMENTATION

Once you have assembled all the photographs of the bicycle, it is time to do the illustration on paper. The first decision involves the size of the work. Since original photographs are too small, you will need to enlarge the image with a photocopier. A lot of detail is lost in these enlargements, but they are still useful in making tracings. The subsequent elaboration of the illustration is done on the basis of the original photographs, not just for the colors but also for other details. Do a few enlargements until you get the size you want. Finally, bring together all the images and count on having at your fingertips all the details and elements needed to produce as detailed a work as possible.

1. *Using the photos or the enlarged photocopies, trace a precise illustration of the bicycle and all its details onto a piece of tracing paper. Once that is done, trace the image onto the paper for the finished work. It is ideal if you can do this on a light table, as the drawing is so complex that it will take quite a while to trace.*

2. Next, cover the whole surface of the paper where you will be spraying with self-adhesive masking film, making sure that there are no bubbles, since there will be some very fine details to spray.

3. Now use a craft knife or a scalpel to cut around the outline of the bicycle. You have to be especially careful with the spokes of the wheel, since they are very thin.

4. Remove the masking from the entire outline to uncover the background. You must also uncover the elements between the spokes that are part of the background.

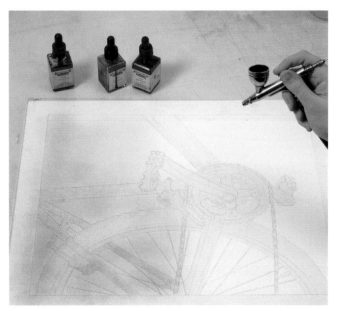

5. Begin spraying the background with a very neutral color; you have mixed English red with a little sepia and blue to produce a warm gray. Hold the airbrush far away from the paper to produce a broad, uniform spray.

6. You have now sprayed the entire background, and you can see how the color is building up on the masking and clearly defining the silhouette of all the features.

7. *Remove the masking from the spokes of the wheel and check to be sure that you have cut the proper thickness and that no paint has gotten into them.*

8. *Spray a little of the background color onto the spokes so they are not so white, and then remove the masking from the rest of the bicycle.*

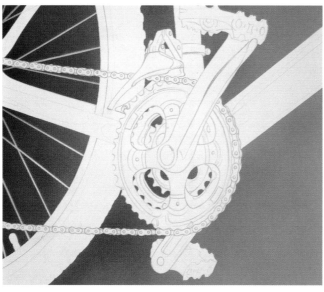

9. *Once all the masking has been removed, go back over the most concrete parts of the chainring and the chain, which make up the drive train of the bicycle. Use a gray pencil whose color is a good match for the whole image.*

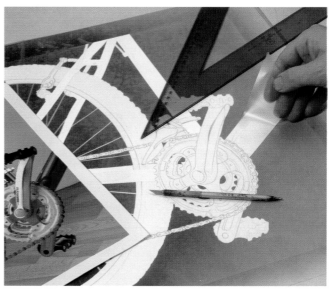

10. *Once again cover everything up with new masking in preparation for spraying the red of the bicycle. Then cut out the outlines of the parts to be sprayed with that color and remove the masking from them.*

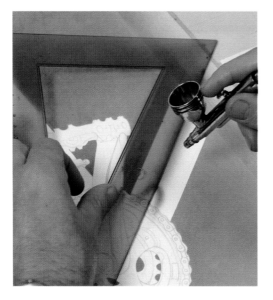

11. *Begin spraying the picture with straight carmine. Use a ruler to keep the spray straight along the shape of the object.*

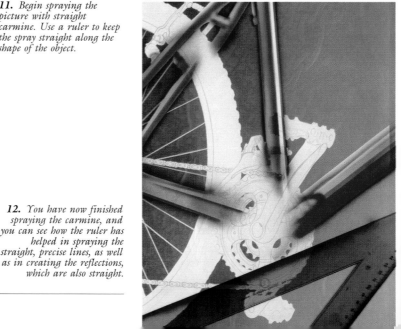

12. *You have now finished spraying the carmine, and you can see how the ruler has helped in spraying the straight, precise lines, as well as in creating the reflections, which are also straight.*

13. *Darken the color of certain areas, such as the reflection on the frame; so that the reflection follows a well-defined curve, make a movable mask from a piece of paper.*

14. *You are going to use some straight black to reinforce the contrast on the red metal. You will accomplish that by using a pair of movable masks, one of which is a ruler, and the other of which is the straight edge of a piece of paper.*

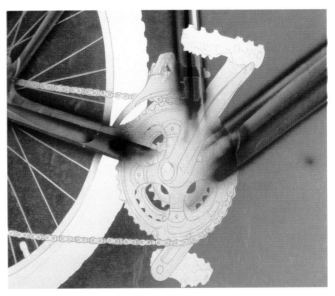

15. *You can see the effect produced by the specific, straight stripes sprayed in black onto the red in all the relevant areas.*

16. *Once again cover up all the areas sprayed in red and uncover only the parts that will be sprayed in black—the wheel and the pedals.*

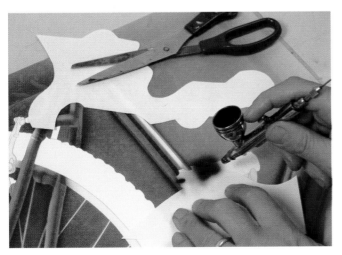

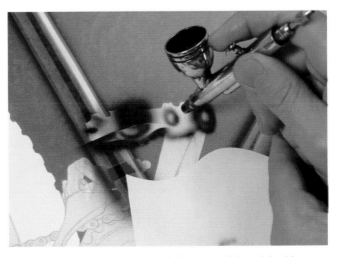

17. *Begin spraying the pedal with straight black; in order to define its shapes clearly, cut out a piece of paper, creating different curves that you will use as a movable template.*

18. *Continue defining the shape and the volume of the pedals with a spray of black paint to make them stand out clearly and precisely due to the shadows and reflected light.*

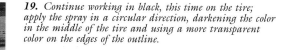

19. *Continue working in black, this time on the tire; apply the spray in a circular direction, darkening the color in the middle of the tire and using a more transparent color on the edges of the outline.*

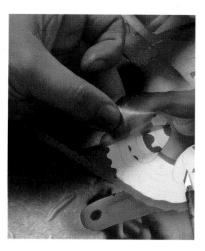

20. *Mix a drop of black with ultramarine blue and create the metal finish of the pedals, cranks, and chain. Use the same paint to define the color of the tire where the light hits it.*

22. *Now refine the gears, since they are the most complicated part of the bicycle. The center and the chain have already been sprayed with grayish blue; now remove the masking from the lightest part.*

21. *You now have an initial overall view of the different basic colors (red, black, and grayish blue) that make up the bicycle.*

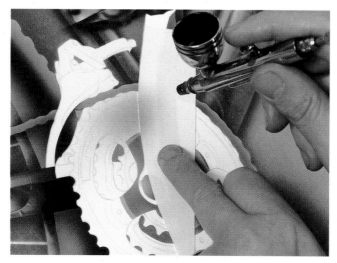

23. *Use a movable template to block off the illuminated part of the gear and spray the gear and the chainrings. To make the template, cut a curve that coincides with the outline of the gear arm.*

24. *From cardboard cut the ellipse that corresponds to the inner and outer shape of the chainring, and spray the area in between with gray.*

25. *Spray the inner shapes of the chainrings freehand, holding the airbrush very close and approximating the various parts that make it up.*

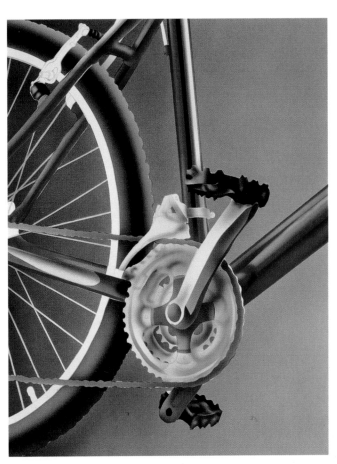

26. *You have now sprayed the entire surface of the bicycle, and the airbrush work is done. All you have left to do is the detail work, which will be done using other mediums.*

27. *Use a brush dipped in black paint to define the most specific linear shapes of the small parts.*

28. *Reinforce the contrasts in the gear arm by using an eraser to lighten the metal on the inside.*

29. *For the most precise details, continue highlighting with specific strokes. In this instance you are setting up the reflections using white gouache.*

30. *Continue defining reflections with white gouache, this time on top of the metallic red. Use a ruler to produce perfectly straight lines.*

31. *Use gray to paint in the smallest parts of the bicycle that you have not sprayed because they are too small to mask conveniently.*

33. *Go over the spokes with a fine-tipped marker, which simultaneously defines them more clearly and creates a sense of volume.*

32. *Paint a gray line that passes in front of the red parts of the frame. You have to be sure that all the spokes are in the right position and of the appropriate diameter; if they're not, you can reinforce them using the same color.*

34. *Begin defining the details in the tire, creating all the shapes of the tread. Use black to draw the shapes that stand up from the lightest area of the tire.*

35. *Use gray to continue defining these shapes; this time go over and color the shapes that stand out on the darkest parts of the tire.*

36. *Using white gouache, trace the areas of reflection on the tread pattern; this makes them stand out very boldly, as they do on shiny, new tires.*

37. *Finally, after all the details have been added to the bicycle, you can declare the picture finished. The result is spectacular and realistic, and it shows all the beauty of the chrome, plus every last detail of the mechanical workings. Add a little border of bicycles in the lower part to go along with the illustration and give it more punch as an advertising tool. The final result could be used for an advertising poster for a brand of bicycle, or for a bicycle store.*

Topic Finder

We wish to thank Joan Blanza, of the firm Bicis López, for his technical advice.

Original title of the book in Spanish: *Todo sobre la técnica de la Aerografía: Manual imprescindible para el artista.*

© Copyright Parramón Ediciones, S.A. 2001—World Rights
Published by Parramón Ediciones, S.A., Barcelona, Spain.
Author(s): Parramón's Editorial Team
Illustrator(s): Miquel Ferrón and Myriam Ferrón
Text and Coordination: Myriam Ferrón
Exercises: Miquel Ferrón and Myriam Ferrón
Design: Toni Inglés
Photography: Nos & Soto

© Copyright of the English edition 2002 by Barron's Educational Series, Inc.

All rights reserved.
No part of this book may be reproduced in any form,
by photostat, microfilm, xerography, or any other means,
or incorporated into any information retrieval system,
electronic or mechanical, without the written permission
of the copyright owner.

All inquiries should be addressed to:
Barron's Educational Series, Inc.
250 Wireless Boulevard
Hauppauge, New York 11788
http://www.barronseduc.com

ISBN-13: 978-0-7641-5509-3
ISBN-10: 0-7641-5509-1

Library of Congress Catalog Card No.: 2002103221

Printed in Spain

9 8 7 6 5 4 3